Supporting Yourself
as an Artist

Supporting Yourself as an Artist

A Practical Guide

Second Edition

Deborah A. Hoover

New York Oxford
OXFORD UNIVERSITY PRESS
1989

Oxford University Press

Oxford New York Toronto
Delhi Bombay Calcutta Madras Karachi
Petaling Jaya Singapore Hong Kong Tokyo
Nairobi Dar es Salaam Cape Town
Melbourne Auckland

and associated companies in
Berlin Ibadan

Copyright © 1985, 1989 by Oxford University Press, Inc.

Published by Oxford University Press, Inc.,
200 Madison Avenue, New York, New York 10016

Oxford is a registered trademark of Oxford University Press

Library of Congress Cataloging-in-Publication Data
Hoover, Deborah A.
 Supporting yourself as an artist : a practical guide /
Deborah A. Hoover.—2nd ed.
 p. cm.
 Bibliography: p.
 Includes index.
 ISBN 0-19-505971-9
 ISBN 0-19-505972-7 (pbk.)
 1. Artists—United States—Economic conditions. I. Title.
NX503.H66 1989
700'.68—dc19 88-38566 CIP

9 8 7 6 5 4 3 2

Printed in the United States of America

To my mother and father

Preface

Though I was elated with the favorable reviews of the first edition, there is, as I discovered through correspondence and further research, room for improvement. My goal in preparing this edition has been to highlight recent innovations in the system of support for individual artists. For while the process involved in supporting yourself as an artist does not change markedly, the means do: new artistic options arise; new funding sources emerge; and new regulations come into effect.

In the three years since the first edition, a great deal more attention has been devoted to the needs of the individual artist. Many factors have been at work. The National Coalition for Individual Artists, an organization composed of several state art agencies, and the National Advocacy Coalition for the Working Artist, composed of national arts organizations, have been established to increase financial support and recognition for artists. The National Ad Hoc Committee on Individual Artists' Support has been promoting the development of new sources of private and public sector funds. The American Council for the Arts has established a National Planning Committee on the Originating Artist to pursue special projects, con-

duct research, support publications, and raise the level of official concern for the special needs of individual artists.

Other developments include a new area of legal exploration, focusing on the needs and rights of individual artists. A pressing issue has been the effect on the artist community of the Tax Reform Act of 1986. Other prominent legislative issues concern artists' housing, copyright, *droit morale*, and artists' rights.

Funding opportunities for the individual artist have shown some modest growth. More state arts councils are now awarding fellowships to artists, and Massachusetts and Ohio have initiated multiyear fellowship programs. New foundations have been established to support individual artists; among them are the Gottlieb Foundation, the Pollock-Krasner Foundation, and the Artist Trust of Washington State.

Finally, there has been a significant increase in service organizations and publications for artists, particularly ones addressing the problem of locating adequate and affordable working space. The additions I have made to Appendix B and the Bibliography exemplify this.

However, reflecting the dynamic nature of the process, some specific sources of information and support reported in the first edition have disappeared. I was not surprised that this would occur. Indeed, it is a commonplace in the arts that the rate of turnover of organizations is high and the life of many new initiatives is short. There is a lesson in this: an important part of the process of supporting yourself as an artist is the regular and systematic revision of your information on potential funding sources and the opportunities they provide. This second edition is a contribution to this process.

Fajara, The Gambia D.A.H.
November 1988

Acknowledgments

Many people who care very deeply about the arts and about individual artists have helped make this book a reality. I am profoundly grateful to all of them for sharing their experiences and insights with me. A few individuals deserve special thanks: Heather Lechtman and William Porter provided me with a constant source of encouragement and intellectual stimulation; Beth Galston, Ann Marion, Tom Norton, and Brian Raila shared so much of their lives as artists; and Kent Davies made valuable suggestions for improving the manuscript. A special word of thanks goes to the staff of the Center for Arts Information in New York City, who helped with sources for this edition.

Throughout the period I have worked on this book, I have had the continued support and understanding of my colleagues at MIT. I am especially indebted to Jerome Wiesner, and to the members and staff of the Council for the Arts at MIT, with whom and from whom I have learned so much.

I would also like to express my gratitude to the St. Botolph Club Foundation, which provided financial support for travel. Its generosity enabled me to expand my research in ways that otherwise would not have been possible.

My husband, Malcolm McPherson, has enthusiastically supported my efforts. His editorial assistance has improved the book, and his good humor has helped me keep it all in perspective.

At Oxford University Press, I wish to thank Valerie Aubry, Jeffrey Seroy, and Rachel Toor. I also owe a debt of gratitude to Susan Rabiner, who edited the first edition. Working with them all has been a pleasure.

Contents

Supporting Yourself
as an Artist

Introduction

In 1978 I left the National Endowment for the Arts (NEA) to become Assistant Director of the Council for the Arts at the Massachusetts Institute of Technology. One of my responsibilities was to administer a grants program for supporting the arts within the MIT community. I had no idea that this experience would prompt me to write a book, much less one in a second edition.

At MIT there were at least thirty Fellows in the Center for Advanced Visual Studies—all mature professional artists involved with video, lasers, holography, or some type of environmental art. And almost as many students in the Master of Science in Visual Studies program were in the process of becoming professional artists. Among them were photographers, graphic designers, filmmakers, and visual artists. The faculty, too, included professional artists—choreographers, composers, playwrights, filmmakers, musicians, visual artists, and poets. Undergraduates taking courses in each of these fields added to this diversity. Soon I learned of yet another group—men and women who worked part-time at MIT to provide themselves with an income and employee benefits to support their careers as artists.

Given this number and variety of artists, I was surprised to learn that the Grants Committee of the Council for the Arts did not support individual artists; instead, its focus was on project grants for student organizations and academic departments. This discovery led me to push for two changes: (1) to convince the members of our grants committee that they should abolish their policy of no support for individuals and (2) to initiate a technical assistance program to complement the grants program. Essentially, the technical assistance was to help grant applicants write proposals as well as seek additional funding and material support for their projects. Both changes were accepted.

The technical assistance program expanded dramatically at the same time that we opened our funding to individual artists. Most artists needed help with proposal writing, and lots of it. Others had creative ideas for projects that were well beyond the funding capacity of our Council, so I aided them in identifying other sources of support, using funding directories or through brainstorming sessions with our staff members. I quickly learned that many of these artists wouldn't follow through because they didn't know how to use such information. They were extremely hesitant to pick up the phone and call a government agency, foundation, or corporation. They often did not know who to ask, what questions to ask, or how to ask them. One internationally acclaimed musician came to my office three times to rehearse a phone conversation with a potential donor and the possible responses he might get to questions about his project and budget. However, I also learned that once the artists overcame their initial fright, most became quite successful in raising funds and securing in-kind gifts of equipment for their work.

Within a short time, my calendar was booked solid with appointments to talk to MIT artists who needed assistance raising funds and other support. At first, an intern helped me with some of the research work, and I tried to accept appointments with artists in the late afternoon only. But I ended up spending breakfast, dinner, and weekends with artists because of the demand for this type of help. At the invi-

tation of several faculty members in the Visual Studies program, I began to give seminars for graduate students on funding for artists. Finally, I realized that it would be much easier to consolidate all this information in a class open to all MIT artists—students, faculty, and staff.

During the January term of 1981, I offered a seminar called "Support Structures for Artists." Enrollment was limited to fifteen so I could work individually with each artist. The first class was attended by forty-five people—I didn't have the heart to turn anyone away.

Because there were no comprehensive books about support for individual artists, I designed the course around my own research, case studies presented by guest speakers, and practical experience in proposal writing and proposal review. I required every student to identify a personal project and a potential funding organization. As an assignment, I asked each student to write a proposal to his or her targeted organization and submit it to me. I reviewed each and offered suggestions and corrections. During the first hour of every class, I presented background information and personal insights about funding opportunities and resources for individual artists. During the second hour, we had guest speakers from corporations, foundations, arts service organizations, and local, state, and government arts agencies. One class was devoted to legal problems, another to proposal writing.

One of the last classes was organized as a mock grants review panel. Every class member received a package of "anonymous" proposals that had actually been submitted to the Grants Committee of the Council for the Arts in previous years. Half the class role-played as members of a "grants committee"— reviewing the proposals and allocating funds based on specific review criteria and an allotted sum of money equal to 50 percent of the total proposal requests. The other half were observers, presenting comments after the mock-panel session. The outcome was the opposite of what I expected. After hearing students complain that funding organizations were unsympathetic to *their* proposals, I was appalled at how stingy and

critical they were when placed in the shoes of the decision maker. They gave partial funding here and there but ended up with a large part of the funds unspent!

In the last class, after disguising identities, I distributed the proposals written during the past weeks by the students themselves for a class critique. This time, the students were far more supportive of the projects and incredibly helpful with suggestions. Most quickly divulged which proposal was their own so that they could get more specific recommendations and comments from their fellow class members.

Classes always extended beyond two hours because the students had so many questions for the speakers and so many preconceived attitudes about funding for the arts. Many artists expected to argue with the speakers. One young woman referred to the people who fund the arts as "the scornful critics of our imagination." When talking about the process of communicating with potential sources of support, they would use words like "terrifying," "scary," and "mysterious." But the opportunity to talk informally with representatives from major corporations, foundations, and government agencies was an eye-opening experience. Indeed, one student wrote, "I was surprised to see that the speakers were affable human beings genuinely interested in helping artists get funding." The students were also amazed to learn that funding was so idiosyncratic. In some instances, I had invited two or more speakers from a corporation or foundation and each had radically different policies and opinions concerning the funding of individual artists.

Many artists in the class objected in general to the need to write grant proposals to obtain funding. "It demeans our integrity," one claimed. They wanted their art to speak for them. It hadn't occurred to them that their sentiments were shared by other professionals. Many scientists, for example, support themselves through grants, and most scientists hate proposal writing just as much as artists. One of the class members said that he had no intention of ever writing a proposal. He was surprised when I pointed out that he had already

done so in filling out his application to MIT. When we started to discuss some of the other choices such as a personal presentation by the artist or a site visit with each applicant by one or more members of a review panel—and the cost of these choices—proposal writing didn't seem so bad after all.

The thought of rejection was difficult to accept for most of these artists. Many were surprised to learn that it was a common fear, one that I, too, shared. My job required that I raise funds to support my own salary, and when I first came to MIT, I made it very clear how I dreaded the thought of fund-raising and the fear of hearing "No." But once I tried, I loved the challenge. A colleague, Gregory Smith, reminded me on several occasions that the art of fund-raising is based on the realization that you are seeking funds from people who know that they have lots of money; you know that they have lots of money; and they know that you know that they have lots of money. The task is simply a matter of convincing them that your project is better than that of the next bloke. His point, which is worth remembering, is that if you believe in what you are doing, raising funds to support your work becomes a matter of convincing others that your project is as good as you know it is. The hard part is finding the right person or the right organization.

My own attitude toward raising funds was influenced by an incident from my college years. During my junior year, I became intimidated by the thought of a five-year graduate program in the History of Art. I was not ready to make that kind of commitment. I went to talk to one of my favorite professors at Dartmouth College, Frank Robinson, and he told me to write down what I would do in the next year or two if there were absolutely no restraints on my life. That was easy. I came back the next morning with a specific plan: I wanted to travel to all the great cathedrals and museums of Europe; I wanted to get a job "in the arts" in Paris; I wanted to learn German and Italian; I wanted to ski and climb in the Alps. Instead of having a good chuckle, Frank said, "OK, now do it." It had never occurred to me that there might actually be a way to make my dream a reality.

But Frank encouraged me to explore opportunities for fellowships with my department chairman and with people in the Career Services Office. One year later, during the spring of my senior year, I received notice that I had received two alumnae fellowships for travel and study abroad. Ever since, I have believed that if you have a good project and are thoroughly committed to it, you will be able to find support for it.

There was a sense among some artists in my seminar that society had an obligation to support them, to provide studios for them, and to allow them special tax deductions. They believed these "perks" should be available to them with little or no effort or obligation on their part. Many pointed to the income tax concessions for artists living in Ireland, the government support of artists in the Netherlands, and the government's role in providing studios or other workspace for artists in Yugoslavia as models of state support for artists. But few were aware of the specific tax advantages or consequences of these policies—many are not as attractive or as financially rewarding as they may at first seem. Although I agreed that in the United States we need more effective funding mechanisms for artists (see Chapter 6), I have learned that many artists are not fully aware of the options already available to them. The objective of my class was to help artists learn about existing sources of support and how to use them more effectively in their careers.

A young poet in my class suggested that I put my course material into a book so it would be more widely available. It took me almost four years to complete the research. During that time, I talked to artists working in every discipline throughout the United States. On numerous occasions, I posed as an artist myself to see how people at funding organizations would react to my request for funding or information. I repeatedly tested my ideas through my own efforts to secure funding and my work with MIT artists to obtain support, write proposals, and more fully understand the opportunities available to them. I have interviewed over three hundred artists, arts administrators, and representatives of foundations, corporations, and government agencies as well as individual donors. My experiences

and theirs, which are derived from our successes and failures, have given the material I share with you a solid practical base.

This book is written to help independent artists obtain support for their work. Whether you are a media artist, visual artist, craft artist, poet, playwright, composer, choreographer, or interdisciplinary artist, these chapters will help you develop procedures for securing the information, funding, and assistance you need to support your career. I have chosen to address artists in a variety of disciplines rather than to focus on, for example, visual artists. The reasons for this are three-fold: (1) the process of seeking support for your career as an artist is similar for all independent artists—only when you begin to market your work do major differences emerge; (2) many artists are becoming more and more interdisciplinary in their work and consequently the distinction between, for example, a visual and media artist is becoming blurred; and (3) the material presented in this book has been highly effective both in a course taught to many different artists and in the support I provide to artists at MIT on a day-to-day basis.

My concern is primarily with the early years of an artist's career when the income from artistic work alone is unable to support a reasonable standard of living. Almost 85 percent of artists receive some specialized art training in school (Wassall et al., p. 21), but little if any of this relates to the basic support and management of a career. Consequently, the poet or the painter enters the world of the professional artist assuming that he or she is not supposed to know about career management, or worse, that artists should not have to know about it. They logically, but inappropriately, assume that there are social institutions in place that will support them. And they are often shocked to learn that this is not the case. Indeed, sources of support do exist—but they are extremely diversified, are not focused primarily on the independent artist, and their representatives do not come knocking at your door. Essentially, the support artists obtain is what they are able and willing to generate themselves.

Young artists, fresh out of school, are faced with a dilemma. They need to survive financially, but their training as artists generally has not given them the skills to enable them to do so. They need money

for living expenses; they require space in which to work; they need materials and equipment to work with. Unless they can depend on family members for support, they are faced with three options.

1. Seeking a full- or part-time job in a field related to their art, and doing their creative work during nights and weekends.

2. Seeking a full- or part-time job in a field not related to their art, and doing their creative work during nights and weekends.

3. Learning the skills needed to support their career so that they can increase their productive time spent in creative activity and decrease or eliminate their time spent on work other than their art.

This book is directed primarily at those who have chosen the third option. It provides the necessary information and skills to help artists improve their chances of adequately supporting their careers.

Artists value creativity. To be successful, artists have to be not only creative and stimulating in their artistic work and challenged by the need to express themselves in new ways, but they also have to creatively support themselves. Both require skills, albeit different ones. Artists must develop organizational, administrative, and business skills as well as their artistic talents. This book will help them acquire these skills through a thorough understanding of both the resources available, and the means to identify them. My goal is to help artists expand their creative talents by developing their ability to support themselves.

Supporting Yourself as an Artist: A Practical Guide will assist readers in identifying the organizations and individuals that can provide the financial and nonfinancial support artists need. It will show artists how to be effective in securing this support. It will expand an artist's range of opportunities. It will also ensure that, when seeking support, artists will have a solid foundation to start from.

In addition, the book provides information for those who assist and support independent artists, whether potential donors, arts administrators, arts advocates, arts educators, or corporate, foundation, or government representatives. My view is that to effectively support

independent artists, arts administrators and arts educators need a more comprehensive understanding of the programs and funding currently available for artists, a deep appreciation of the needs of artists, and a close examination of whether these programs and funds actually meet artists' needs. Individual artists have too frequently been last on the priority agenda for arts organizations. As those dedicated to promoting art, we must reevaluate our support system for independent artists, both in the private and the public sector, and make that support system more responsive to the artists' changing needs.

An artist's success in securing support is correlated with his or her understanding of the types and sources of support available. Chapters 2 and 3 provide this background information. You may find my approach somewhat cumbersome at first because you will have many questions that will go unanswered. Be patient. Your questions will be answered in later chapters. Each chapter builds on the information of the one before. As I did in my class, I try to acquaint you with the many opportunities for financial and nonfinancial support by taking you behind the scenes and sharing with you the opinions of the individuals who are in a position to provide support for individual artists. I then describe how you can obtain and efficiently use this support—how to write a proposal, how to learn about new funding opportunities, how to get valuable equipment donated to you, and how to find an accountant to help you with your taxes—for free!

I have tried to make this book comprehensive as well as practical and concise. When helpful information is readily and inexpensively available in published form or through established service organizations, I refer you to it. Rather than listing names, addresses, and phone numbers that are subject to change, I outline the process by which you can find this information on your own. Consequently, with the exception of parts of the Bibliography and Appendix B— which give the name, address, and telephone number of every organization cited in the book—little of the material is dated.

The principles I outline for obtaining and effectively using support will, with modifications you choose to make, provide a robust set of

procedures to serve you throughout your entire career. I begin by assuming that you already have some knowledge about types and sources of funding and some understanding that obtaining support requires special efforts on your part. The set of procedures I outline helps you structure this knowledge and develop a framework for organizing new information that you gain through personal contacts, publications, and experience. A schematic representation of the approach is given in the following figure.

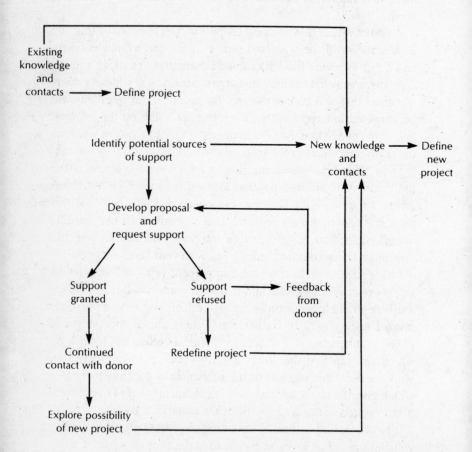

As an artist, you enter the cycle by having a project or activity in mind for which you need financial support or some form of technical assistance. Once you define your project, you build on your existing knowledge to identify potential sources of support. This leads you to the stage of requesting support, most often through a written proposal. Your proposal is either accepted or rejected. If accepted, you complete the project, making sure to remain in touch with the donor or organization for possible funding or help with a future project. If your proposal is rejected: (1) find out why to avoid the mistakes or overcome the inadequacies that led to the rejection, (2) identify other funding possibilities, or (3) seek help to redefine the proposal or activity so that it can either be resubmitted or submitted to a new donor or organization. Each step in the cycle adds to your knowledge and provides a firmer basis for supporting new projects.

Although the information I have included is extensive, there are several areas I have either ignored or discussed briefly. My intention was not to cover all areas of support for independent artists exhaustively—an impossible task for one book. Rather, I have tried to provide you with an approach to securing support so you will be better able to help yourself. I, therefore, focus on the procedures to obtain the information you need to support your career, irrespective of what that information may be or when you may happen to need it.

One subject that applies to every individual artist, and that I have not directly addressed in this book, is marketing. Methods of pricing and distributing your work vary greatly, depending on whether you are a video artist, a potter, or a choreographer. But there are common elements of marketing that apply across disciplines—promoting your art work, understanding your customers, and perceiving yourself as a productive artist within your local community and the larger national community of artists. You will find most of this material covered indirectly.

Much research still remains to be done on the needs of independent artists and the best means of meeting these needs. We could all benefit from thorough studies of marketing opportunities for artists,

the support structure for independent artists in other countries, and the problems and opportunities specific to each artistic discipline. By addressing in this work the most basic concerns common to all independent artists and by studying their principal sources of financial support (other than their own work), perhaps others will be encouraged to continue this line of research.

My hope is that, after reading this book, you will obtain confidence in your own ability to support your artistic career. You will obtain valuable knowledge here about a wide range of financial and nonfinancial resources, and I hope you will be less intimidated in approaching the organizations or individuals that provide them. You will benefit, too, from the insights of other artists— their successes and their failures. Finally, you will realize that funding agencies are there to help you, but they can't do their job without you.

This book will not help you become a better artist. But it will show you how to find the money, materials, time, and support to let you be as good an artist as you can be.

ℒ 1

Support
for Artists:
Where to Begin

How can an individual artist begin to identify potential sources of support systematically and economically? Is an artist destined to a life of thumbing through directories and lists—most with insufficient, out-of-date information compiled for the use of arts organizations, not artists? Isn't there a better way? This chapter addresses these questions.

RESOURCE IDENTIFICATION

Many artists receive funds from sources that are well documented and well publicized. Others obtain funds through informal channels or undocumented sources of support. Still others receive funds and support from sources that are not earmarked for philanthropy and, therefore, are not documented as such—for example, corporate budgets. Identifying these sources of support requires diverse methods. Locating information about documented sources of support is relatively simple when you become familiar with the best reference materials and the proper information networks. Trying to locate

information about undocumented sources of support requires a great deal of imagination and personal energy, but it can be extremely rewarding. Both types of resource identification are described and illustrated in this chapter.

Imaginative approaches to fund-raising can perhaps be best learned through successful examples from other artists. Some of these examples are given in this book. But imaginative fund-raising can also be learned from creative professional fund-raisers, and there are plenty of them in any community. Brainstorming with professional fund-raisers can produce results quickly. A little imagination coupled with the following five methods of identifying support will lead to effective results without demanding excessive amounts of time.

Personal and Professional Contacts

Develop a working relationship with individuals at local arts organizations—arts councils, art-presenting organizations, and service organizations. The key person is not necessarily the director of an arts organization but the one who works most frequently with individual artists and understands their needs. You can often identify these people by asking other artists or by asking the secretary at the arts organization. Start by placing a call to your local arts council and arranging a short appointment with the staff person who works most closely with individual artists. If you do not know any local arts organizations, call your state arts agency (the number can be found under the government listing in your phone book) and explain the type of information you are seeking. Ask for recommendations of the arts administrators in your state or local community who can be of most assistance to you as an individual artist. Be sure to request names, addresses, and phone numbers.

Managers and directors of the local museum, dance company, theatre, or arts council are not the only arts professionals in town. Colleges and universities in your area have faculty and administrators familiar with the arts and arts funding. The staff of local foundations

and corporations may also be helpful. If a particular person is highly recommended to you for her or his expertise and resourcefulness but lives too far away to visit, write a letter—be specific about your work and your needs.

Once you have the name of a resource person, call and arrange an appointment. Introduce yourself and your work. Discuss your current projects and your future plans. Take a portfolio of your work or material that describes your work with you. Most important, find out what this person does and how she or he might be of assistance to you in the future. If located nearby, ask if their office subscribes to periodicals, newsletters, annual reports, or reference materials that might be available for your use. Don't leave the office without (1) asking for recommendations of other particularly helpful people in arts organizations, (2) leaving your résumé and some visual materials for their files, and (3) adding your name to their mailing list.

Every artist should know several people at key organizations who can provide information about funding sources and technical assistance. Usually, the most valuable individuals are those from your own community and those who work with projects related to your own. You should certainly try calling staff members of arts councils. As civil servants supported by tax dollars, their responsibility is to assist you; except in the rarest cases, you will find them extremely helpful.

Generally speaking, the opportunity to obtain support from an organization increases as the distance between your residence or studio and that organization decreases. This is especially true if you are an emerging artist. Many funding sources have geographic restrictions as criteria for support. Consequently, few know the opportunities for support in a given community better than the local arts administrators. It is their job to support and foster the arts in their community, and to provide funds and information to artists and arts organizations, but they can only do this if you first identify yourself and ask for their assistance.

Experience leads me to add that being polite is a tremendous asset. Recently, I received a phone call from an artist who refused to give

her last name. She had been "referred to me," she said, "by someone at the State Arts Council" and wanted "a half-hour appointment as soon as possible." My reaction would have been quite different if she had first introduced herself by name, mentioned who had referred her, explained briefly her project and needs, and asked if I might have ten or fifteen minutes to discuss her project and potential sources of support. A little courtesy and respect go a long way.

The local business community may seem to be the least likely place to find people who will support your work, yet the majority of artists I interviewed have found exactly the opposite to be the case. The following three examples demonstrate this.

A young muralist/sculptress, Barbara, requested cash support from U.S. Steel, which has its headquarters in her hometown, Chicago. The executives who read her proposal became personally intrigued with her project. Not only did they permit U.S. Steel architects and engineers to work with her at no cost, but the company later donated hundreds of dollars of supplies and $2,000 worth of cement for her park sculptures. Barbara keeps in touch with these executives through periodic visits to the company headquarters and by letters. She regularly receives in-kind support from them for her projects.

Michael, a visual artist from the San Francisco Bay area, was preparing for a small exhibition of his computer-aided sculptures. He wisely decided to invite many of the top executives of Apple Computer, Inc., located in nearby Cupertino, to the opening reception. The secretary who answered the phone at Apple was fascinated with his project and willingly gave him the names of the top executive officers, even mentioning other employees who would be interested in coming to his exhibition. One gentleman at the opening introduced himself to Michael and expressed his interest in his work. After a brief but stimulating conversation, Michael asked for his business card and phoned shortly thereafter to schedule a meeting. Thus, the Vice President of Marketing and Advertising became a loyal patron. So did Apple. After four or five luncheon meetings (Michael called them "the most tasteful in-kind support I have ever received"), he received a cash grant

of $1,000 from Apple. The relationship continues and thrives. Apple has donated and loaned a number of computers to Michael since that time.

In Chicago, a young artist, Joy, needed printing costs for the poster announcing a local show of her photographs. She called a printing firm in the Chicago area. The Technical Director answered the phone and Joy tried to explain her interest in the company above the din of the printing presses. The Technical Director asked to see her work. Not long afterwards, the company offered to print, publish, and distribute Joy's posters with all costs covered. She acknowledged the support and assistance of the printing company at the bottom of each poster. Joy kept in touch with the Technical Director by bringing in her recent work for him and the company employees to view. A year later, the same company produced an entire catalog of her work. When queried, the Technical Director commented that he and the other executives felt that Joy's work was of high quality and that they also personally enjoyed working with her because they were all amateur photographers.

In each example, the artist was able to secure support from local businesses by capturing the interest of various members of the staff. With this support came personal interest and assistance. Imagination and initiative were the only prerequisites—the imagination to involve or seek support from a local business and the initiative to actually pick up the phone and pursue requests. Although corporations and businesses may seem foreign to you, just think how alien you and your work seem to them! Many people who are not professionally involved in the arts never have the opportunity to meet artists; they only experience art at a distance. Chances are they would welcome the opportunity to meet with you and engage themselves in your work by providing assistance.

As an artist, your task is not only to create, but also to seek and recognize opportunities to share your work. Begin with your local arts and business community.

Newsletters, Newspapers, and Annual Reports

It is important to ensure that you receive a steady flow of information about funding opportunities and services. One of the most inexpensive means of doing this is to add your name to the mailing list of arts organizations. Most state and local arts councils have newsletters that provide information about upcoming grant deadlines, technical assistance workshops, funding opportunities, and other issues of importance to artists. These newsletters are usually free.

Although you may think that the newsletter of the Chicago Council on Fine Arts, the *Art Post*, for example, is of no value to you as a video artist in Texas, you would change your mind if you were to see a copy. The *Art Post* is issued quarterly and includes timely, well-written articles relevant to artists of every discipline. Although state and local arts councils orient their newsletters toward arts organizations rather than individual artists, don't despair; this information can still be useful. It helps point toward new trends and emphases in funding. Even information about other disciplines can be a source of new ideas and new targets of opportunity. A phone call or a stamp will place you on the mailing list for years to come.

Join a service organization or artists' association and subscribe to their newsletter. One representative example of an active service organization with an especially good newsletter is the Dramatists Guild, a professional association of playwrights, composers, and lyricists. For $50 a year, a subscribing member receives the monthly *DG Newsletter* and the *Dramatists Guild Quarterly*.* The *DG Newsletter* contains current information on legislative issues, special events, contests, awards, conferences and workshops (both local and national), publications, script requests, legal services, and typing and copying services. Members also have access to health insurance, business advice, marketing information, royalty collection services,

*I have included current subscription rates to give readers some idea of how much they might have to spend on such materials. Of course, subscription rates often change.

and use of the Guild's minimum basic production contract. Members living anywhere in the continental United States can use the toll-free hot line for information and assistance. To locate other artists' organizations and their newsletters, see "Service Organizations" in Chapter 3.

The Center for Arts Information publishes *For Your Information* (*FYI*), an excellent quarterly newsletter written specifically "for those who create and work in the arts." Artists may subscribe for $5 a year. Along with the newsletters from your state and regional arts councils, *FYI* is perhaps the most important publication for the working artist.

Program guidelines for the NEA, and the *Guide to the National Endowment for the Arts*, can be obtained free of charge by writing or calling the NEA.

Local newspapers provide a great deal of helpful information. For instance, articles in the business pages will acquaint you with local companies involved directly or tangentially with your work—corporations engaged in broadcasting, computers, printing, publishing, recording, acoustics, design, and so on. Information about individuals working at these corporations is found in both the business and social sections. Articles featuring a particular business leader and covering many aspects of his or her career, family, and interests are often part of the business or local sections of a paper. Articles in the social pages list or include photos of people who attend or organize special arts events. The arts section includes announcements of new or controversial funding programs by government, foundation, or corporate entities at the national, state, and local level. Clip and file this material for future reference, and add the names to your mailing list. If some of your family members subscribe to major newspapers, ask them to serve as an informal clipping service for you.

Annual reports from foundations and government bodies are usually free. They list the grants awarded in the previous year. Call or write to receive a copy. If a corporation has a separate foundation, it may also produce a separate annual report.

Use these materials to begin your own library. You will find that useful material accumulates quickly. Keep one bookshelf just for this type of information.

Libraries

The reference section of most libraries includes numerous directories of grant-making organizations. The majority contain tedious lists of addresses of foundations, corporations, and government agencies that provide funds for health care, social research, women's issues, and the arts, among other things. Few relate solely to the arts; fewer still have information relevant to artists. However, those in the following list will prove particularly useful in helping you develop a file on potential sources of funding and assistance. You will also find that you can refer to these directories when you need detailed information about a funding organization or agency that has been brought to your attention through other means. The following directories are commonly found in public and private libraries.

- *Cultural Directory II* (Coe et al., 1980)
- *Directory of Financial Aids for Minorities* (Schlachter, 1986–87)
- *Directory of Financial Aids to Women* (Schlachter, 1987–88)
- *Directory of Grants in the Humanities* (Oryx Press,1987)
- *Foundation Directory* (Foundation Center, 1987)
- *Foundation Grants to Individuals* (Foundation Center, 1986)
- *A Guide to Corporate Giving in the Arts-4* (ACA, 1987)
- *Guide to the National Endowment for the Arts* (NEA, annual)
- *National Directory of Corporate Charity* (Sternberg, 1984)
- *Taft Corporate Giving Directory* (The Taft Group, 1988)

Take the time to become familiar with each directory. Most have geographic and subject indexes that will guide your search. Copy into a notebook the names of organizations that could potentially provide assistance. Note the address, phone number, eligibility requirements, name of the directory, its reference number, and the

library. If you do this one time, your notes should provide enough information so that you will not have to return to the library frequently, and, if you do, you will know exactly which book and page to turn to. The book you will probably use most frequently is *Foundation Grants to Individuals* (Foundation Center, 1986). If you can afford to purchase a copy, it will be well worth it. (It is also a tax-deductible business expense.)

One of the greatest assets of a library is its staff. Good librarians can direct you immediately to the books most helpful for your purposes and recommend new or alternative sources of information. They may often be willing to purchase books or magazines that have been highly recommended to you but are too expensive for your own budget. Most librarians would be more than willing to purchase books mentioned throughout this book. And reference librarians will usually respond to requests for information by phone—saving you time and trouble.

Arts libraries at educational institutions and arts service organizations often have extensive reference collections for artists. The most comprehensive library of funding information and technical assistance is the regional network of Foundation Center Libraries. At least forty states have one or two such libraries. Call their toll-free number to locate the library closest to you.* Foundation Center Libraries can be daunting because the information they house is not limited to the arts and is primarily oriented toward organizations. But the information is kept up to date and is not limited to foundation support—despite their name. Find a knowledgeable staff person to assist you, and your time will be well spent.

If you live in or near New York City, you will find the library and staff at the Center for Arts Information especially helpful. (The offices and libraries of the American Council for the Arts and the Volunteer Lawyers for the Arts are adjacent.) Many state and local arts agencies also have extensive reference libraries. A recent publi-

*Telephone numbers of organizations cited in the text are found in Appendix B.

cation by the Center for Arts Information may also be useful, *Money for Artists* (Green, 1987). Another of their publications, *Visual Artists' Grants: A Report to the Field* (1988), is valuable as an initial reference for visual artists.

The Telephone and the Telephone Directory

An often overlooked and undervalued source of information is the telephone directory.

Many government agencies have tie-lines that enable them to phone long distance at relatively inexpensive rates, therefore, such calls are not costly for you. When asked, government personnel will usually call you back at their expense. The program assistants at the National Endowment for the Arts (NEA) and the National Endowment for the Humanities (NEH) can provide helpful information when it comes to technical assistance and advice on proposals. Even if you are not eligible for Endowment funds, it is worth a call to their staff to explore other options. Providing such information is part of their job, yet few artists take advantage of it. Call the main information number and ask to be connected to the program that best meets your needs or call that program directly. The *Guide to the National Endowment for the Arts* (NEA, annual) and the National Endowment for the Humanities's *Overview of Endowment Programs* (NEH, annual) contain in-house phone directories. (Both publications are free; the postage or telephone call to request them are tax deductible.)

Other organizations, especially corporations, have toll-free numbers. They are often given in newspaper or trade magazine advertisements. The operators who respond will be able to assist you or forward you to someone who can.

The *Yellow Pages* harbors a wealth of information. Have you ever checked the directory listings under Art, Music, Dance, and so on? These are the local organizations you should be familiar with. If you are not acquainted with programs and staff at your local or state arts

council, call the information number under the government listing in your phone book. If, for example, you are a graphic artist, are you familiar with the local businesses listed in the *Yellow Pages* under Graphic Designers? Have you ever thought to ask for a tour of a local printing firm? You will be surprised how receptive firms will be if you express genuine interest in their work, their research, and the activities of their employees. By taking the initiative to learn about resources in your own community, you will not only meet interesting, sympathetic people, but you will become acquainted with individuals at these local companies who can assist you with in-kind or cash support.

Making the telephone work for you is not always a simple task. Keep in mind the following. First, try to ensure that you are not interrupting the person you are calling and that it is a convenient time for him or her to speak with you. Introduce yourself by saying something like: "Hello, my name is Lionel Butterworth and I am a composer from Bremmentown. I am calling to ask for information and advice about some professional matters. Do you have a moment or two to speak with me or should I call back later?" Usually a courteous opening such as this will elicit a courteous and helpful response. Second, try to be sure that you are speaking to the appropriate person for the information you are seeking. If you call an organization where you have no personal contacts, describe to the secretary the general nature of your query and ask who you should speak with regarding this matter. Third, if you fail in your efforts to reach the appropriate person, do not give up. Call the secretary back and ask if there is someone else who may be able to help you. Persist but be courteous. Fourth, be brief.

Secretaries

A staff member of the Arts and Humanities Program of the Rockefeller Foundation once told me, "Never underestimate a secretary." It has been good advice. Secretaries will be one of your most reliable

and knowledgeable sources of information. They are the focal point of communications in any office, and their opinions are usually well respected.

When phoning a corporation, foundation, or arts agency, you will almost certainly find yourself speaking to a secretary. If you describe your project and your interests, that individual can direct you to the most appropriate person in the organization. If asked, most secretaries will indicate how you might best approach this person, when the best time to call might be, and what the current concerns of the organization are. If you are calling to request program guidelines, ask about upcoming deadlines and proper format; the secretary can indicate whether your project falls within the organization's funding criteria and what aspects of the project should be emphasized. Most secretaries working in arts related organizations are artists or are interested in the arts. If a secretary becomes interested in your work, you not only expand your audience by one, but you will find that your work is more readily brought to the attention of those who make funding decisions.

RESOURCE IDENTIFICATION: AN EXAMPLE

To gain a better understanding of potential funding sources for artists and the methods by which they might be identified, I decided to experiment with my own suggestions and report what happened.

During a recent trip to a large midwestern city, I spent a day "disguised" as a video artist. I began by scanning the telephone directory for the arts council offices of that state. Their address was within walking distance of my hotel, so I decided that my chances of getting lots of helpful information would be greater if I went to the office in person rather than phoning to schedule an appointment. Without any form of introduction, I walked into the arts council office and told the receptionist that I was interested in information about their programs for individual artists. Hardly letting me finish my sentence, she picked up the phone and arranged for me to see their Director

of Artists' Development. Within five minutes a young woman, Laura, introduced herself and ushered me into her office.

Laura described the arts council programs for which I, as a video artist, was eligible. I also asked about local foundations and corporations that funded artists; she was less familiar with this but did offer the names and phone numbers of people who could be more helpful. She was also aware of new and proposed programs at the NEA. When I questioned her about their criteria and deadlines, she placed a call to Washington, D.C., and we received an answer immediately. I also queried her about local service agencies and specific individuals at these agencies who could be helpful. This led me to organizations such as the local Artists Coalition. I remembered to ask if I could use her name when I called or wrote to these people and she willingly agreed. Within twenty minutes I had over a dozen references to key arts people in the local community.

As I left the arts council office, I asked the receptionist for directions to some of the organizations Laura had recommended. One arts service agency was located just around the corner, so I went there immediately. The fellow at the front desk asked if he could help. I said that I was searching for information on corporate support, both financial and in-kind, as a video artist. His answer was blunt, "There isn't any." I assumed this meant that *he* wasn't aware of any, so I probed further and asked if there wasn't someone in his office who would know the name of one or two corporate officials who were known to be genuinely interested in, and supportive of, video artists. Two other staff people overheard our conversation and began to question me more specifically. They, in turn, suggested that I speak with a woman, Lynn, across the hall who was more knowledgeable about corporate support. They introduced me to her. Lynn was wonderfully cooperative. She suggested specific people for me to phone or write and directed me to the programs within her organization that supported individual artists. She also gave me a recent publication that listed local corporations supporting art and artists, her phone number for future use, and a quick tour through their library of resource information for artists.

I said good-bye and thank you to Lynn in the library and took a seat next to other artists who had already discovered its extensive reference materials. Adjacent tables were equipped with phones available for free local calls. During the course of my productive afternoon there, I soon discovered that artists could also use the copier in moderation.

The willing and helpful advice of people like Laura and Lynn is not unusual, neither is the use of their organization's library, the phone, and the copier. But no one is going to offer their time and services unless first asked. The job of arts administrators is to assist artists and arts organizations, but you must first take the initiative to explain your needs and interests.

INFORMATION MANAGEMENT

A task that I believe is equally as important as identifying potential sources of support is organizing this information in a systematic and convenient fashion. You should not have to repeat the search process every time a new product or new idea develops. It is far less time consuming and more productive to collect information about potential sources of support on a regular basis—just as you gather ideas and material for new creative work.

The key to this cumulative process of resource identification is good management. The following three suggestions are simple, effective methods of organizing your information.

Keeping Files

Maintain accurate and detailed files of the people and organizations you encounter every day. If you don't have a file cabinet, use manila folders in a drawer or a box. Have a separate folder for every foundation, corporation, government agency, arts service organization, or individual donor that you discover. Arrange each in alphabetical order. As you collect annual reports, guidelines, news items, and clip-

pings from newspapers, add them to the appropriate folder. Make notes from phone conversations and file them. Do the same for resource material in libraries. This information will prove valuable later and will be easily accessible in your time-saving reference file.

Organizing a Mailing List

Keep an alphabetical index card file for use as a mailing list and as a quick reminder of all the people and organizations that have assisted you or may be of aid in the future. Each of your manila folders should be cross-referenced into your index file. Whenever you write, call, or visit someone with whom you want to maintain a working relationship, add an index card with the information shown in the following sample, and include any other comments you may care to make.

Arrange the cards in alphabetical order according to the individual's last name or the organization's name. Be sure to keep these cards current.

An index file can be easily used as a mailing list to announce a performance, an exhibition, or a new work. Add a card for commu-

Potter Palmer, Mrs. Berthe
Organizational Affiliation

Street Address
City, Zip Code
Telephone Number

Profession

How you met, when, who referred you

Potential or demonstrated interest in your work

Additional comments

nity arts leaders, museum staff, professional groups, government offi-
cials, mass media staff, and local hotels and merchants.

Your index file can also be used as a handy reference. Whenever
you begin a new project, flip through the cards for people or orga-
nizations that could be of assistance. You might also scan through
the files every six months to ensure that you have maintained contact
with each person or group. By doing this, they will remember you
and your work when you next come to them for assistance or direct
support. One accomplished painter I know mails a holiday greeting
card each year to every person in his index file. He maintains that
this goodwill is an investment in his future.

Using a Calendar as a Reminder

Whether you have a calendar on your kitchen wall or hanging above
your desk, use it to note upcoming deadlines. Mark not only the
deadline, but also put a reminder three or four weeks before so that
you can give some thought to the proposal or collect additional mate-
rial. Application deadlines for large funding agencies are often only
once a year, so you don't want to miss them.

Maintaining Your Portfolio

In the same manner that you have collected and organized informa-
tion on your individual and organizational contacts, you should main-
tain an active, attractive portfolio of visual and written information
about yourself and your work. Whether it is a notebook or a brief-
case, your portfolio should be relatively small and easily manageable.
It should include outstanding examples of your creative work or the
best representations that can be made of that work. Original work is
preferable but not always practical. If you are using slides or photo-
graphs, pay a little extra for the best materials or for a professional
photographer. And present the material in a clean, professional man-
ner. If you are a poet, have your work typed. If you are a composer,
be sure your tapes are clearly and neatly titled. You should not
expect others to respect or care for your work if you don't.

Your portfolio should also include a typed copy of your résumé, letters of recommendation, news clippings, and reviews about your work. (For a sample résumé and suggestions for effective résumés, see Appendix A.) If you have promotional material, such as posters, program notes, or exhibition invitations, include these, too. Have extra copies of each item in your portfolio to leave with buyers, dealers, investors, and potential supporters. Be certain that your name, address, and phone number are on each sheet.

Take your portfolio with you everywhere. When you have appointments with personnel at funding agencies, your portfolio will make introduction easier, and display your work. It also eases the problem of communicating your ideas —your art speaks for itself.

Visual artists seeking more detailed information about "Promoting Yourself and Your Art" and "Preparing Your Portfolio" will find the relevant chapters in *The Business of Art* (Caplin, 1982) useful. Media artists should refer to *The Independent Film and Videomaker's Guide* (Wiese, 1984).

Promoting your work goes hand-in-hand with seeking support. Most decisions about grant proposals are made by peer review, therefore, it is helpful if the reviewers are already familiar with your work before the review session. Anything that will increase your credibility or visibility will also increase your opportunity for getting a grant. It is important to maintain contact, either in person or through the mail, with each individual in your index file.

CREATIVE COMMUNICATIONS: AN EXAMPLE

Professional fund-raisers commonly use the farming metaphor of cultivation to describe the process of resource development. This rural metaphor is apt because it emphasizes the importance that artists should attach to preparing and sustaining all the factors on which their support depends. Once you have made the acquaintance of someone at a funding organization who is interested in your work, keep that person informed, ask for advice when appropriate, and, by all means, remember to invite her or him to hear your new compo-

sition or see your new film. These are the minimum requirements for cultivating *and* sustaining your potential sources of support.

A frequent complaint I hear from personnel at funding organizations is that: (1) they are rarely invited to see an artists' work, performance, or exhibition, yet they are inevitably asked to fund it; and (2) if the project is funded, they rarely receive any information about it and are seldom notified of the final presentation. Communicating with potential, current, or past donors is crucial as well as courteous.

One of the best illustrations I know of creative cultivation and communication is a local artist who works in experimental video and graphics. Ted has chosen to support his work by finding odd jobs related to his skill in mechanical engineering. He does this for six months and then works full-time on his photography for the remainder of each year.

Because Ted experiments with color, shape, and form by manipulating the electronics or hardware of cameras and copy machines, he is constantly searching for detailed technical information about new equipment that he cannot afford to purchase but can assemble himself. No sooner had Ted discovered the Polaroid toll-free hot line than he was on it, requesting information about a new color processing technique. The person who answered the phone became interested in his work, so Ted carried his portfolio over to Polaroid. This led to a mutual friendship with a key member of the Advertising and Design Department. Since that time, Mr. W has called Ted occasionally to offer him cartons full of slightly irregular film, material he knows is valuable for Ted's work. Whenever Ted needs material or equipment that Polaroid produces, he calls Mr. W. But Ted was quick to assure me that the relationship does not end here. "I've made a point of regularly showing Mr. W my new work and discussing my ideas with him. I'll be inviting him to my first one-man show." That's creative cultivation.

This unexpected relationship is the key to many others. Ted has now discovered that Polaroid has a gallery program that exhibits and purchases the work of local artists. He also knows that they have a corporate foundation. Without taking advantage of their friendship,

Ted can ask Mr. W about these two areas of the corporation. He can find out who directs the programs and how best to approach them. Chances are that Mr. W will pick up the phone himself and arrange an appointment.

Ted has also become familiar with Mr. W's professional network of corporate, foundation, and university officials who share his interest in experimental graphics. Although Ted was at first hesitant to ask Mr. W for further assistance, he decided to do so. He described his reasoning as follows: (1) The odds were high that the professional acquaintances of Mr. W shared his interests. (Ted discovered that all the people to whom Mr. W referred him—including Polaroid colleagues and personal acquaintances—were deeply interested in photography as an art form; many were collectors.) (2) One of the easiest ways to let someone know you need support, without asking directly, is to ask if they know of other people or organizations that can provide support. Ted discovered that he could give Mr. W a proposal and budget as a reminder to contact someone else rather than directly ask him for support. If Mr. W showed interest in the project, he had the information and budget at his fingertips, yet there was no pressure for him to provide support. (3) Few people will turn down the opportunity to give advice and opinions when courteously asked.

As we reviewed his experience, Ted and I agreed that there were three important elements in his relationship with Mr. W: (1) Ted's genuine interest in the technical developments at Polaroid, (2) Mr. W's interest in art and his respect for Ted as an artist, and (3) Ted's willingness to share his work and time. Furthermore, Ted never expected anything; he always offered to purchase materials but hoped that they would be given to him free or at cost. He admits that in at least one instance, he was broke and took a calculated risk, knowing that he might have had to borrow money if asked to pay.

Although it may be easy to discuss Ted's case as being exceptional—every photographer or graphic artist cannot live in the same town where Polaroid has its headquarters—I suspect that Ted is no different from most artists. He has lived in the same area as Polaroid and has been a serious artist for fifteen years, but his first major con-

tact with the company was only four years ago. Moreover, his story is a wonderful illustration of the principle of how artists should be creative in the way they cultivate support.

The process of identifying potential sources of support creates a flow of information to the artist. To promote your work and increase the chances of receiving support, you should regularly keep potential funding sources informed of your work. This two-way flow of information maximizes results for the artist.

2

Types
of Support
for Artists

Every artist has certain basic requirements: time, income, living and working space, material, and equipment. You must also be able to manage these resources effectively. Perhaps the most obvious and immediately useful resources for you are direct financial and material support. This comes in many forms: fellowships; project completion support; loans and emergency funds; festivals, prizes, and competitions; international travel and study; opportunities for art in public places; residencies; and in-kind contributions of equipment or material. You will also need nonfinancial resources. They include such things as technical assistance and information about legal contracts and agreements; artists' rights regarding living and working spaces; copyright privileges; estate planning; starting a business; insurance; record keeping; and income tax preparation. These resources are valuable. They help you save time; they create additional sources of income; and they lower your costs.

I have attempted to be comprehensive and therefore some of the material presented here, such as the description of fellowships and project completion support, may already be familiar. Other material, such as the description of art in public places, may not be relevant

to your particular art form or at this stage in your career. If this is the case, I encourage you to skim through it or move ahead to the next chapter. I have included information about the full range of support for two reasons: (1) my experience has shown that many artists are not familiar with this information; and (2) though not relevant to you now, it may be useful at a later stage of your career as your priorities change.

FINANCIAL AND MATERIAL RESOURCES

All the types of support described in this section are commonly referred to as project support by many funding agencies because the applicant is generally required to describe a specific project for which the funds will be used.

Fellowships

A fellowship is an artist's favorite type of support because it buys time. Funds from a fellowship cover both living and working expenses for a fixed period of time. Some programs award funds based on your proposed project or activity for the fellowship period. Other programs are interested primarily in the potential of your artistic work; a recipient may use the funds at his or her discretion— to explore new directions, to complete work in progress, or to advance professional training. Most fellowships for artists are for full-time creative work; consequently, full-time students pursuing undergraduate or graduate degrees are usually not eligible. Other fellowships are specifically for graduate study and will cover all or part of tuition, room, and board.

The most common fellowships to artists are available from state arts councils, the NEA, and from private foundations. Conditions of a fellowship vary, but most will support you for a period of six to eighteen months. Fellowship awards generally range between $5,000 and $25,000, and they can be used to cover anything from laundry to artists' supplies and equipment. In some instances, a basic stipend

may include your room and board and a separate allowance will provide for equipment, material, and travel.

Fellowship applications are usually simple; they consist primarily of the art work itself and a short application form.

Criteria for choosing fellowship recipients vary according to program objectives, but most are based on the quality of the artists' work, as evident through slides, films, tapes, photos, or manuscripts. The work is assessed either by a peer review panel or a board of trustees. If the organization awards fellowships for specific activities, the review process involves both your work and your written description of the proposed project.

Project Completion

A typical project completion grant provides funds for completion or production of a specific project or for a work-in-progress. The project may be, for example, a film, a dance, a composition, a series of poems, or a sculpture for a public plaza. The amount of funds allocated depends on the project budget, as presented by the artist, and on the funds available. These grants may or may not cover an artist's own time in addition to the material costs of the project. Applications require a description of the project and a detailed budget. Decisions are based on the merit of the project, and the quality of the artist's past work.

Funds for project completion support are among the most common types of grants awarded by funding agencies, especially public art agencies and foundations.

Loans and Emergency Funds

Several organizations make grants, loans, or interest-free loans to artists who encounter emergency situations or financial crises. In some instances, advance loan funds are available for artists who are anticipating the receipt of funds—a royalty check, a project advance, or a grant award—but who are in need of cash until the check arrives.

Organizations providing these funds are primarily service organi-

zations, such as the Authors League Fund and the PEN American Center. For a comprehensive list of organizations offering loans and emergency funds, refer to A *Quick Guide to Loans and Emergency Funds*, a publication available at modest cost from the Center for Arts Information in New York City.

The Artists' Community Federal Credit Union makes personal loans to members of thirty-day standing. Membership is open to artists nationwide. Its other services include interest-bearing savings and a financial referral network.

Festivals, Prizes, and Competitions

Three types of support that tend to involve small sums of money but often significant recognition for the artist are festivals, prizes, and competitions. Art fairs and festivals provide substantial opportunity for the support and development of new artistic talent. There are now more than one thousand arts festivals held annually, ranging from First Night (Boston), a community-wide celebration of New Year's Eve through the arts, to the Spoleto Festival (Charleston, South Carolina), a two-week festival of the arts. The majority of these festivals encourage the participation of local artists. Jon Kimball, Director of the Prescott Park Festival in Portsmouth, New Hampshire, notes: "As a result of the Prescott Park Festival, there are now eleven arts groups in this little town of 25,000. There are three dance companies, a chamber music group, a mime troupe, a visual artists consortium, and others" (Briskin, 1981, p.90). Festivals tend to be an excellent way to make the arts accessible to a great number of people, and to develop new audiences and future arts patrons. They are also effective in gaining exposure for artists.

Many organizations, both national and international, sponsor art competitions and exhibitions, with prizes or awards for the best work. Some awards are prestigious; others are not worth the effort involved. You should take time to learn as much as possible about specific competitions and exhibitions before participating in them. An important question to ask is whether there are art professionals

serving as judges, and, if so, who they are. Also, find out how much the prize is; reconsider entering the competition if it isn't compara- ble to the value of the work you plan to submit. Other issues to con- sider are: Is there an entry fee? Is there a prospectus outlining the details of the competition? Will the sponsor charge a commission? The best way to research a festival, award, or competition is to talk to an artist who has participated in it.

National Artists Equity Association (Washington, D.C.) has pre- pared national policy guidelines for juried exhibitions. The Associa- tion states its opposition to the use of entry fees since the cost of the exhibition is thereby subsidized by participating artists, often with- out insurance or security provisions for juried work when it is in the sponsors' possession. Artists are encouraged not to participate in competitions when an entry fee is charged.

For listings of festivals, prizes, and competitions, consult the news- letters of professional art associations in your discipline. Your arts council may also refer you to regional listings of art festivals, such as *Fairs and Festivals in the Northeast* (Arts Extension Service, 1984). *How to Enter and Win Contests* (Gadney, 1984) may also be help- ful—each guide in the Gadney series lists almost two hundred cash prizes, awards, festivals, exhibit opportunities, and contests for artists of every discipline.

International Opportunities

A number of opportunities for artists exist to travel, perform, and study abroad with the assistance of a fellowship, contract, or schol- arship to pay for full or partial expenses. A young black dancer and choreographer, for example, received a Fulbright scholarship to research and study tribal and contemporary dance techniques in The Gambia, West Africa. Fulbright grants for creative and performing artists provide funding for a year of study and training overseas. Another opportunity, Partners of the Americas, arranges residencies of one month or more to exchange artists among the United States, Latin America, and the Caribbean. The NEA also offers fellowship

opportunities for creative and performing artists in Japan and France.

Touring opportunities for individual artists or groups of artists tend to be difficult to secure. Artistic merit is one consideration among many others, including currency exchange, political climate, and the level of risk or inconvenience artists can tolerate. Foreign sponsors will rarely engage an artist without having seen their work first-hand, or heard about it from a reliable source. Short of going to Europe and seeking one-to-one visits with potential sponsors, artists must rely on their visibility in the United States. Another opportunity, the Artistic Ambassador Program of the United States Information Agency (U.S.I.A.), sends gifted American musicians who are neither currently under management nor have had a major debut, on solo tours overseas. The U.S.I.A., in collaboration with the Rockefeller Foundation and the National Endowment for the Arts, has formed a new group called the Fund for U.S. Artists at International Festivals and Exhibitions. This is a joint effort to get more international exposure for American artists in the visual and performing arts. For more information, visual artists should contact the U.S.I.A; performing artists should contact the International Office of the NEA.

Two comprehensive sources provide information about international opportunities. The first is a publication entitled *International Cultural Exchange*. It lists eighty-five organizations that facilitate or fund international cultural exchange programs and is available at a modest cost from the Center for Arts Information in New York. The other source is the Arts International Program at the Institute of International Education in New York City, which operates a computer data base listing international fellowships and arts exchange programs worldwide. For the cost of membership, Arts International will provide artists with a newsletter subscription, one hour of consulting at no charge, and additional hours at member rates. Consulting includes a computer search of those organizations that offer opportunities suited to your needs. Nonmembers have access to consulting services at a higher fee.

Art in Public Places

The goals of an art in public places program are to enhance the public environment through works of art and to create a working relationship between the artist and the community. The program also recognizes that artists should be regular contributors to city planning and the establishment of aesthetic guidelines for public spaces. Commissioning art works for public spaces is not new; what is new is the focus on collaboration between the artist and the architect or planner to create site-related art.

Art in public places programs are frequently referred to as percent-for-art programs, so named because of their funding source. Many cities, states, and universities as well as the federal government have legislation or a policy that allocates a percentage (usually ½ to 1 percent) of total construction or renovation costs of public or university buildings for works of art. Some examples of public art projects include Alexis Smith's *The Grand* in Grand Rapids, Michigan; Luther Utterback's *Five Stones and a Tree* in Des Moines, Iowa; David von Schlegell's *El Nuevo Mundo* in Miami, Florida; Red Grooms' *Way Down East* at Northern Kentucky University in Highland Heights; and Nancy Holt's *Rock Rings* at Western Washington University in Bellingham, and *Dark Star Park* in Arlington County, Virginia.

Not all public art is visual art or permanent. Temporary public art is the primary focus of the Alternative Spaces Residency Program sponsored by the City Beautiful Council of Dayton, Ohio, and the Wright State University Department of Art and Art History. Approximately five artists each year are invited to create art in public locations of their choice throughout the city. Some works are performance pieces that last only a few hours, others remain in location for up to six years. Another example, Creative Time, Inc., of New York City, specializes in nontraditional public art that takes place in both indoor and outdoor spaces that have been vacated or abandoned. *Art on the Beach* is one such example, a presentation of numerous works of visual and performance art over the course of six

summers at a two acre landfill in Battery Park City in lower Manhattan. There has also been a growing interest at the NEA in temporary and multidisciplinary works of public art.

Most public art projects are administered by public agencies responsible for the government buildings, parks, plazas, schools, airports, recreation facilities, community centers, police stations, power plants, libraries, and public transportation facilities where the art is located. The selection procedures vary. They include: (1) direct purchase by the panel or jury; (2) invitation—by using a slide registry, a panel selects one artist to prepare a proposal, and if the proposal is accepted, the artist receives the commission; (3) limited competition—same as above except that more than one artist is invited to submit a proposal; (4) open competition—artists are invited to submit site-specific proposals based on published information describing the site. The panel chooses one or more entrants to further develop their proposals. Usually, artists invited to make a proposal are compensated.

You may obtain information about potential commissions for city, county, and state building projects from your local or state arts council. National Artists Equity maintains a listing of over eighty public art programs nationwide, available at minimal cost. It includes the agency name and address, the program type, a prospectus, eligibility requirements, and whether or not the agency maintains a slide registry. For limited competitions or invitational projects, you will want to submit slides of your recent work to selected slide registries. Your state arts council staff will be able to recommend the most actively used slide registries in your state and region. A small brochure entitled Percent for Art Programs, prepared by the Center for Arts Information, lists local arts councils and agencies nationwide that monitor percent-for-art programs. The General Services Administration and the Veterans Administration, both federal agencies, have art-in-architecture programs for their buildings nationwide and maintain their own slide registries. Keep a list of the registries where your slides are located, and try to keep your entries representative of your

current work. Also maintain a list of the slides sent to each registry and submit new ones periodically.

True collaboration in public art occurs when the artist is considered as one who shapes space and environments rather than as an interior or exterior designer. The artist is asked to address architectural and planning specifications, building codes, zoning ordinances, safety regulations, maintenance recommendations, and community needs. The task is not simply to create a sculptural appendage or a decorative embellishment. To integrate the art work more fully into the architectural and planning process, the artist should be engaged in a joint search with the architects and planners for solutions to aesthetic and functional problems. The artist participates in both the process and the product.

Recent experiments have emphasized greater involvement of the artist with the architect, landscape architect, and/or urban planner. One example is the Jerome B. Wiesner Building for Arts and Media Technology at MIT, completed in 1985. When the blueprints were drawn in 1980, three artist consultants began working with the architects, I.M. Pei & Partners, on design aspects of the building. Kenneth Noland, well known for his color-field abstract paintings, has added subtle coloring to the interstices of the aluminum panels of the building's four-story atrium wall and parts of the exterior skin of the building. Scott Burton, who works with furniture-as-sculpture, has designed public seating and railings for the main lobby—benches that emerge from and echo the building's atrium staircase. Landscape design, including ground covering, lighting, seating, and pathways, has been the responsibility of Richard Fleischner. The final achievement has received wide critical acclaim.

An architect and artist collaboration, such as that at MIT, is not without its problems. It is much more complicated than commissioning a work for a specific site and considerably more time consuming and expensive. Its success depends on mutual respect, trust, and open criticism between architects and artists, and among the artists themselves. Richard Fleischner, who has worked on numerous public arts

projects, insists that the key to most public art is the incredible commitment of all parties involved. There is much frustration involved in public art but there is also much stimulation and challenge.

For more information about public art projects and the process of public sponsorship, you can refer to *Art in Public Places* (Beardsley, 1981) and its sequel, *Insights/On Site* (Paleologos-Harris, 1984). Both are available from the Publishing Center for Cultural Resources in New York City. *Going Public: A Field Guide to Developments in Arts in Public Places* (Arts Extension Service, 1988) provides artists with insight into the process of public art, explains artists' rights, and serves as a source book of case studies and observations. For an excellent discussion about artist and architect collaboration and the contrast between the "traditionally private and intuitive" approach of the artist versus the "public and practical" approach of the architect, refer to "Perception at All Levels" (Tomkins, 1984, pp. 176–81).

Residencies

Two major types of residency programs exist; both are described in this section. The first, artist-in-residence programs, is an opportunity for an artist to reside in a given community as an artist/educator. The second, artist colonies, offers an artist the opportunity to create in an environment with no demands and no obligations on her or his time.

Artist-in-residence programs place a practicing artist in an educational, cultural, or community setting. They are designed so practicing artists can explore and explain the creative process as they share their artistic work with others. For example, a video artist, Wendelin, commuted daily during a three-month period to work with twenty teenagers in a mental health center. By the end of the residency, the young people were skilled in video technique and fascinated by their ability to express themselves in this medium. Wendelin's documentary videotape of his experiences was screened at a gala premiere at the local museum, and aired on cable television. Reflecting back on his residency, Wendelin noted, "The situation called for a lot of improvisation and spontaneity. My work benefited

from that. I learned to work in a different way; my approach became looser, less rigid, and I think more lively. I would do it again anytime."

Residencies generally include performances or exhibits, workshops, lectures, and demonstrations. As with public art projects, the goal is to integrate the artist more fully into the community and meet the community's specific educational needs by drawing on the artist's skills and experience.

Eligibility requirements vary. Some state agencies that administer residency programs require that the artist is a previous recipient of a state award. Other programs are more concerned about the artist's interests and teaching ability as evident in questionnaires, recommendations, and samples of work. Artists are selected by host organizations, often through interviews with its representatives. The range of residency programs is diverse: architects, musicians, filmmakers, poets, writers, dancers, craftspeople, folk artists, painters, photographers, and theatre artists.

The location of an artist's residency could be an elementary or secondary school, a community organization, a college or university, a cultural or social institution, or a corporation. The duration of residencies range from one day to one year. Funding levels and procedures differ widely, but you are usually given a per-diem fee plus reimbursement for travel expenses. Funds may or may not include materials and supplies. Residencies are usually administered by a site coordinator who helps with orientation and scheduling activities. If necessary, the site coordinator will also help locate studio space for the artist, usually at the host organization or in the nearby vicinity. For more detailed information about the mechanics of a residency, and examples, refer to *Artists-in-Residence* (Artists Foundation, 1983).

Every state and territory in the United States operates an artist-in-residence program. Contact your state arts council to learn about its system for referral, evaluation, and recommendation as well as the types of residency programs available. Although some programs are open to out-of-state artists, the majority give preference to artists

who reside in that state. Other residency programs may be administered by local arts agencies, private arts organizations, nonprofit cultural organizations, and colleges and universities. Some universities have residency programs in which an invited artist, such as a writer, comes for a day, a week, or a term to participate in seminars and classes and give readings of her or his work. Although these institutions often contact the artist of their choice, it is not unusual for an artist to initiate discussions with key people at a university or other organization that offers artist residencies.

Some independent artists are eligible to apply for residencies through Affiliate Artists, Inc., a national organization that provides residency opportunities in communities across the country for talented performers. Artists reside in a community for one to six weeks and give informal presentations that combine performance with conversation. The application procedure involves an audition. In San Francisco, the Exploratorium operates a more unusual paid residency program for artists whose work relates to science and technology.

"Research" residencies are offered by a growing number of organizations. These programs encourage artists, architects, and humanists to work together. The emphasis is on process rather than the creation of a product. Creative Time, Inc. and Los Angeles Contemporary Exhibitions (LACE) both have variations of research residencies.

Another type of long-term residency is available through artist colonies. Colonies offer artists—mostly composers, writers, and visual artists—a quiet, distraction-free working environment away from home. You are provided with a studio or workspace, sleeping quarters, meals, and protected privacy. In most cases, a daily or monthly fee is charged for the use of facilities. For directories and a more detailed description of artists' colonies, refer to "Service Organizations for Artists" in Chapter 3.

An interesting combination of residency, colony, and art in public places is found at Artpark, a state park in Lewiston, New York. Their

artist-in-residence program brings approximately forty artists each summer to studios in the park for three-week periods. Other artists, called Project Artists, are invited for three- to six-week periods to create large-scale works on outdoor sites. In both instances, the artists are paid a weekly salary, travel allowance, and living expenses—artists-in-residence receive a flat fee for material; project artists are financed according to the budgets they submit.

Internships

Young artists may find that internship opportunities help give direction to their careers. They also serve as an introduction to the routine of a professional artist, and supplement the arts education of the classroom. More mature artists often find that student interns provide valuable assistance to their work.

Internship opportunities vary widely. Some may last for a few weeks; others for a few months or a year. Some are salaried; some are nonsalaried. Most require a formal application and, when possible, an interview.

If you are interested in having one or more student interns work with you, try calling your local or state arts council or a local arts institution. They may already operate an internship program through which you can participate. If you live in New York City, contact the Arts Apprenticeship Program of the Department of Cultural Affairs. This program places approximately 400 students with professional artists and arts service organizations annually.

An excellent reference book, *1987 Internships* (Jobst, 1986), is available in many libraries. It lists training opportunities in the Arts and Communications, among other areas, with detailed descriptive information about each. Examples include the salaried positions for young opera singers at the Central City Opera House Association, Denver, and the Lyric Opera Center for American Artists, Chicago. Another example is the nonsalaried apprenticeship for craftspeople at the Great Barrington Pottery in Housatonic, Massachusetts.

In-kind Contributions of Equipment and Supplies

For the typical artist, equipment and supplies necessary for creative work are expensive. If you work with video, lasers, computers, and other electronic equipment, costs are usually prohibitive. One way to avoid or reduce this expense is to solicit in-kind gifts of equipment and material from the corporations that manufacture them.

An artist from the Midwest who frequently worked with public art projects told me that she had been able to secure most of her material and equipment through corporate donations. When I asked about her key to success, she replied, "The *Yellow Pages*." Whenever Gwen needed paint, brushes, spray guns, or other material, she would thumb through the *Yellow Pages* and phone or visit local suppliers until she had what she needed. Although it was time consuming at first, she claimed that the benefits and contacts were well worth her effort.

Most of us find it unnerving to pick up the phone, call someone we don't know, and ask for something they have and we need. But Gwen assured me that it wasn't all that bad. She actually enjoys it now because she has met so many interesting people through the process. In her view, it is vital "to get people excited about what you do." She added, "You've got to have perseverance and be willing to be rejected."

Corporations are more likely to contribute equipment to you if it will be used for a specific project rather than for everyday use. Moreover, if the equipment is an essential component of the project and its use will gain publicity for the corporation, your request will be even more appealing. For example, John David Mooney, an environmental artist from Chicago, completed a 30–foot long aluminum and crystal sculpture for the atrium of the University of Chicago's Crerar Library. He was able to interest the Waterford Glass Company in Ireland in his project. The company developed a new type of crystal to serve Mooney's purposes, and it flew the finished material to his studio—both at no cost to the artist.

The best route for soliciting in-kind contributions is to call the

manufacturer of the equipment. Some corporations have a formal program of in-kind contributions through their corporate contributions office, but most handle requests less formally. Try calling the Director of Community Relations, the Director of Public Relations, or the Director of Marketing. If the company is small, ask to speak directly to the President. If your initial request is received positively or with some interest, follow through with a letter reiterating your interest and needs; better yet, visit the company.

Names of manufacturers can be identified through the *Yellow Pages* or through *Standard and Poor's Register of Corporations, Directors and Executives, United States and Canada.* Be sure you know the exact name or reference number for the equipment you are requesting. This can easily be located in a catalog, at a store, or on the equipment itself.

Many artists ask whether they should openly discuss or remind corporate executives that their contribution may be tax deductible. My advice is to leave that business to them. They are well aware of their options and how it will affect the corporation financially. In most cases, when a corporation, organization, or individual contributes in-kind services, the primary reason is the project itself—not the tax write-off. Whatever the benefit may be to the donor organization, your responsibility is to give them ample acknowledgment in whatever way possible.

LEGAL INFORMATION AND ASSISTANCE

As an artist you need money, time, space, and materials, but you also need to protect and secure these resources once you get them. To do so, you need information and assistance about legal and financial matters, such as zoning regulations, copyright, insurance, contracts, starting a business, tax deductions, and record keeping. For an artist starting a career, these topics may have a low priority. But part of your success as an artist will depend not only on the support you

obtain, but also on how effectively you use the support you actually get.

Most of you, at some time during your career, will search for an appropriate studio or workspace, explore the advantages of copyright protection, seek insurance coverage, enter into contractual agreements, plan your estate, consider starting a business, file tax returns, and learn how to keep accurate financial records. Although these nonfinancial resources may seem less important to you than other resources I have discussed, they are, in fact, equivalent to financial resources because they can augment your income or reduce your expenses. Learning how to effectively use these resources early in your artistic career is essential for avoiding unnecessary and unforeseen costs and for providing a future source of income.

This section does not contain legal advice. It is intended to help you recognize a legal problem and suggest how to seek appropriate advice. It also identifies some aspects of the business of art about which lawyers and accountants may be particularly knowledgeable, and it will refer you to places where you can get legal counsel and accounting advice. There are people and organizations that can assist you with information and free services.

In my experience, many artists maintain a policy of avoidance toward the legal profession. They make the assumption that you can deter legal problems by being ignorant of the potential legal issues concerning your career. A mid-career media artist, Bruce, worked with a lawyer to establish his own film production company and discovered that this attitude was unsound: "All my life I thought that lawyers were hindrances, but, in fact, I've learned that they allow for greater flexibility in the law." As he found, it is wise for you as an artist to become familiar with the legal implications of the profession so you can protect your work and better manage your career.

An artist in need of free or below cost legal advice and representation has two options.

1. Informal referral, either from a local artists' group or arts council or from friends and fellow artists who have had similar problems.

If a lawyer is recommended to you by these methods, discuss fees and ask if you will have to pay for the first conference.

2. Legal counsel and information from the Volunteer Lawyers for the Arts (VLA) in New York City or one of their many affiliate organizations throughout the United States. More information about the VLA is given in Chapter 3.

In addition to the legal matters discussed in this chapter, attorneys can also assist you in connection with litigation, landlord/tenant relations, small claims court procedures, immigration, registration and protection of trademarks and patents, and labor relations.

Artists' Living and Working Space

Anyone can have a problem locating adequate and affordable housing, but it is especially acute for artists. Most artists cannot afford to pay rent for two places—one to live in and one to work in. One of the most trying problems is finding safe, legal, and affordable live-in studio space, and ensuring the long-term security of that space.

Artists generally have special requirements for their workspaces, such as sufficient lighting, freight elevators, high ceilings, and large open spaces. Artists also need access to performance and exhibition spaces, materials, and proximity to other artists. These requirements usually lead artists to industrial and commercial downtown areas, which tend to have lower rentals, but they also have ordinances that restrict their use to commercial rather than residential use. Artists who live in these areas often do so illegally because of zoning ordinances and building codes. The lack of adequate plumbing and wiring often makes such spaces uncomfortable and dangerous. The uncertainty of these arrangements is compounded because artists, by having such "illegal" addresses, forfeit many civil rights (voting privileges), social services (trash collection), and any hope of long-term security.

In this respect, Fred's situation is relatively common. Fred, a recognized Boston painter, lived and worked in a run-down building in

Boston, as did a number of other artists. As he said, "It wasn't really legal to do it but nobody seemed to care." A fire destroyed the building and Fred lost everything. He didn't have insurance on his work or his possessions, and it is doubtful whether any insurance company would have offered him protection because he had no legal status as a resident. With the assistance of a local museum director, the artists in the building were able to locate a lawyer familiar with arts law. Taking their case on a contingency basis, Fred brought a suit against the landlord. It took five years to go to trial and in the meantime the artists were left with nothing. Although the artists won the suit, they suffered substantial material and financial losses.

The three most common solutions to the problem of security and protection of an artist's living and working space are: (1) changes in the zoning laws or variances to permit legal access to appropriate spaces, (2) revisions in building code standards, and (3) property ownership. Unfortunately, the first two may only be short-term solutions unless coupled with the third.

Many cities, including Seattle, St. Louis, New York, Boston, San Francisco, Los Angeles, and Minneapolis, have already changed zoning laws and relaxed building codes to allow artists to reside legally in inexpensive industrial loft and commercial warehouse spaces. In some cases, only the zoning laws are changed, and the building codes remain so demanding that artists cannot afford to comply with them. In each case, artists have found that after three or four years of relaxed zoning laws, their efforts are self-defeating unless they are able to demand long-term leases. In one instance after another, the artist community has enlivened downtown areas. Once the artists move in, the neighborhood begins to attract wealthier individuals, and formerly "undesirable" property begins to sell at high prices. The artists are then forced to leave. This process of gentrification began with the transformation of SoHo, Manhattan, and has been repeated in many large cities throughout the United States. Some cities have tried to restrict professionals other than artists from moving into these newly zoned areas, but such legislation has, to date, been difficult to enforce.

Until artists can be better protected from displacement, the only certain security over a space comes with ownership—an option requiring some financial security. One of the least financially demanding means to secure ownership of a property is through homesteading, or sweat equity, that is, when repossessed property is sold (or leased) for nominal amounts to a group of individuals who will rehabilitate it—in an artist's case, for use as living and working space. Try going to the director of a local Savings and Loan Association to learn about housing facilities available in the community and the possibility of securing financing for a cooperative living and work arrangement.

Although individual ownership may be beyond your current means, you may find a solution by joining other artists in a collective, a cooperative, or a nonprofit corporation and, thus, secure outside financing. With these arrangements, artists' groups are eligible for private or government funding from individuals, developers, private foundations, corporations, and municipal governments that recognize the professional and special needs and contributions of artists within the community. Your local or state arts council, or the Design Arts Program of the NEA will be able to suggest organizations to which you can go for funding. They can also inform you of recent legislative developments concerning less financially demanding alternatives to ownership, such as subsidized housing.

Artists have a lot to offer that a real estate developer or a city government wants and needs. As more artists, artists' unions, and artist service organizations take an active stand within their communities by promoting artists as purveyors of cultural amenities and important partners in the revitalization of neighborhoods, more means seem to be emerging to make artist ownership possible. Instead of being taken advantage of, artists, as small business entrepreneurs, can advocate and lobby for their cause.

A number of nonprofit arts service organizations and artists' organizations are now working with artists to assist in the location, development, and management of artists' living and working spaces as well as exhibition, performance, and support spaces. Call your local

or state arts council to identify local organizations that offer these services.

Artspace Projects, Inc., in Minneapolis, and the Fort Point Arts Community, Inc., of South Boston, are organized exclusively to assist artists secure needed space. Although they work primarily with artists in Minnesota and Massachusetts, respectively, they also assist a growing number of out-of-state artists and groups of artists by phone, mail, and through independent consulting. Artspace Projects has about fifty inexpensive and informative handouts designed to help artists search for space, comply with building codes, and make decisions about insurance. Others address health and safety standards, insurance, related housing issues, and the process, problems, and strategies for developing cooperative arrangements for arts tenants. The Fort Point Arts Community and Jero Nesson, director, have published an excellent handbook entitled *Artists in Space*, designed to assist groups of artists who are interested in developing affordable studio space on a rental or ownership basis.

For comprehensive information about artists' living and working space, refer to one of the following books: *Artists' Housing: Creating Live/Work Space that Lasts* (Lipske, 1988), *Artists' Live/Work Spaces* (Artists Equity Association, 1981), or *Artists' Spaces* (Landsmark, 1981). The *Legal Guide for Emerging Artists* (Philadelphia Volunteer Lawyers for the Arts, 1981) includes an excellent section on leases. The *Legal Guide for the Visual Artist* (Crawford, 1987) also includes a section on lofts and leases.

The Center for Arts Information publishes *SPACES*, a monthly newsletter featuring listings of artists' and performers' workspaces for rent, sale, or swap in the United States and Europe. For artists seeking spaces in New York City, it would be wise to refer to the *Artists' Housing Manual* (Volunteer Lawyers for the Arts, 1987).

Copyright

Knowledge and information about copyright law are important because they give you the right to stop others from copying and receiving payment for your work without your approval. Once your

work is copyrighted, a potential user is legally obliged to seek your permission to duplicate, copy, perform, or recreate it. You then have the option to sell them the rights. Therefore, it is especially important to maintain a personal register of your copyrights.

Almost any kind of artistic or literary work or any work that conveys information or ideas in any tangible medium can be copyrighted. Tangibility implies that the work can be touched. That is, a performance cannot be protected by copyright, but a film, tape, or score of a performance can be protected. Furthermore, the work must be original, and it must be "expressed" in some manner. An idea cannot be copyrighted, but the expression of an idea can.

Many artists confuse the registration process with the placement of copyright notice. They are two different items. Formal registration of copyright at the U. S. Copyright Office involves a small fee ($10), completion of a standard form, and generally submission of two copies of the work. For certain art works, identifying material can be submitted instead of copies; in some cases, the deposit copy can be returned to the artist. Because the cost of copyright may be prohibitive for many artists, it is important to recognize that registration is not necessary to validate a copyright. Registration of a copyright is not required if the work has not been "published" (sold, rented, leased, lent, or publicly distributed); in such cases, the creator has a good course of action against any unauthorized user of copyrighted but unregistered works. Only if a work has been "published" is registration a prerequisite for enforcement of the creator's rights.

Under the new copyright law of 1976, any work created on or after January 1, 1978, is protected by common law copyright as soon as it is completed in some tangible form. This protection lasts until fifty years after the author's death. If the work is "published," the common law copyright disappears. Once a work falls into the public domain, a copyright notice must be placed on it to maintain the copyright protection. Without this, someone else could reproduce your work, sign it, and sell it. The most widely acceptable notice of copyright is

© Copyright 1989, Heather A. McPherson

The symbol ©, the word Copyright, the year of first publication, and your name, complies with requirements of all countries that have signed the Universal Copyright Convention.

At the time of the second edition of this book, Senator Edward Kennedy has reintroduced the Visual Artists Rights Act of 1987 in Congress. This Act would, among other things, eliminate the requirement that a copyright notice appear on all works of fine art for which copyright is claimed. Unless you are able to confirm that this Act has been passed, you should continue to place a copyright notice on all of your work.

If the aesthetic value of your art work would be impaired by a copyright notice (for example, on the front of a canvas), the notice can be affixed or permanently secured to a less conspicuous part of the work, such as the back of a canvas. For details about the position of the copyright notice, ask a lawyer or refer to *Law and the Arts* (Horwitz, 1979, p. 95).

"Works for hire" are a special category under copyright law. If you are employed or apprenticed and you create a work of art within the scope of your employment or apprenticeship, the employer or master owns the copyright. The author of a "work made for hire" is the person who does the hiring. The creator has no rights to the work whatsoever. Unless you and your employer have agreed in writing, in advance, that copyright ownership will be transferred to you for certain types of work, the copyright belongs to your employer. Any such written agreement must be signed by both parties, or it will not be valid.

Under the new copyright law, the copyright for almost all commissioned work belongs to the creator. For example, the painter of a commissioned portrait owns the copyright, not the person who commissioned it. Only certain types of commissioned works are treated as works made for hire and then only if the creator and the commissioning party formally agree that this is to be the case.

A series of three *VLA Guides to Copyright* (Jensen, 1987) are available at reasonable cost from the VLA in New York City. One is written for visual artists; one for musicians and composers; and one for performing artists. For additional information, refer to the bibli-

ography provided on the data sheet entitled *Copyright*, available for
$1.00 from the Center for Arts Information in New York City if you
send a stamped, self-addressed envelope. *An Artist's Handbook on
Copyright Law*, available at modest cost from the Georgia VLA, is
especially helpful; it gives step-by-step information on filling out
copyright forms for every type of artistic work. Most useful for writ-
ers is *A Writer's Guide to Copyright* (Rand-Herron, 1979). A more
detailed discussion of copyright, as it applies to artists of every dis-
cipline, is given in *The Copyright Book* (Strong, 1986).

The U.S. Copyright Office publishes numerous free circulars,
some of which relate to specific art forms. Ask for the latest copies
of *Publications of the Copyright Office*, Circular R2, and *Copyright
Basics*, Circular R1. Copyright registration procedures and applica-
tion forms may be obtained free by calling the local number listed
under Copyright Forms in the U.S. Government section of your local
telephone book or by calling the U.S. Copyright Office. Copyright
law is extensive and complicated: you should seek professional legal
advice for any problems you encounter.

Insurance

By obtaining adequate insurance, you can substantially reduce the
risk of a devastating loss. Many types of insurance are available, and
you will need to be selective and choose an insurance policy based
on the degree of risk you may encounter, the value of a potential loss,
and your available funds. The three major types of insurance needs
for independent artists are property insurance, health insurance, and
liability insurance, and they are discussed below. Other forms of
insurance, however, which should not be overlooked, are life insur-
ance, social security, and unemployment insurance. The last is an
especially important form of support for performing artists who are
employed for a certain minimum length of time and then laid off.
Many performing arts organizations schedule their seasons specifi-
cally to qualify their employees for unemployment benefits from the
State.

Property Insurance

Your studio, your art work, and your equipment should be insured against fire, theft, loss, damage, and destruction. Rather than risk the loss of everything, you will probably find it wise to pay an annual premium to provide you with coverage in the event of a major loss. Your policy can be extended by an endorsement to cover your living space if it is a part of your studio or vice versa. Some artists also carry Inland Marine policies on their artwork to cover their work in transit, or in any location outside their studio. It is usually easy to obtain this insurance inexpensively. Where problems arise is in the assessed valuation of your work, something that is worth careful exploration with a knowledgeable lawyer. For more information about a sample fine art insurance program, contact the National Artists Equity Association.

Health Insurance

As a self-employed artist, you will find it essential to explore your options for health insurance. Some artists are able to depend on their spouse's employment for insurance coverage; some artists go without insurance and hope they stay healthy enough to avoid medical expenses, hospitalization, and disability. Other artists have explored ways to reduce the cost of individual health insurance coverage by enrolling in a group health plan, which is provided by many artists organizations for their members. For a listing of these groups, send $1.00 and a self-addressed, stamped envelope to the Center for Arts Information in New York City and request a copy of *Group Health Insurance for Artists*.

For information about doctors who offer health care at reduced rates for artists, contact Doctors for Artists. Performing artists should contact the offices of *Dance Magazine* for referrals to health practitioners offering special rates.

Be aware that the coverage provided by these groups varies considerably in scope and cost. A recent study by the NEA explored

ways in which better health care coverage could be more widely available and more affordable for independent artists (available from the Office of Policy, Planning, Research and Budget). It concluded that a comprehensive nationwide plan for artists would be feasible if problems relating to cost and distribution could be overcome. To date, no such plan has yet been marketed.

Liability Insurance

To cover bodily damage to a prospective patron or a friend on your property, you may want to consider liability insurance. A common variation is to have a project liability policy that covers injury related to work on a specific project, such as a public art project. This short-term insurance covers possible injury to the public during the installation period of your work.

For more information about insurance, refer to *This Business of Art* (Cochrane, 1978, chap. 11).

Contracts

No matter what your discipline, you will find it necessary at some point in your career to become familiar with different types of contracts. Those briefly described here are some of the contractual agreements that most artists will find useful—consignment arrangements, artist/agent agreements, sales agreements, and commissioned work. Whether you initiate a contract or are asked to sign one, it should be a written agreement signed by both parties, and both parties should keep a copy. A written contract clarifies and documents the understanding of both parties. In situations where a contract is provided for you, you are generally not expected to sign it without careful review and possible changes in the provisions. It is *always* wise to seek legal advice regarding any contractual agreement, especially if you are unfamiliar with legal terms.

Many of the reference books listed include model contracts. Before using one of them, it would be useful to arrange a meeting with a

lawyer to adapt the contract to your own particular needs. After you have gone through the exercise once and understand the effect of certain provisions, you will be more capable of modifying other model contracts for your own use. It is often said that the lawyer who represents himself has a fool for a client. Artists with no legal training who contemplate representing themselves would do well to remember this!

Consignment Arrangements

Some artists entrust their work and the responsibility to promote and market it to a dealer, agent, or gallery. If the work is sold, the artist receives an agreed-on percentage of the sale price. This type of consignment arrangement should be confirmed through a written agreement that outlines the arrangements, procedures, and responsibilities of both parties. The consignment relationship is delicate and complex. If you wish to use this arrangement, you should be concerned with the integrity of the dealer, agent, or gallery owner as well as with their professional experience and sales records for other artists.

To uncover some of the problems that should be addressed in a consignment contract, ask yourself these questions: Does the agent have exclusive rights to your work? In what geographic areas? Who determines the price at which your work is to be sold? Distributed? Who is responsible for insurance, loss, damage, or delivery costs of your work? How, where, and when will your work be promoted? At what time can or will the agreement be terminated? What happens if you make a studio sale? Who will own the copyright for your work? What are the terms of payment? How frequently should the agent provide you with a statement of accounts? A record of the status or location of each of your works?

A few states have laws that partially reduce the risks facing an artist who enters into a consignment arrangement. In California, Connecticut, Massachusetts, Michigan, New York, and Wisconsin, the transfer of an art work to a dealer for sale or exhibition to the public is defined as a consignment relationship, and the art dealer

acts as a trustee in holding money from the sale of consigned art until the artist is paid in full.

You will find more information about consignment agreements with galleries as well as model contracts in *The Artist-Gallery Partnership* (Crawford and Mellon, 1981). An excellent small brochure, *Guide to Artist-Gallery Agreements* (Philadelphia Volunteer Lawyers for the Arts, 1981) will also be helpful.

Artist/Agent Agreements

At some point in your career, you may want to work with an agent who will represent you, generate more publicity, and take care of some of your business matters. In return, your agent will receive a percentage of the new business. This type of artist/agent or artist/ representative relationship is delicate and personal in its nature. You should carefully select your agent based on reputation, experience, and your trust in the person's judgment. Ask friends and professionals in your field for recommendations. Interview two or three prospective agents; ask them for names of current and former clients so that you can check their credentials.

A simple written agreement clarifies your responsibilities and those of your agent. The questions to be addressed are similar to those given earlier. It is especially important for you to specify the geographic restrictions of your agent's services and the scope of the market your agent is authorized to represent.

Model contracts are available in *Making It Legal* (Davidson and Blue, 1979). For more detailed discussion on contracts, refer to *The Art Law Primer* (Leland, 1981). Writers will find both *The Writer's Legal Guide* (Crawford, 1977) and *Negotiating a Book Contract* (Levine, 1988) particularly useful.

Sales Agreements

For tax purposes alone, it is advisable to use a sales invoice to document each work you sell. A written sales agreement can also serve

to clarify your artistic and legal rights, the obligations of both parties, and obligations to the art work. A simple sales agreement follows.

Under Terms of Sale, you should include the following information, if applicable: ownership of copyright and reproduction rights; size of edition; resale royalties; right to loan the work for exhibition; notification if work is on loan, resold, or otherwise placed; and right to restore or repair the work. More demanding contracts may include such rights as receiving a percentage of any increase in the value of the work each time it is sold.

You will find model sales agreements in Making It Legal (Davidson and Blue, 1979).

CONTRACT OF SALE

Date of Sale:

Description of Work:

Price:

Terms of Sale:

Terms of Payment:

(Signature) (Signature)

_____ _____

Purchaser Artist
Address Address

Commissioned Work

A commission is an authorization to create a specific work of art in return for an established fee. A visual artist may win a competition for a public work of art for a park square; a composer may be commissioned to write a twelve-minute piece to be performed by a wind ensemble; or a dancer may receive a commission to choreograph a piece for a modern dance troupe. A person or group commissioning a work usually has a specific idea in mind for the piece, therefore, you should not accept the commission unless you are interested in the project as described and are qualified to meet the requirements. Accepting a commission without a written contract is risky.

A commission agreement should outline the scope of the work and define both your obligations and duties and those of the client. Some questions you will need to resolve and stipulate in the commission agreement are: When is the work to be completed? What will its dimensions and materials be? Who will own the copyright? Who will provide insurance if it is needed? What are the terms of payment? What if the client does not accept the work or cancels the commission?

This Business of Art (Cochrane, 1978) or The Art Law Primer (Leland, 1981) have model agreements for commissioned work and they address other relevant issues, such as budgeting and schedule of payments. Although both are written primarily for visual artists, the material in This Business of Art is easily adaptable for commissioned work in other areas of the arts.

Other Contracts

Depending on your artistic discipline, you may find the need for other types of contracts, such as publishing contracts, loan or rental agreements, illustration agreements for publication in books and magazines, and lecture agreements. For information and model contracts, refer to Making It Legal (Davidson and Blue, 1979). Professional assistance with contracts, at minimum expense, is available through Volunteer Lawyers for the Arts.

Estate Planning

If you hold a large number of unsold art works and copyrights, you should seriously consider estate planning. It may seem like the furthest thing from your mind, but the benefit to your heirs could be substantial, including reduced taxes and higher income. At a minimum, you should write a will so your estate can go to the people you choose, not those determined by the state. A lawyer can help you write a will.

You can learn more about estate planning from *Protecting Your Heirs and Creative Works* (Crawford, 1980) or from the chapter "You and Your Estate," in *This Business of Art* (Cochrane, 1978). You may also find useful the chapter "Estate and Gift Tax Planning" in *The Business of Art* (Caplin, 1982).

Starting a Business

Artists frequently ask whether it would be to their advantage to incorporate. As a private individual, you are ineligible for purely philanthropic support from most sources under existing tax laws. By establishing a not-for-profit, tax-exempt corporation, you are in a better position to attract public funds and contributions. Other advantages include limited personal liability, potential tax advantages, and greater credibility. However, incorporation is a time-consuming and complex process and should not be undertaken without the assistance of a lawyer.

As a general rule, you should consider incorporation if you are currently making more money than you need to cover your personal and business expenses or if you want to start a small company with other artists—the most common examples are small performing arts organizations. Initially, you might also examine other forms of business operations; many filmmakers, for example, establish themselves as a limited partnership so they can attract investors. In both cases, talk to an accountant to determine whether it would be beneficial to incorporate and what the process entails. A Chicago dancer, Anne,

found that the process of incorporating her small dance company was relatively easy. By doing much of the paperwork herself and with the assistance, free of charge, of a lawyer from the Lawyers for the Creative Arts, she was able to incorporate and gain tax-free status within six months.

You can obtain more information about different forms of business operations from *Making It Legal* (Davidson and Blue, 1979). *To Be or Not to Be* (Volunteer Lawyers for the Arts, 1982) discusses the process of incorporation and the issues you should consider.

FINANCIAL INFORMATION AND ASSISTANCE

Richard, a painter living in New York City, was not able to support himself solely by his painting, although, during the past six years, he had begun to sell more work and have occasional gallery exhibitions. What surprised me most about him was that it had been only in the past two years that he learned the importance of keeping receipts, ticket stubs, and canceled checks of his art-related expenses. He only consulted an accountant recently and then learned how important it was to pay all his major expenses and deposit all his fees and payments through a checking account. Before then, he took no deductions whatsoever for the considerable expenses he incurred as an artist. Consequently, he had paid more in taxes than he should have. It was only within the past few months that he learned to keep a running journal of his activities with an account of all his expenses. Richard now regularly uses an accountant to help him with his income taxes—an accountant to whom he was referred by friends. He claims that the accountant's fee is far less than the amount he saves in taxes; moreover, the accountant's fee is tax deductible.

Bruce, the media artist discussed earlier, was referred to an excellent accountant through his lawyer. Fred, the painter who lost his studio in a fire, found his accountant in an unusual way. He had gone in desperation in early April to a tax consultant in his neighborhood. The accountant who worked with him "got a real challenge out of

working with someone different—an artist." Fred learned from this accountant the necessity of using checks for all his business expenses; now, each month, Fred pulls his canceled checks representing his expenses as an artist and keeps them in a separate folder. He uses a notebook to record his daily accounts, with columns for each type of expense. The accountant also encouraged Fred to pay his taxes on a quarterly basis, "so I don't have to pay a huge check all at once, and avoid tax penalties for not estimating payments."

You can locate accountants who will work with you free of charge or at a considerably reduced fee through the Accountants for the Public Interest (API). Somewhat similar to the VLA in its structure, API provides free accounting services to organizations and individuals who could not otherwise afford professional assistance. More information about API and how to contact them is given in Chapter 3.

Income Taxes

You may find that your most difficult problem at tax time is proving to the Internal Revenue Service (IRS) that you are an independent professional who intends to make a profit from your self-employment activities. The IRS tends to challenge anyone who consistently or frequently takes a loss from their profession. Starting in 1987, you will only get the benefit of a "presumption" of a profit-making intention if you have had three profitable years out of the previous five years. Detailed and accurate record keeping will help prove that you have made efforts to sell and exhibit or distribute your work and that you are not merely participating in the arts as a hobby. Proper records will also prove—despite the fact that you may not have made a profit from your art—that you are still eligible to take deductions against your expenses as a professional artist. They also prove that, although the bulk of your income comes from your employment as a night guard, for example, you are a professional artist, not a professional night guard. A diary recording the date, cost, and purpose of meetings with gallery representatives, agents, curators, and produc-

ers is necessary. This is why it is important to find an accountant who understands your career choice and can help you present it fairly and accurately.

As this book enters its second printing, lobbying campaigns are underway on Capitol Hill to get certain artist groups exempted from the capitalization section of the Tax Reform Act of 1986. According to this Act, artists would have to attribute each expense incurred (rent, materials, etc.) to a specific project, and may deduct those expenses only when the "product" becomes income producing. The application of this law would have severe consequences on many artists.

Even if the uniform capitalization provision is not repealed, artists should maintain accurate records. You will then be able to claim as tax deductible, to the extent of the current law, most expenses that are routine and necesary to make an income as a professional artist. Please note, however, that according to the 1986 Tax Reform Act, fellowships and scholarships are no longer excludable from income unless received by degree candidates at accredited institutions and spent on tuition, books, or supplies. Furthermore, all unemployment compensation must be included in income.

Some expenses that may be deducted from your income and thereby reduce your taxes are listed below.

- Commissions to agents and managers.
- Dues to professional organizations.
- Periodicals, books, and research material.
- Special clothing worn solely for your work as an artist and the resulting laundry and cleaning bills.
- Business meetings.
- Supplies and materials.
- Postage.
- Publicity photos, materials, and fees.
- Business stationery, letterhead, and cards.
- Rent on your studio or workspace.
- Depreciation on work-related equipment.
- Utilities and upkeep for your studio or workspace.

- Work-related hotel, taxi, and travel expenses.
- Work-related telephone bills.
- 25 percent of health insurance premiums.
- Copyright registration fees.
- Legal and accounting fees.
- Training to maintain or improve your skills.
- Entertainment related to your profession (theatre, dance, concert, and movie tickets and museum entrance fees).

Other taxes and possibly other deductions exist, particularly at the state and local level, yet this list indicates only some of the substantial benefits you may be overlooking by not keeping adequate records. Taxes are part of your costs; within the limits of the law, you should attempt to minimize what you pay. Holding on to the money you earn is just as important as earning additional income.

To prepare annual tax forms, many artists depend on an excellent publication, *The Art of Filing* (Messman, 1987). Annual supplements to the book inform you of changes in the tax law. *The Art of Filing* guides you step-by-step through the federal income tax forms. If your records are well organized, you should be able to complete your own tax forms with the assistance of Messman's book. Another excellent publication is *The Art of Deduction* (Bay Area Lawyers for the Arts, 1983). Remember that the cost of books, periodicals, and magazines about your profession are fully tax deductible.

Record Keeping

Accurate and detailed records will enable you to take maximum advantage of the deductions for which you are eligible. By keeping records of all income received and all payments made in connection with your work, you will probably be able to handle your own tax affairs or, alternatively, significantly reduce the time needed by an accountant to do so. You will find it useful to keep a ledger recording all income received, and from whom, as well as all payments made, and to whom, during each calendar year for your arts-related, profes-

sional activities. Document as many transactions as possible through receipts, canceled checks, diary entries, written agreements, and sales agreements.

An elementary record-keeping system is a notebook with separate pages for travel expenses, business meals, phone expenses, supplies and materials, equipment, magazines and books, and income. Each entry should include information as to date, description of item, payee or payer, method of payment, amount, and a brief explanation of the transaction.

Under Method of Payment, note whether the transaction was made by check (and, if so, the number of the check), by cash, or other arrangement. Also note whether you have the check or some other written record of the transaction. At the back of your notebook or in a separate folder, you may also find it useful to keep a number of envelopes marked with the same headings as your notebook in which you can file your credit card slips, receipts, and canceled checks. Write a brief description of the transaction on each check or receipt. At the end of the year, you can add up the entries on each page in your notebook, and you will be ready to fill out your income tax form.

Use your checkbook for as many transactions as possible so that you have documentation of all money received and all funds expended. Even if you intend to deposit your royalty checks in your savings account, deposit them first into your checking account and then transfer them. A canceled check is the best kind of record for your expenses, and it is easy to keep.

Keep all your tax records for at least three years in case you are audited. (The statute of limitations on audits is three years.) Many accountants will recommend that you keep your records for five years in case you are asked to document that your income as an artist justifies your expenses as an artist.

For more information about bookkeeping, refer to *The Art of Filing* (Messman, 1987).

3

Sources
of Support

Artists should be familiar with five major sources of support: foundations, corporations, government agencies, private individuals, and service organizations. The largest amount of financial support for individual artists continues to come from government agencies—federal, state, and local—yet the other four sources can make a significant contribution to your search for space, time, information, and finance.

To help you make greater use of the five sources of support, this chapter will provide the following information: (1) the motivation for support, or *why* support for individual artists is considered; (2) the nature and character of the support, or *how* support is provided; (3) the decision making process, or *who* makes decisions about support; (4) methods of identification, or *where* to find more information about sources of support; and (5) recommended approaches, or *how* to maximize your opportunities of receiving support. The opportunities are much broader than you may realize, and, in certain cases, are significantly greater than shown in statistics. This does not mean that funds are available for every person who wants to pursue a

career as an artist. But if you have a good idea, funds and resources will be available to support it.

FOUNDATIONS

A foundation is a nonprofit organization given the privilege of almost complete tax exemption because it contributes some portion of its funds to charitable causes. Foundations are managed by trustees and directors and are established to promote social, educational, scientific, religious, and other activities primarily by making grants. Because foundations differ in size, purpose, and source of funds, their application and review procedures also differ. To complicate matters, some foundations change their interests and procedures from year to year.

The majority of foundations state in their guidelines that they only fund tax-exempt organizations, not individuals. Federal laws make it unattractive for foundations to fund individuals—more expense and paperwork are involved—and it is riskier. If a grantee's project is controversial and the grantee is an organization, the criticism is shared by both the funding organization and the grantee. If the grantee is an individual, much greater criticism tends to be directed against the funding agency. Most foundations, especially smaller ones, have chosen the safer and simpler route—to fund organizations only.

A number of artists have circumvented foundation guidelines that exclude support to individuals by submitting their application through an institutional sponsor—a nonprofit organization that serves as a conduit for project funds. If your project fulfills the stated objectives of a foundation, but you are not eligible to apply as an individual artist, you should either identify a local institutional sponsor to serve as a fiscal agent or discuss your project with the foundation staff and ask them to suggest possible sponsors. More information on institutional sponsors is given later in this chapter.

The two types of foundations most likely to support individual art-

ists are independent foundations and corporate foundations (i.e., company-sponsored foundations). Independent foundations will most often assist artists with fellowships and project grants; corporate foundations tend to emphasize community-oriented projects. Both traditionally place a heavy emphasis on education, thus, a significant amount of their funds for individuals is awarded through scholarships. In many cases, these funds are awarded to a university or college department and students must apply through the university for support.

Independent Foundations

Independent foundations are established through the gift of an individual or a family and often carry the name of the donor. They range in size from small, family foundations to multipurpose, internationally oriented ones, such as the Ford and Rockefeller foundations. In small family foundations, the family members generally serve as the trustees and review all proposals; in a larger foundation, the staff makes recommendations to the board of trustees.

Hundreds of small family foundations have been created by wealthy individuals yet the problem for the artist is trying to identify them. Information is often only to be had by word of mouth.

Broad publicity is intentionally discouraged by small family foundations because they have no staff and distribute only a few grants each year. For example, a noted Boston club raised funds to start a small foundation, and now supports at least seven young New England artists each year, including video artists, musicians, and writers, on the basis of the artists' career potential and current projects. Publicity is primarily by word of mouth. The President of the club commented that, since the foundation was small and had no staff, it would be forced to close if it were inundated with proposals and inquiries. Hiring a staff person would reduce available grant funds to a negligible amount.

Small foundations that seek, through their grants, to have national impact are easier to identify. Publicity is often advantageous because

it helps them attract the best candidates. These foundations tend to be listed in the major state and national foundation directories, as well as in many reference books. Usually there is at least one full-time staff member to respond to inquiries, to process applications, to seek press coverage, and to develop means of attracting applicants. But the majority of small foundations cannot afford full-time staff and do not seek publicity. Although many of these foundations are also included in funding directories, it often entails much patience and persistence on the part of the grant-seeker to obtain further information from them.

Larger foundations may be identified by foundation directories. Usually, they have staff, guidelines, and proposal deadlines. The size of their grants tends to be larger; the geographic area from which they will accept proposals is often broader; and the competition for grants is greater. These large foundations may be multipurpose. The Ford and Rockefeller Foundations have programs in agriculture, international affairs, and human rights as well as in the arts. Other large foundations may be special purpose, such as the Ingram Merrill Foundation, which only supports individuals engaged in creative and scholarly pursuits in the cultural and fine arts, or the Koussevitzky Music Foundation, Inc., which awards grants to musicians for commissioned works.

Corporate Foundations

A number of corporations establish and fund their own independent grant-making foundations, called corporate foundations or company-sponsored foundations. Of course, a corporation doesn't need to form a foundation to engage in philanthropic activities—corporate giving programs can serve the same function. Both are operated similarly, but the foundation has a separate legal entity.

A corporation may chose to establish a foundation for a number of reasons: (1) it increases the visibility of its giving program; (2) grants may be awarded on a broader basis than with a corporate giving program, where the purpose of the grant must usually be closely asso-

ciated with the corporation; (3) the foundation's budget is less depen-
dent on corporate profits (an endowment can be established to
maintain a constant annual foundation budget in years when corpo-
rate profits are down); and (4) it establishes a formal decision-making
body separate from the corporation President. The President is still
able to influence decisions, but is assisted by a separate body to take
full responsibility for rejected or difficult proposals. One conse-
quence of establishing a corporate foundation is that government
regulations applicable to foundations, including often prohibitive
restrictions on grants to individuals, must be met.

Almost all major corporate foundations now allocate some portion
of their funds to the arts. Most companies with a corporate founda-
tion tend to be large, and recent research shows that "senior man-
agers allocate both company money and their own time to arts orga-
nizations whose activity is unrelated to any tangible company
benefit." Michael Useem gives one reason: "The arts are viewed as
enhancing the quality of urban life, reducing alienation, and pro-
moting a culture conducive to the prosperity of free enterprise" (*The
Inner Circle*, p. 124). Because any number of projects by individual
artists satisfy these broad guidelines, artists should make every effort
to apply to corporate foundations through an institutional sponsor.

Corporate foundations are not known for their grants to individ-
uals except as scholarship support to children of employees. How-
ever, my research has identified several examples to indicate that this
policy is changing. For instance, Louis N. Zelle, Chairman of the
Board of the Jefferson Company in Minneapolis, a holding company
in real estate and securities, noted the following about his company's
support of individual artists: "There have not been a large number
of grants to individual artists; there have been a few, and we would
rather hope that there will be more in the future." The Jefferson
Company Foundation has supported local artists ranging from scene
designers to instrumentalists and environmental artists. Funds are
channeled through local arts organizations and universities. Mr.
Zelle added that "The arts are so individual in character that they

really can't respond awfully well to too much organization, and we believe they shouldn't be penalized for this inability."

Most corporate foundations attribute a certain amount of public relations value to their giving programs and therefore contribute solely or primarily in geographic areas where their sales, marketing, and manufacturing occur. Decisions about grants are made by a board that may include executive officers, other employees, and community representatives. Corporations are more likely to fund your project if you reside in the same geographic area as the company, if your project is community related, and if one of the employees can recommend it.

Further discussion on corporate support for individual artists is found later, in the discussion of corporations.

Identifying Potential Foundations

Given your project, how do you determine the foundations that may be possible sources of funding? The most convenient source is the directory *Foundation Grants to Individuals* (Foundation Center, 1986). This is one of the few comprehensive and well-indexed guides compiled solely for individuals. Because it is issued annually, the information is accurate and up to date. Check the index listings under Dance, Film, Literature, Video, Writers, and Visual Arts. It is also indexed by state. You may order a copy for yourself or suggest that a local library purchase a copy.

Another helpful reference book is the *Foundation Directory* (Foundation Center, 1987). This national compendium of foundations is available in most libraries. Over four thousand entries are arranged by state. Because many small foundations make grants only within their community or region, it is worth your time to read through the listings for the state in which you reside. Although the index does not list Art or specific art forms, the *Foundation Directory* is a handy reference for information about foundations that you

may discover through other sources. When you read "no grants to individuals," don't get discouraged; pursue it further.

Small family foundations depend to a large degree on local educators and arts administrators as their primary means of identifying applicants. Therefore, it is essential to maintain contact with local and regional educators and arts administrators.

Corporate Foundation Profiles (Foundation Center, 1983) is the best and most detailed source of information about company-sponsored foundations. Information about most U.S. foundations can be found at the regional network of Foundation Center Libraries, of which there are over ninety nationwide. A staff person can direct you to the guides and grant indexes for individuals.

Requesting Support from Foundations

There is no standard procedure for requesting support from foundations, because they vary so much in size, scope, and interest. Some have guidelines and deadlines; others do not. Some have simple and straightforward application forms, others have long and detailed ones. Although it is not uncommon for small foundations to be liquidated or lose their nonprofit status, always try to obtain current information. If a foundation is large enough to have staff, you should submit a one page letter describing your project; depending on the response—a phone call, interview, or letter—you should then send a full proposal. For small foundations with no staff, follow the guidelines as carefully as possible. Send only the information requested. If there is additional material you would like to submit that is not specifically solicited (slides, tapes, written recommendations), include a note saying that this material is available on request.

Of twenty-one foundations I surveyed by letter for the first edition of this book, I received responses from only six. I had included a stamped self-addressed envelope with each letter. Whether this low rate says something about the nature of my inquiry or about foundation attitudes regarding their obligation to the public, I am not sure. Since then, I have preferred to contact foundations by phone.

If a phone number is given, always call before you submit any material to discuss the appropriateness of your project. For small foundations without a listed phone number, I recommend that you send a stamped, self-addressed envelope or postcard along with your proposal and a request that they respond to you concerning its receipt. It is extremely frustrating to send a proposal to a small foundation and never receive a response. Unfortunately, it is a common experience.

Institutional Sponsors

Many funding sources, especially foundations, restrict their giving to nonprofit, tax-exempt organizations, not to individuals. If your project falls within the guidelines of a particular foundation but the foundation does not make grants directly to individuals, you should consider using an institutional sponsor. Such an organization should ideally be an arts organization with a strong record of performance and credibility. Institutional sponsors are commonly referred to as fiscal agents, conduits, or umbrella organizations.

An institutional sponsor technically applies for funds on your behalf and administers the funds, if awarded. In return, most institutional sponsors will request reimbursement for their administrative and bookkeeping costs (usually ranging from 7 to 15 percent of the total project cost) and acknowledgment of their role in any publicity or credits. The administrative cost can be added to your budget and requested from the foundation. Your institutional sponsor usually will thoroughly review the project proposal and budget before submitting them. Because your sponsor is legally liable and accountable for spending the project funds according to the terms of the grant, you may be asked to submit descriptive and financial progress reports.

You can identify institutional sponsors by going first to the local organizations that are most familiar with your work. In practice, fiscal agents will only sponsor you if your project meets their organizational objectives and doesn't compete with any of their own proj-

ects. Some artists' service organizations regularly provide institutional sponsorship for their members. For example, the network of Media Arts Centers located across the United States—these can be identified by calling or writing to the American Film Institute in Los Angeles—perform this service for independent filmmakers. Video and filmmakers can also refer to a brochure published by the Center for Arts Information, *Sponsors: A Guide for Video and Filmmakers* (1987). Your local arts council, artists' union, or professional organization might also be able to serve as an institutional sponsor or refer you to an organization that can. For example, the New York Foundation for the Arts will serve as a fiscal agent for New York artists in all disciplines, and they only charge 7 percent for administrative services. To have them sponsor your project, the Foundation staff first reviews the project description, the tentative budget, and the résumés of the primary project participants.

If you have already discussed your project with a potential funding agency that is interested but cannot fund individuals, ask their staff to suggest possible fiscal agents. They will usually be cooperative. To illustrate, the director of a corporate foundation that did not support individual artists was approached by a visual artist, Christopher, for support of his participation in a local arts festival. Because the director was familiar with Christopher's work and liked it, she called a local arts council that had previously funded Christopher's work and arranged for foundation funds to be transferred through them to the artist. This is the reverse of the normal situation in which the artist makes the initial contact with the fiscal agent.

Artists I have worked with have used institutional sponsors to channel funds from individual donors, foundations, corporations, and government agencies. Remember, when you do this you are asking the institutional sponsor to take full legal and financial responsibility for your project. Many organizations are unwilling to do this unless they know you and your work and that the funding organization is well known and reputable. It is wise to develop a good working relationship with the Director of your sponsoring organization. Although some artists resent the necessity of submitting their grant

indirectly, through another organization, most have found that such sponsors can be helpful in numerous ways and that the relationship opens up many other possibilities for future funding.

CORPORATIONS

Corporations are the most diverse and most rapidly growing source of support for individual artists. In comparison to foundation's and government agencies, corporate gifts or grants to individuals tend to be small, usually $1,000 or less. But their assistance may also include expensive equipment, access to experienced professionals, and research. Once an individual succeeds in obtaining funds from a corporation, the chances of receiving additional support, either from that corporation or another, tend to increase.

Corporate philanthropy has been aggressively encouraged by one of Washington's most successful economic lobbies, the Business Roundtable. The Roundtable calls on the business community to increase its contributions to education, health, welfare, and cultural activities and to give philanthropy greater importance. The NEA in 1983 initiated a corporate-federal partnership program and created the Office for Private Partnership. Its objective is to generate additional private sector support for artists and arts institutions. Many cities across the country have business-initiated 2 percent and 5 percent clubs whose members are corporations that contribute this percentage of their pretax earnings to philanthropic endeavors. Since 1967, the Business Committee for the Arts, a national service organization located in New York City, has encouraged and recognized leadership in corporate support of the arts.

If your work could benefit from financial, technical, or in-kind support from corporations, it is essential that you understand the motives for corporate philanthropy. Corporations are business entities—their bottom line is profit. They answer to shareholders who care more about the corporation's dividends than about its support of artists.

Corporate contributions, other than those through corporate foundations and corporate giving programs, are a measured investment. Although at first it may seem farfetched, many artists *do* have the ability to offer a corporation the potential for a significant return on their investment. To understand how, consider the five most common reasons why corporations support artists and the arts through means *other* than their corporate foundations.

1. It directly influences corporate profits, primarily through advertising.
2. It improves the environment at corporate and affiliate locations—physically, aesthetically, socially, or culturally.
3. It creates good public relations.
4. It is personally gratifying for the chief executive officer to be a patron of the arts.
5. It is tax deductible.

Unlike many individual donors or private foundations, corporations not only want to do good, but they also want to be *seen* to be doing good. You, as an artist, can benefit if your project helps them in this effort.

Suppose you are an independent filmmaker. If your completed film is shown on local cable TV or if it is distributed nationally, it will carry the name of the corporate sponsor in its credits. The company's employees can be proud of their company; potential employees may be attracted; new buyers and markets may be influenced by such advertising; and community residents and civic officials will gain a positive image of the corporation. The corporation's public interest is translated directly into dollars and goodwill—and it often costs far less than other means to achieve the same end.

Three years ago I was introduced to an MIT alumnus who was the President of a company in Michigan that produced steel heat exchangers. His company was doing well, and he was interested in directing corporate funds to the arts, especially toward research in the arts and projects involving art and technology. I referred him to

two artists in our graduate program who needed funds to support a collaborative project with the Joffrey Ballet Company—the design of an interactive theatre set using a body imaging system. He supported the two artists for a period of three years. The project was given publicity through his company newsletter; during the second year, his company received a Business in the Arts Award from the Business Committee for the Arts. Clearly, the project was a worthwhile investment for him because he later supported other artists at MIT.

The return on investment does not necessarily have to be measured in dollars. The Director of a small Midwest printing firm has been helping young photographers for years by printing and distributing their posters or exhibition catalogs for free or at cost in return for the reproduction rights. As the Director stated, "We can't afford and couldn't get the rights to photographers like Ansel Adams, but we can afford to bet on younger, lesser known photographers and hope that it will pay off in the future to have published their works." When asked whether his generosity had, in fact, paid off, he smilingly admitted, "We haven't made money yet." Nor had his company ever taken advantage of the tax write-off—and it had been supporting artists in this manner for forty-seven years! He concluded by saying, "We continue to do it, because we want to."

Methods of Corporate Support

Corporations can provide funding and assistance to individual artists in a number of ways: (1) the award can be made to an institutional sponsor who then transfers the funds to the individual artist; (2) the corporation can establish a foundation that follows the federal rules for grants and awards to individuals; (3) the corporation can purchase the artist's work or contract directly for the artist's services, thereby incurring a direct business expense; (4) the corporation can donate or loan equipment and supplies to an artist; (5) the corporation may enable employees to volunteer their time to assist artists with technical needs; or (6) the corporation can develop a gallery program to exhibit and sell artists' work.

Most companies, large or small, will have one or more of the following departments through which they might provide support to individual artists: a corporate collection; a corporate gallery; a corporate foundation or giving program; publicity; advertising and design; corporate communications and community relations; and research.

Corporate Collections

Acquisition programs at corporations are either developed along with a gallery program or as a separate entity for exhibition in offices and corridors throughout the corporation's buildings. The art is usually selected by a curator, the chief executive officer, or a committee of corporate employees in consultation with a curator or arts consultant. Private gallery owners, museum curators, and your state arts council staff will often be able to identify companies in your community or state that acquire the work of local artists; they may also know local, independent art consultants who work for these companies. Visual artists should add these people to their mailing list, and if possible, arrange to meet them.

Most corporations buy art to create a pleasant working environment or enhance their public image. Although it is also commonly thought that corporations purchase art as an investment, most corporate executives will deny this. Art work that is pleasant for a working environment is not necessarily the best investment. In discussion with a corporate arts consultant (a young art history graduate), I learned that she often finds her clients more receptive to the work of young, relatively unknown artists than to that of blue chip artists. The reason: they can purchase something they like—and for a considerably smaller sum of money.

More corporate collectors are focusing on the work of contemporary artists. The art director for Southeast Banking buys the work of young, local artists for their 120 branch offices throughout Florida. Approximately 70 percent of the six thousand piece collection of Los Angeles's Security Pacific National Bank is devoted to contemporary

California artists (Brooks, 1982). Wachovia Bank and Trust, based in Winston-Salem, North Carolina, owns more than nine thousand paintings, prints, and drawings, which are exhibited throughout their offices. The collection focuses on the work of artists from North Carolina and the South. Prudential Insurance Company spends 1 percent of its construction and renovation costs for its thirty buildings across the country on the acquisition of works by emerging artists ("Keepers of Corporate Art," Namuth, 1983). And it is not just large corporations that collect art—I have come across many small companies where the President has single-handedly built an outstanding collection.

Corporate Galleries

Many corporations have public art galleries in their headquarters, and many concentrate solely on the exhibition and sale of work by contemporary or local artists. The Arco Center for Visual Art, for example, is a corporate gallery located in the downtown Los Angeles headquarters of Atlantic Richfield. Exhibitions often feature the work of California painters and photographers. The policies of corporate galleries vary, but in this case neither the gallery nor Atlantic Richfield takes a commission when works on display are purchased.

Your state arts council should be able to tell you which companies collect the work of young artists. You may also want to refer to the ARTnews Directory of Corporate Art Collections (Howarth, 1986).

Corporate Foundations and Giving Programs

Whether corporations have a separate foundation or a special giving program, the funding is usually restricted to organizations, at least on paper. It is well worth exploring just how rigid this restriction is. When asked if she ever supported individuals, the Director of a corporate foundation for a large bank stated: "I wouldn't touch them; there's not enough impact." On the other hand, the vice president of another major financial institution noted, "We don't give to indi-

viduals, but there is plenty of room for discussion. We have a budget of $300,000." When approaching corporate foundations, artists need to be especially imaginative and persistent. If your individual project meets the foundation's criteria, you may be eligible for support by using an institutional sponsor.

Some corporate foundations will also arrange for free technical assistance by their company employees in such areas as bookkeeping, management, and legal matters. In-kind gifts or loans of products manufactured by the corporation can frequently be obtained through the corporate foundation or giving program. Numerous corporations manufacture equipment that is used by artists. Honeywell, SONY, Apple Computer, Westinghouse Electric, American Speaker, Rockwell International, and Eiki International are companies that have been extremely generous to individual artists through in-kind gifts and extended loans of costly equipment. As more artists turn to technology-based and media-based art forms, there will be a greater need for corporations to provide this type of assistance.

Publicity, and Advertising and Design Departments

Most corporations have a Publicity Department or an Advertising and Design Department that is primarily concerned with marketing. Commissioned works for advertisements for De Beers Diamonds and the Container Corporation of America were among the earliest examples of corporate support of artists. Some corporations will also assist artists and arts organizations by printing publications, brochures, or program announcements. It is an excellent and inexpensive way for the company to gain publicity.

Corporate Communications and Community Relations Departments

Corporations commonly have one division that promotes the overall corporate goals rather than one particular product or activity. This department may be called Public Affairs, Public Relations, Com-

munity Relations, or Corporate Communications. Funds from this division will often be used to support community, cultural, and social organizations. This department may also have an artist-in-residence program or a noon-hour performance program by artists. If a corporation does not have a foundation, often the corporate communications department operates the corporate-giving program.

The Corporate Communications office of Springs Industries, based in Fort Mill, South Carolina, has sponsored a regional art show for twenty-six years. Artists who maintain a legal residence in North or South Carolina are eligible to submit works. The work receiving first prize is purchased for the Springs Art Collection. Judges are drawn from some of the most prestigious museums in the nation. Each year, an exhibition of the most outstanding works from this show travels to museums, college campuses, and galleries in the two Carolinas.

Research Departments

A number of product-oriented companies, as well as some high-technology ones engage artists as researchers. Examples include General Motors, Corning Glass Works, SONY, and ATARI. Some choose to have an artist-in-residence; some give or loan materials to artists and keep in close contact with them; some pay artists on a contract basis; others have well paid summer internships available. Working for or with a corporate research department tends to be one of the most productive and exciting relationships an artist can have with a corporation. It allows for the most artistic freedom, encourages the greatest level of creativity, and generally provides the largest amount of money. Unfortunately, it remains a rare opportunity for most artists.

Artists who do experimental work with computer graphics and design, transmission, animation, lasers, and imaging should be aware of, and correspond with, corporations that research and develop related equipment. Many graphic artists, musicians, designers, visual artists, and media artists have recently developed imaginative part-

nerships and mutually beneficial relationships with computer companies. It is not unusual for corporations to seek talented artists who are experimenting in areas of interest to that corporation. For example, a sculptor from Chicago who worked extensively with light was approached by the head of the Optics Division of General Motors to spend a fully paid year as artist in residence at their Optics Laboratory.

The Polaroid Corporation: A Case Study

Polaroid is one of the few corporations that supports individual artists in a variety of ways. Much of the following material that is related specifically to Polaroid comes from a presentation and discussion at MIT in 1981 with Mr. Samuel Yanes, Director of Corporate Communications at Polaroid. Note how many of the following support mechanisms are direct business expenses and, therefore, not documented in current literature about corporate support for the arts.

The Polaroid Collection: United States and International

Three times each year, the Polaroid Collection in the United States makes significant purchases of work done on Polaroid materials. Artists submit small portfolios of their work, and a jury of people from within the company selects the work they feel is most important, representative of contemporary trends, or appropriate as additions to their collections. The jury actively seeks the work of young and emerging artists. The International Polaroid Collection, housed in Offenbach, West Germany, operates an artist support program and purchases work, through a cash or materials exchange program, from more than fifty artists worldwide each year. As Mr. Yanes noted: "I don't think you should minimize the investment possibilities for a corporation in terms of art. You are spending relatively little, often for the work of minor artists, and you never know what possibilities come later on."

The Clarence Kennedy Gallery

The Director of Publications and Exhibitions at Polaroid oversees ten exhibitions a year for Polaroid's Clarence Kennedy Gallery in a wide range of photographic concerns, from the historical to the experimental. Many artists independently submit portfolios for review, both for the Gallery and the Collection. A few are requested by invitation. Photographs are selected by a committee of volunteer employees and are loaned from the artist for exhibition in the Gallery.

The Polaroid Foundation

The guidelines for the Polaroid Foundation state that "The Foundation does not make grants to individuals." However, the Executive Director of the Foundation notes that individuals sponsored by a nonprofit organization are eligible for support and in-kind gifts of equipment. Mr. Yanes describes this support as either "innovation grants" for artists who propose risky, unusual, or especially interesting projects, or as "acquisition grants" for museums that want to purchase the work of individual artists. The Director's reason for not funding individuals directly is the familiar one—legal forms and accounting measures are too time consuming. Because the Polaroid Foundation already receives approximately 3,000 grant requests per year, of which only about 350 are funded (not including in-kind grants of equipment), this policy is understandable.

Publicity, and Advertising and Design Departments

The Publicity Department and the Advertising and Design Department at Polaroid commission photographers and commercial artists to create artwork that can be used for marketing needs. This work is put onto a computer-aided visual data base from which it may be drawn for use in magazines, advertisements, editorial work, press kits, and other instructional and promotional materials. When questioned about corporate control and restrictions on artists, Mr. Yanes

responded, "We don't feel that we should impose any particular taste requirements. To get good work, you've got to let the artist go, and take what you get." He added that some artists are asked to accept assignments "to try some idea that the corporation might have . . . to experiment."

Research Division

Polaroid's founder, Dr. Edwin Land, believed that to explore all dimensions of a novel photographic invention, the company required the services of artists as well as scientists in the early experimentation stages. He believed that an artist could often be more innovative with the materials than, say, a quality control person from the engineering department. As Mr. Yanes points out, "Independent artists often put Polaroid materials to uses quite different than those we originally intended. While the company has an interest, often a vested interest, in a project producing certain kinds of results, an artist has the license to be creatively independent, and to get at the truth."

The Polaroid Corporation may be an exceptional example because its concern with the medium of light is shared with many artists, and its products—cameras and film supplies—are essential materials for many other artists. But it does illustrate what a corporation committed to expanding the limits of art can achieve. Although the opportunities for support for individual artists in other corporations are far more restricted, they may eventually be encouraged to emulate Polaroid's programs.

Identifying Potential Corporations

Corporate support for individual artists is a well kept secret. Because it is frequently recorded as a legitimate business expenditure or as a charitable contribution to a nonprofit organization, it is rarely reported to the IRS as a contribution to an individual. Consequently, there are no comprehensive data on corporations that support indi-

vidual artists, except for the data available on corporate foundation giving. However, the number of corporations that contribute to the arts is steadily increasing. Where there is support for the arts, there is support for individual artists.

Printed indexes to corporate foundations or corporate giving programs, such as *A Guide to Corporate Giving in the Arts-4* (ACA, 1987), can be used as a general reference and as a source of addresses, names, and telephone numbers. None of the directories with which I am familiar list whether the foundation will consider supporting individuals through an institutional sponsor.

Because corporations are more likely to give to artists and organizations in their own community, I recommend that you read the business pages of your newspaper to locate corporations in your area. Keep alert for roadside signs and advertisements. Check the *Yellow Pages* of your phone book. Ask your state or local arts agency for suggestions. For a comprehensive list of nationwide corporations and the names of their top executives, refer to your library's copy of the *Standard and Poor's Register of Corporations, Directors and Executives, United States and Canada.*

Requesting Support from Corporations

There are several ways to approach a corporation for support. The method you choose should depend on the nature of your project, the size of the corporation, and what you know about it. The smaller the company, the more likely the giving program is located in the chief executive's office. Even with a large corporation, there is some justification for going directly to the President. A former foundation representative from Olin Corporation, Stamford, Connecticut, stated, "When I received a letter requesting support, it was one among many. I added it to the pile of other proposals and I eventually got to it; when I received one from the President's Office, and it said, please handle, I read it and responded immediately because I never really knew whether the person who was writing the chief executive officer might know him." He added that applicants frequently note

in their letter that they will phone the President in a few days to learn the response. The applicant can be certain that a corporate officer will call you before you call the President! If you want a quick response, one way is to write to the President.

An alternative approach is to call the receptionist and ask if there is a Public Relations Department or a corporate foundation—and request their direct dial number and the name of the department head. Call or write directly to the department head. Always try to arrange a brief appointment. Describe your project, your interests, and ask if they would consider a gift of money or equipment—whatever you may need. Explain what you can offer them in return—publicity, a finished work, or new uses for their product. If a foundation does not directly support individual artists, ask for suggestions of sponsoring institutions that might serve as a fiscal agent. Consider the corporate foundation and all other departments of the corporation as separate entities; just because the foundation cannot be of assistance to you does not mean that another department cannot, and vice versa.

Another recommendation, garnered from Mr. Yanes at Polaroid, is to ask a professional in your field to call the corporation or corporate foundation official to whom you wrote and give a personal recommendation for your project and your work. Because the corporate executive receives so many requests from artists and arts organizations, this is an especially good way to draw attention to your letter. References and recommendations tend to be extremely important for corporations because their personnel usually have little expertise in the arts.

Remember, unless you are requesting support from the corporate foundation, decisions concerning your request are generally made by one person—a corporate executive. Standard review procedures have no role. It is your contact with this person and people who know him or her that is important. Chances are that the corporate executive you contact is not only knowledgeable about the arts but is sympathetic to the problems artists have obtaining support. More often than not, you will find that the executive is a collector or an avid

theatregoer—or even a frustrated artist! It is not often that she or he has the chance to genuinely affect the life of another individual, let alone an artist.

A cordial, warm, and understanding response from a corporate executive officer is not uncommon. Perhaps it is exactly because most business executives do *not* work regularly with artists that they often go out of their way to be helpful when the opportunity arises. An example is the following letter received by a video artist from Detroit in response to his request for a loan of an expensive piece of equipment from the manufacturer.

> Dear Mr. Nillingham:
>
> We are pleased to respond to your request for the loan of a 16mm projector with an endless loop attachment.
>
> I would suggest our model HT-O. If you let us know where this should be shipped we will do so promptly. Please let us know approximately when this current project will be finished so we can set up our files as to the expected date of return.
>
> I am personally very sympathetic to the work you are doing and the difficulties of getting funding. I have 2 sons and a daughter, all of whom are married, and all six of my "children" have gone (or are going) through the same thing.
>
> Lots of luck on your project. Please keep us informed as to your success.
>
> Sincerely,
> Hank Galsworthy
> Executive Vice President and General Manager

This sort of response readily undermines the artist's stereotype of the profit-mongering, insensitive entrepreneur. It also shows that many people in business do not stereotype artists as bohemian, romantic, and idealistic. In the process, an increasing number of artists are discovering that corporate executives, both as individuals and as members of the corporation, can be significant and reliable sources of support.

For more details about how to approach potential donors or funding organizations, refer to Chapter 4.

GOVERNMENT AGENCIES

Your taxes help support a number of government art agencies at the federal, state, and local level. By understanding the procedures by which these funds are allocated to individual artists and with some perseverance, most artists are able to secure government support early in their career.

Federal Support for Individual Artists

At the federal level, the primary arts agency is the National Endowment for the Arts. As an independent agency of the federal government, the NEA was created in 1965 to encourage and support American art and artists.

The Endowment assists *creative* artists directly through fellowship support and indirectly through a range of mechanisms aimed at helping dissemination of their work. *Performing* artists are assisted through the institutions that make their art possible, with the exception of solo recitalists and jazz musicians—for whom there are endowment fellowship programs. Fellowships usually range between $3,000 and $20,000, depending on the program.

The current chairman of the NEA, Frank Hodsoll, established as one of his four basic concerns the support of individual artists, both creative and performing. The NEA's *Five-Year Planning Document: (1989–1993)* (NEA, 1987) states: "the Arts Endowment will strive to maintain its categories of direct and indirect assistance to artists. Simultaneously, the Endowment will work to encourage the private sector, and other public sources, to increase their direct support for artists." A particular emphasis is expanded distribution, publication, and dissemination outlets for artists. The Endowment will also continue to assist organizations that present, exhibit, and distribute the work of individual artists.

In 1987, the Endowment reinstated the Advancement Grant Program to help smaller, artist-run organizations and, through them, their artists. It also plans to include subgranting opportunities for

individual artists in its Challenge Grant guidelines, and initiatives for housing/workspace and distribution projects.

For a copy of the *Guide to the National Endowment for the Arts*, call or write the NEA's Office of Public Affairs. You may also want to request published guidelines for one or more of their twelve programs: dance, design arts, expansion arts, folk arts, inter-arts, literature, media arts, museums, music, opera-musical theatre, theatre, and visual arts. Each guideline is available at no cost and each includes an application form. For a comprehensive listing of all other federal agencies that may prove useful as potential sources of funds or assistance, consult the *Cultural Directory II* (Coe, 1980). Opportunities include Fulbright awards for performing artists, commissions to design postage stamps, and full- or part-time employment for artists, craftspersons, and performing arts groups in prison recreation programs.

Regional Support for Individual Artists

Seven regional arts organizations serve all fifty states and four jurisdictions with grants and technical assistance programs for individual artists and arts organizations. Although these are not government agencies, they obtain the majority of their funding from government sources and therefore their application procedures are similar to other public funding agencies. The programs of each regional arts organization are designed to promote the sharing of outstanding artists and artistic resources in that region. Touring programs offer opportunities for individual performing artists to present their work before diverse audiences. Visual artist residency programs enable individual artists to work for periods of two weeks to three months at host organizations. Visual and media artists are eligible for regional fellowships.

Artists should contact the regional arts organization that serves their state of residency. The seven regional programs, and the states served by each, are listed below.

Arts Midwest
Hennepin Center for the Arts
528 Hennepin Avenue, Suite 310
Minneapolis, MN 55403
(612) 341-0755

Illinois, Indiana, Iowa, Michigan,
Minnesota, North Dakota, Ohio,
South Dakota, Wisconsin

Consortium for Pacific Arts and Cultures
2141c Atherton Road
Honolulu, HI 96822
(808) 946-7381

American Samoa, Guam, Northern Marianas

Mid-America Arts Alliance
20 West 9th Street, Suite 550
Kansas City, MO 64105
(816) 421-1388

Arkansas, Kansas, Missouri, Nebraska,
Oklahoma, Texas

Mid-Atlantic Arts Foundation
11 East Chase Street, Suite 1-A
Baltimore, MD 21202
(301) 539-6656

Delaware, District of Columbia, Maryland,
New Jersey, New York, Pennsylvania,
Virginia, West Virginia

New England Foundation for the Arts, Inc.
678 Massachusetts Avenue
Cambridge, MA 02139
(617) 492-2914

Connecticut, Maine, Massachusetts,
New Hampshire, Rhode Island, Vermont

Southern Arts Federation
1401 Peachtree Street, N.E., Suite 122
Atlanta, GA 30309
(404) 874-7244

Alabama, Florida, Georgia, Kentucky,
Louisiana, Mississippi, North Carolina,
South Carolina, Tennessee

Western States Arts Foundation
207 Shelby Street, Suite 200
Santa Fe, NM 87501
(505) 988-1166
Alaska, Arizona, California, Colorado,
Hawaii, Idaho, Montana, Nevada,
New Mexico, Oregon, Utah,
Washington, Wyoming

State Support For Individual Artists

Every state has an arts agency responsible for the funding and
encouragement of art and artists. Each provides various types of
assistance to individual artists who are residents of that particular
state, including both financial and technical assistance. Some states,
such as New York and Massachusetts, have established separate
foundations exclusively for this purpose. The Public Information
Officer at your state arts agency will be able to describe their current
programs. Look under government listings in your phone book to
find the phone number or call your U. S. Representative's office.
(Most agencies are called the [State name] Commission or Council
on the Arts or the [State name] Arts Council.) You may also find the
address and phone number of your local arts agency by asking at your
public library or referring to the back pages of the NEA's *Guide to
the National Endowment for the Arts.*

Every state or U. S. territory operates an artist-in-residence pro-
gram through the state arts agency or through a private, nonprofit
organization. Artists are supported for periods that range from two
weeks to one year to work in schools and community organizations
on a part-time or full-time basis. Qualifications for artists vary from
state to state. More detailed information about artist residencies is
given in Chapter 2.

There are also a growing number of fellowship programs for artists

operated at the state level. The Illinois Arts Council, for example, awards $5,000 fellowships "to a limited number of creative artists who have demonstrated exceptional talent and achievement." The purpose of the fellowships is "to enable Illinois artists of outstanding promise to continue to develop their artistic careers." Although the Illinois program supports only visual artists, writers and film/video makers, some state programs will also support artists in choreography, music composition, and mixed media/new genres. In most cases, a simple one page application form is requested and, if applicable, visual materials representative of your work.

The majority of state art agencies operate slide registries that are used by public and private organizations to select artists for public art projects. There are over seventy-five publicly held slide libraries throughout the United States. Many will accept the work of artists and craftspeople from any region in the country. Artists are advised to send their slides to the registries in their state, since most local, state, and regional public art commissions and selection committees give preference to local artists. Furthermore, slide reproduction is costly. Call your state arts council for recommendations and advice concerning the most actively used registries. Remember that local and state registries are also used by curators, arts consultants, and gallery owners. Both the General Services Administration and the Veterans Administration, of the federal government, have art-in-architecture programs and operate slide registries. To be considered for their public art projects nationwide, any artist should send a résumé and slides.

Some state art agencies also offer project completion grants or grants-in-aid for artists to complete a work of art currently in progress; others offer master artist/apprenticeship programs providing one-to-one training opportunities. Other programs for individual artists that are operated by some state arts councils include art in public places, commissions, support for new works (including performances, recordings, and publications), design competitions, travel grants, art banks, and financial assistance for artists to attend training workshops. Each agency also offers services for individual artists that

often include artists' slide registries, job registries, resource libraries, technical assistance workshops, referrals for advice on legal and accounting matters, and art banks. Several states also have funding to support a Poet Laureate and a State Folklorist.

Local Support for Individual Artists

Art agencies in your community are your most convenient and most potentially rewarding source of funds. To identify these agencies, call your state arts agency or a local government representative. Services and programs for individual artists vary but often include technical assistance, festival opportunities, funding for community related projects, and support for art in public places. The Chicago Council on Fine Arts, for example, is a service agency of the city government. One of the programs it operates, Neighborhood Arts Projects, provides grants of up to $4,000 to Chicago artists for neighborhood art activities.

A tremendous growth in the number of local arts agencies has occurred; they currently number over two thousand in the United States. The National Association of Local Arts Agencies hopes that the number continues to grow so every artist and every citizen will be served by a local arts agency. Although these organizations are not all government agencies, they tend to obtain the majority of their funding from government sources.

Characteristics of Government Support

The most common restriction on grants to individuals by government agencies is residency. For example, fellowships from the NEA are usually given only to citizens or permanent residents of the United States. State arts agency requirements are usually less stringent; most require six-month residency in that state. To be eligible for local arts agency support, artists are usually expected to be a resident of the community the agency serves. Alternatively, the project

for which an artist is seeking support must take place in that community.

Another common restriction is that the applicant cannot be enrolled as a full-time student in a degree-granting institution—however, artists who will have completed their education by the time the grant project begins are often eligible. Because there are sources of scholarship support for artists enrolled as students and very few sources of support for entry level or mid-career professional artists, most government arts agencies try to channel the funds where they are most needed.

Application forms for artists are generally simple. The application forms for fellowships currently used by the NEA, for example, require only a half-page career description and a summary of the proposed activity. These forms include the fellowship applications from choreographers, designers, creative writers, literary translators, video artists, composers, composers and their collaborators, solo recitalists, playwrights, and visual artists.

The deadline for receipt of applications to government agencies is infrequent—often once a year. In reviewing applications, government agencies rely heavily on the recommendations of advisory panels composed of arts professionals and community representatives. Consequently, personal contacts in the arts and government community can never hurt, although they can never guarantee a positive outcome either. From my own experience as a panel member, I have found that any information a panelist can offer to supplement the written applications is extremely useful—especially when the competition for grants is keen.

Government agencies encourage potential applicants to discuss their projects or eligibility status with staff representatives before submitting an application. Staff members at government agencies may be busy—but they are there; they are helpful; and they will usually take the time to understand your needs and make recommendations to increase your chances of receiving funds. They will also have available, on request, lists of previous grant recipients and annual reports listing former grantees and brief project descriptions.

These will give you an idea of whether your project is suitable for funding.

Typical of government funding agencies is the length of time between application deadline and the notification of grant award decisions. At the NEA, this period is frequently nine months; at the state level, it is more commonly three months. Government agencies are, therefore, not the best place to go for immediate funding needs.

Because the source of government funds is taxpayer's money, the grantee is expected to explain how the funds were used and what was accomplished. Written project descriptions and financial records are needed. In some cases, artists cannot be reimbursed unless they submit an invoice or receipt for material purchased or services rendered. Fellowship recipients are often asked to provide a written description of their activities and to submit either a sample or documentation of works completed during the fellowship period.

For similar reasons, grant recipients are usually requested to acknowledge the support of the government agency in all published material, announcements, exhibitions, films, and tapes.

Another characteristic of government funding for the arts is public service responsibility. Requirements for project funding often include public demonstrations, workshops, presentations, exhibitions, or performances in the local community. In New York State, the State Arts Council's Artist Fellowship Program requires grant recipients to develop a public service component as a condition of their fellowship.

Government agencies are known for their constant shifts in priorities and procedures. Each year new funding categories will emerge and old ones disappear; grant deadlines will change and new application forms will appear. When applying for government funds at the federal, state, or local level, always write or call for the most recent guidelines, application forms, and application dates.

Perseverance is the key in obtaining government funding. There is such keen competition that many outstanding artists may not be awarded support the first time they apply. Because a public agency is equally as accountable to you as you are to it, the agency will be

most helpful in explaining why your application was rejected, and what you can do to improve it. Keep on trying; once you've completed an application form, it is easy to improve it or resubmit it. Remember that federal, state, and local arts agencies cannot meet their goals without you.

PRIVATE INDIVIDUALS

Support from private individuals occurs in a number of ways, including the outright purchase of work, commissions, use of space, introductions to other potential donors, and gifts of money.

Gifts of Money to Artists

People provide funds to an individual artist because: (1) they like the artist's work; (2) they share the artist's beliefs or the message expressed by the art work; (3) they see potential for investment; or (4) a combination of the above.

Private individuals may make an outright gift of money to an artist through one of two methods. They can either write a personal check to the artist or they can locate an institutional sponsor that will accept the check for that artist and transfer the funds to him or her. In the first instance, there is no tax deduction for the donor, but there is clearly great personal satisfaction and enjoyment. In the second instance, the donor *does* receive a tax deduction. This is not to say that tax considerations dominate the decision to assist the artist but rather to emphasize that tax consequences do play a role, which can often work to the artist's advantage. If the donor is able to weigh the tax consequences of a gift, she or he may be able to consider a larger gift, because the cost to the donor is considerably less.

In my interviews and research with individual donors who have supported artists, I found that the majority prefer to channel their funds through an institutional sponsor. If you are asked by a private

donor to suggest an institutional sponsor, contact your state arts agency. If you have previously received funds from a foundation or arts council, explore these options first because these organizations are already familiar with you and your work.

A Boston businessman, Mr. B, was approached by a fellow board member of the Boston Symphony Orchestra to support a highly recommended young opera singer who had an opportunity to study at a special school in Europe but did not have sufficient funds to make it possible. Mr. B called the singer to discuss his proposed course of study and to ask if he had ever received funds from a grant-making organization. Because the singer had received a grant from a foundation in New York the previous year, Mr. B immediately called the foundation to enquire whether it could legally accept his check and then allocate the funds directly to the singer. It could and did. Thus, Mr. B was able to support the opera singer's study in Europe; giving both the donor and the artist tremendous satisfaction—and the donor received a tax deduction for his gift.

This example indicates the importance of indirect contacts in getting support. The artist never directly solicited funds from Mr. B; but he did inform his friends and acquaintances of an opportunity to study in Europe and his lack of funds to take advantage of it.

A young musician and mother, Nina, supported her artistic career through employment as a secretary. For several years, she had been trying to raise money to attend a music conservatory. She happened to mention this during a conversation with a friend, Yvonne, whom she had known for eight years. When Yvonne asked what was keeping her from enrolling immediately, Nina answered: "Money!" In response, Yvonne said that she would pay for the tuition. When Nina was accepted at the conservatory, Yvonne wrote a check to cover the cost of a year's tuition. After a year, Yvonne, who was not a wealthy woman, said that she would continue to cover the cost as an interest-free loan, payable on whatever terms were most convenient to Nina. Needless to say, Nina accepted the offer. Although situations such as the two I've described do not happen frequently, they do occur—perhaps more often than most of us would think.

It is no coincidence that both examples involve scholarship fund-
ing—funding of an educational opportunity. The value of a good
education is well known, especially to those who have enjoyed the
benefits. Consequently, the support of educational study for a tal-
ented artist is a request that is difficult to turn down. Remember:
what might be an unfulfilled dream for you might be an exceptional
opportunity for someone else to provide assistance.

Identifying Potential Donors

How can an artist identify potential donors? There are three ways.
The first is to attend events that these people do. The second is to
ask people you already know—friends, relatives, professional associ-
ates—to help identify potential donors. The third is to stay in touch
with people who have already expressed an interest in your work.

Think of the acquaintances and contacts you already have and
begin to explore them. Is your doctor or dentist interested in the arts?
Does she or he have acquaintances or patients who are? What orga-
nizations do you belong to? Didn't the father of one of your former
classmates have a recording business? Didn't your cousin mention
during Christmas dinner that her new neighbor was a producer?
How about all those invitations to openings or receptions that you
routinely throw into the wastebasket—isn't it possibile that by
attending such gatherings you could meet people with similar inter-
ests who also have the means to support those interests? Don't be
shy at these affairs; introduce yourself and ask about your fellow
guests' interest in the arts. Artists have met potential donors every-
where—at lectures, weddings, and at service stations. A ceramic art-
ist from Cambridge recounts how his auto mechanic became
intrigued with his work and now owns three pieces. Opportunities
are always there; your challenge is to begin to recognize them.

What types of people could introduce you and your work to a
potential donor? Let's assume that you are a young cellist. Most
likely you have some affiliation with a conservatory, music school, or

performing ensemble. Each of these organizations has a board of directors that may include potential donors and people who could introduce you to potential donors. There are always open sessions when the board meets. Ask a staff member of the organization (preferably a director, administrative officer, or faculty member) to invite you to the next session and introduce you to some of the board members. Then stay in touch with the people you meet. Invite them to special performances. Keep them abreast of your work by arranging to meet for coffee or a drink after a performance. When you need funds to support a project that might be of interest to one of them, go back to the staff member who originally introduced you. Ask them whether they would be willing to call the board member and explore the possibility of support for your project.

A Boston area media artist, Harry, who had been introduced to me by his roommate, calls me from time to time or stops by my office to describe his present project, and he always sends me an announcement of his screenings. Once Harry came by and asked if I could suggest someone who might be interested in helping him raise the additional funds he needed to complete a film. I immediately thought of two of our board members—one was also on the board of a local television network, the other had just been introduced to new video work at MIT and was intrigued with the art form. Both were wealthy. Because Harry was not currently affiliated with MIT, I was reluctant to call on his behalf, but I told Harry to use my name when he called. He was received cordially by both gentlemen and had the opportunity to discuss his proposal and budget needs. In addition, one expressed an interest in viewing the raw tape, and Harry arranged to meet him at the TV studio. The result: Harry received substantial financial support—$4,000 from one donor, $1,000 from the other. Both asked Harry if his other funds had come through a nonprofit, tax-exempt organization, and they both arranged for their contributions to come to Harry through that organization.

As you seek support, you should follow Harry's example and go to the arts administrators and arts educators with whom you have

worked and encourage suggestions of potential donors. Ask if they will introduce you, whether you can use their name, or where you would be most likely to meet a particular individual.

People who have already expressed an interest in your work, through a purchase or a commission, for example, are the most likely to support you and your work through other means. Keeping in touch with them is fundamental to your career. They will usually welcome a periodic phone call to hear about your progress. They would be likely to accept an invitation to your studio to discuss new projects or new ideas. And they might also be interested in helping you obtain the resources so that you can give form to these ideas. Your past patrons are sources of future support. Stay in touch with them. It is simple to do, courteous, and good business.

Requesting and Receiving Funds

My research has shown that everyone who has supported one or more individual artists said that they would be willing to fund other artists. The problem is that most of them found that the opportunity rarely arose. This astonished me. It's hard to believe that there were people with the interest and ability to support individual artists, yet they were rarely approached by artists. The reason, which occurred to me later, is one of the first rules of fund-raising: *few people make a gift unless they are asked to.* Even though more than 80 percent of the money given to the arts comes from individual donors, it is mostly arts administrators, not artists, who have asked for the funds.

It is rare that potential donors will give support solely because they are aware of an artist's financial need. They must be asked for support. My own experience serves as an example. Two years ago in Chicago, I visited a man who gave annual support to the arts programs at MIT, but his gift had never increased. After describing the many exciting projects that MIT was able to support with contributions from people like him, I summoned my courage and asked him whether he might consider an increase in his gift. To my sur-

prise, he replied, "No one from MIT has ever asked me for money. Yes, I would be delighted to substantially increase my contribution." This taught me a valuable lesson. Now I tell people exactly what our organization is able to do with their funds. I explain our needs, and I ask whether they would consider a gift of a specific amount.

To increase the chances of securing support, I recommend that artists approach individual donors for project completion funds or support of educational training and study. Although this does not exclude other requests for support, it recognizes that private donors attach significance to the fact that their funds enable artists to accomplish something concrete or further their careers in a meaningful way.

Whether you succeed in meeting people through your own efforts or through the assistance of others, always try to have someone else introduce your request to that person. Each of the individuals I interviewed recommended that artists "ask someone to intervene for them." In the example of Mr. B, the key factor in his decision was the outstanding recommendation from his colleague on the Board of the Boston Symphony Orchestra. Mr. B commented that he would not have been as responsive to an "unsolicited phone call or letter." Ideally, the person should be someone who knows the potential donor or someone known to the potential donor, such as a curator. Alternatively, ask if you could use this person's name when you call the potential donor.

Always have a brief one-page description of your project and budget as well as a copy of your résumé to give or send to the potential donor or the person who introduces you. Keep in mind that you are asking for a gift, not a grant. The difference is that there is no formal application and review process. Although it is helpful and useful to have written information, the decision to give is usually a personal one; it is based on you and the person who introduces you. If the potential donor is convinced by your enthusiasm or by the recommendation of the person who introduces you, chances are that you will receive support.

It is extremely important to keep both the donor and the person

who introduced you informed of your project or progress. It bears repeating that there is no better prospect for future funds than a past donor—it doesn't take much to change a one-time donor into a patron. For example, take the case of Fred, whose studio burned down. He became deeply depressed for a number of months. His depression ended only after a curious incident. A buyer of one of Fred's paintings met him by chance on the street and asked where he had been, what he had been doing, and why there hadn't been any notices of Fred's work lately. He was shocked to learn of the fire. The next day, he called and offered, in Fred's words, "to buy an undone work up front—to offer money in return for a painting that would come at a later time." Fred continued, "I figured that if he felt that way, maybe I should write to some other people and bring them up to date and propose the same idea." He wrote to six people who owned his paintings, asking for $500 to help pay for materials and living expenses in return for a painting not yet begun. "I was either dumb or desperate," he said, "but I got four checks for $500 and really nice letters from the others." It is interesting to note that each of these four people visited Fred's new studio later and bought paintings—not one of them ever referred back to Fred's $500 obligation. In essence, it was a gift to Fred, strictly on a personal basis.

How should an artist keep in touch with donors? Today, Fred accomplishes this by sending out invitations to his exhibitions and a yearly Christmas card. A young film/video artist from Michigan, Mark, discovered that a local businessman who had provided him with financial support for production expenses, had a hobby of collecting corks. When Mark moved to California, he gathered corks from California wines and sent an entire boxfull to Mr. E. When Mr. E visited his daughter in California, he went out of his way to invite Mark to dinner. You don't need to write a formal written report to an individual donor—just keep in touch in an informal, friendly manner.

It is commonly noted that individual donors expect something in return for their support. For instance, in *The Individual's Guide to Grants* (Margolin, 1983, p.141) the author writes:

... one can be sure that a gift from an individual donor, even if "anonymous," usually comes with strings attached. In fact, individual donors are the most likely of all funders to expect something specific in return. At the very least, they will probably require a show of allegiance and/or gratitude. They may even want to change your ideas in some meaningful way to correspond to theories or plans of their own.

People who are sufficiently interested in financially supporting an individual artist are familiar with, and respect, the creative process. In my experience, these people rarely, if ever, consider imposing their own ideas.

Of the many individuals I interviewed who have supported the work of artists, none mentioned any expectations. Artists who received support have confirmed this. Almost the opposite seemed to be the case. If the artist made no effort to remain in touch with the donor, there was often no further communication.

Individual artists could obtain a significantly larger amount of support from private donors than they now do. If you have done your homework and identified someone who is interested in your specific art form and you have someone to "intervene" for you or someone who will let you use their name, your chances of receiving support are high. But knowing potential donors, or meeting potential ones is not enough; you must develop a personal relationship with them. The worst that can happen is that they will say "no," in which case you can always ask if they could suggest someone else who might be interested in the project. Give it a try!

For further examples and suggestions for requesting support from private donors, see the discussion on personal solicitations in Chapter 4.

SERVICE ORGANIZATIONS

In addition to foundations, corporations, government agencies, and private donors, numerous local, regional, and national organizations

act as advocates for individual artists and provide resources, financial assistance, technical assistance, professional training, space, and group benefits. The service organizations I will describe fall into one of three categories. The first is professional associations that provide a variety of services for artists working within one discipline, such as music or crafts. The second provides services, such as legal counsel or technical assistance, to artists working in one or more media or for artists within special interest groups. Examples include Volunteer Lawyers for the Arts (VLA), artist colonies, and women and minority art organizations. The third includes an assorted group of organizations that serve diverse audiences, yet have a number of services or opportunities available for artists. These include Accountants for the Public Interest, organizations providing support and information for elderly or disabled artists, educational institutions, clubs, and churches.

Professional Associations

Organizations that provide a variety of services for artists working within one discipline are frequently called professional associations. Examples are American Composers Alliance, Dramatists Guild, American Craft Council, American Dance Guild, Poets & Writers, American Music Center, American Film Institute, National Artists Equity Association, Association of Independent Video and Filmmakers, Center for New Television, American Alliance for Theatre and Education, and Theatre Communications Group.

The Association of Independent Video and Filmmakers, for example, is a nonprofit trade association providing advocacy and direct services for independent producers, directors, and technicians. Membership ($35 in 1988) entitles you to group medical and life insurance, short film distribution services, seminars, screenings, an information clearinghouse, and a subscription to the *Independent*, which reports on business, technical, and legislative matters and also contains notices of jobs and funding opportunities.

National Artists Equity Association serves a similar function for

professional visual artists, including photographers, craftspersons, printmakers, painters, and sculptors. It works to advance their economic, cultural, and legislative interests. Affiliated chapters are located nationwide. The New York Artists Equity Association, although no longer affiliated with the national organization, still serves a national membership. Its services are extensive and similar to those of the national organization. It provides interest-free loans for artists with a demonstrated need, discount privileges for many items, group medical insurance, and fine arts insurance that protects work while in your studio or in transit. Legal counsel is available for such problems as contracts, gallery/artist relationships, copyright, and reproduction rights. The *National Artists Equity Newsletter* features association activities and discusses topics of current interest to visual artists. It also presents forums and workshops. Membership is minimal; in 1988 it was $40. For more information, call both the New York and the national headquarters in Washington, D.C.

Some of these professional organizations also sponsor competitions and juried exhibitions for artists. A national juried fair such as the American Crafts Enterprise sponsored by the American Craft Council is an example. It provides prestige, sales opportunities, and visibility for participating artists. Professional jurors handle your work, publicity, entry inquiries, and fees.

Service Organizations for Artists

Some service organizations are organized *for* artists and *by* artists. For instance, the Boston Visual Artists Union (BVAU) is an artist's cooperative. For a yearly fee of $40 (as of 1988), visual artists have access to gallery space, an active exhibitions program, a slide registry, a job bank file, a housing and studio space file, a monthly newsletter, cooperative supply purchases, technical assistance workshops, a credit union, weekly programs and meetings, and advocacy efforts for personal and professional rights. The Chicago Artists Coalition is another example of an artist-run organization. To locate service organizations for artists, refer to the National Association of Artists'

Organizations (NAAO) in Washington, D.C., which is itself a ser-
vice organization for nonprofit organizations that provide public
access to artists working in different media. The *NAAO National
Directory of Artists' Organizations* lists over one thousand organi-
zations that provide programs and support for visual, performing,
and literary artists; it also describes their programs and policies. A
similar publication describing national individual artists' organiza-
tions is being prepared by the American Council for the Arts.

Other service organizations for artists differ widely in the pro-
grams and assistance they offer. Those discussed below include orga-
nizations that provide several services for artists of every discipline,
such as the Resources and Counseling Program of the United Arts
Council in Minnesota and the Arts Extension Service in Amherst,
Massachusetts. Others specialize in one particular area, such as the
VLA, artist colonies, and a variety of arts organizations for women
and minorities.

The Resources and Counseling Program of the United Arts Coun-
cil is a service organization in Minnesota that provides assistance to
individual artists in the development of their professional careers.
Information and advice is available on legal questions, insurance mat-
ters, business practices, funding opportunities, and marketing. Art-
ists may either schedule one-to-one consultations or attend a series
of workshops, both reasonably priced. Since 1978 over four thousand
artists, primarily from the Minnesota area, have been served through
this program.

The Arts Extension Service, a division of Continuing Education
at the University of Massachusetts at Amherst, is a community
development program that provides nonfinancial support to artists
and arts organizations. One of its primary objectives is to help artists
realize their artistic and economic potential through their own
efforts. Its services include workshops, seminars, legal assistance
referral, and an extensive arts information library. They also coor-
dinate the New England Arts Biennial, a festival of New England
artists and arts activities.

Volunteer Lawyers for the Arts (VLA)

Another specialized organization, Volunteer Lawyers for the Arts (VLA), provides artists with free legal assistance. Individual artists of every discipline who are unable to afford legal services and have an arts-related problem are eligible for VLA's services. Headquarters for the VLA is in New York City, but it currently has thirty-seven affiliate organizations located in twenty-four states and the District of Columbia. Offices of VLA maintain a roster of lawyers who are willing to provide their services for free or for a minimal cost. They also have informative newsletters and publish excellent books about legal issues. Ask to be placed on their mailing list.

To locate the VLA affiliate closest to you, contact one of the following organizations, or call your state arts council.

> California Lawyers for the Arts
> Fort Mason Center, Building C, Room 225
> San Francisco, CA 94123
> (415) 775-7200

> Lawyers for the Creative Arts
> 623 South Wabash Avenue, Suite 300–N
> Chicago, IL 60605
> (312) 427-1800

> Volunteer Lawyers for the Arts
> 1285 Avenue of the Americas, 3rd Floor
> New York, NY 10019
> (212) 977-9270

> Texas Accountants and Lawyers for the Arts
> 1540 Sul Ross
> Houston, TX 77006
> (713) 526-4876

Free services are available if your income and assets are below the level established by the VLA. Each VLA affiliate has different eligibility requirements, but in most cases individual artists with a gross family income from all sources of $10,000 or less are financially eligible for VLA's assistance. Individuals with income in excess of

$10,000 but under $15,000 may still be eligible for assistance if they can demonstrate that their net income after business deductions would otherwise qualify them for services. Individuals with liquid or nonliquid assets (savings accounts, money market funds, etc.) in excess of $5,000 will generally not be eligible for VLA's services. An exemption is made for real estate that is used for living or work and for work-related material and equipment. If you do not meet these financial criteria, VLA staff will refer you to non-VLA lawyers who will provide their services at a considerably reduced rate. In the latter case, the VLA will help you negotiate a contract.

The most common legal problems for which artists seek advice are: contracts and agreements, copyright, landlord-tenant disputes, and incorporation as a not-for-profit organization. Artists are asked to complete a form specifying the nature of their artistic activity, their legal problems, and the financial situation rendering them unable to retain private counsel. Applicants are then screened and referred to an attorney.

Smaller chapters of VLA are frequently found at law schools throughout the country, for example, at the University of California Law School in Los Angeles and the University of Cincinnati, in Cincinnati, Ohio. Even if a law school does not have a VLA chapter, a few phone calls to the administrative offices will uncover the names of students who are qualified and interested in providing counsel for artists on a volunteer basis. I have also found that there are several lawyers who are well versed in art law but not affiliated with VLA. To locate these individuals, try calling local law firms and asking if they could refer you to someone who has expressed an interest in working with artists on a volunteer basis.

Artist Colonies

A colony provides an artist with time to create. It is a place to work without the intrusions of the outside world and with few distractions or obligations. It provides an opportunity for sustained concentration and creativity. The tremendous productivity of residents, the artistic

achievement of former residents, the constant stream of artists seeking admission, and the growing number of colonies are an indication of their success.

Applications for residency at an artists' colony are similar to other grant applications. Artists are asked to submit samples of their work and letters of recommendation. These are reviewed by a panel of recognized artists and arts administrators in the appropriate discipline. Eligibility varies from colony to colony; some accept applications only from artists of demonstrated talent, others seek applications from artists who are beginning their careers. Some are open to artists of all disciplines; many are limited to writers, composers, and visual artists. Residencies can vary in length from one week to several months. Some colonies offer full fellowships or stipends to cover all expenses, others charge a minimal amount per week, still others offer space alone.

A listing of artists' colonies in the United States and abroad may be obtained at modest cost from the Center for Arts Information in New York City. Poets and writers may request a reprint of "On Cloud Nine: 24 Heavens for Writers" (Pies, 1983) from Poets & Writers.

Women and Minority Artists' Organizations

Special service and professional organizations have developed to meet the growing number of minority artists. Statistics from the NEA show that the number of women artists in the labor force increased by 162 percent between 1970 and 1980, accounting for 52 percent of the increase in the number of working artists during that decade, and that minority artists increased by 2.6 percent during the same period (NEA *Arts Review*, Supplement, Summer 1984).

Service organizations for women and minorities vary according to the services they provide and the audience served. For example, the Renaissance Development Corporation in Louisville, Kentucky, offers technical assistance to minority artists in Kentucky. It also serves as a presenter for black dance and theatre performances,

poetry readings, and visual art exhibitions. The Black Filmmaker Foundation in New York City sponsors programs to gain support and recognition of independently produced work of black filmmakers. It also offers consulting services for fund-raising and distribution. ATLATL in Santa Fe, New Mexico, works to preserve, promote, support, and develop contemporary and traditional native American arts. The Association of Hispanic Arts in New York City acts as a clearinghouse of information on all the arts; it publishes a newsletter and runs a funding resource library, workshops, and forums. The International Women's Writing Guild in New York City offers workshops, a newsletter announcing funding opportunities, contests, and awards, and health and life insurance at group rates. Midmarch Associates in New York City serves as a women's art service organization and publishes *Women Artists News*. Women in the Arts, also based in New York City, is dedicated to overcoming discrimination and promoting wider opportunities for all women artists.

For more information about minority artists' organizations, write to the Civil Rights Division of the NEA and ask for their free brochure, *Directory of Minority Arts Organizations* (NEA, 1987). The *Guide to Women's Art Organizations* (Navaretta, 1979) is a useful, although dated, reference for organizations serving women artists.

Other Organizations

Several types of organizations or institutions provide a range of services to a broad segment of the population. Although their programs, facilities, and services are not specifically designed to meet the needs of individual artists, these organizations provide resources that are of great assistance to artists.

Accountants for the Public Interest

Somewhat similar to the VLA in its structure, Accountants for the Public Interest (API) offers free accounting services to organizations

and individuals who could otherwise not afford professional assistance. API has assisted a number of individual artists and small groups of artists, but the staff note that they have the potential to be of much greater service to the artist community. Members of API are called on most often by artists to assist with tax returns and bookkeeping and assess the advantages of forming a nonprofit corporation. For information and assistance, call the national office of Accountants for the Public Interest in Washington, D.C., or one of its ten affiliate offices, as listed below. If you do not live in the area of one of the affiliate organizations, call the national office to be referred to an accountant in your vicinity who can assist you.

Accountants for the Public Interest
1625 I Street, N.W.
Washington, DC 20006
(202) 659-3797

Accountants for the Public Interest
Support Center of New York
36 West 44th Street, #1208
New York, NY 10036
(212) 302-6940

CPA's for the Public Interest
220 South State Street, #1404
Chicago, IL 60604
(312) 786-9128

Clearinghouse for Volunteer Accounting Services
315 West 9th Street, Suite 1109
Los Angeles, CA 90015
(213) 623-3147

Community Accountants
1700 Sansom Street, #703
Philadelphia, PA 19103
(215) 564-5986

New Jersey API
965 West Seventh Street
Plainfield, NJ 07036
(201) 757-9313

Oregon API
71 S.W. Oak Street
Portland, OR 97204
(503) 225-0224 ·

The Support Center
57 Eddy Street, #504
Providence, RI 02903
(401) 521-0710

The Support Center
Accounting Aid Program
525 Northwest 13th Street
Oklahoma City, OK 73103
(405) 236-8133

The Support Center of Washington
1410 Q Street, N.W.
Washington, DC 20009
(202) 462-2000

Western Pennsylvania Community Accountants, Inc.
612 Frick Building
Pittsburgh, PA 15219
(412) 471-5533

You may also try calling the Society of Certified Public Accountants in your state; some have public service committees to provide the assistance you may need. The number is in your phone book. And remember to ask your friends. An artist friend of mine has had an accountant do her taxes for more than twelve years, initially at no charge, and now for a small fee. He actually knocked on her door one evening (she lived in a building with many other artists) and asked if she needed some help with her taxes. He did the same for the other artists in the building. He offered his services solely because he wanted to help people, and this was his way of doing so. There must be many other accountants who share this man's need to do more than just make a living and use his skills to benefit others.

Organizations Serving the Elderly and the Disabled

Although all the information in this book, including types and sources of support, apply to artists who are elderly or disabled, a growing number of organizations and services cater to these groups. The National Endowment for the Arts, for example, now has a TDD phone number (telecommunications device for deaf people), listed in the Index for hearing-impaired people. To obtain a cassette recording of the Guide to the National Endowment for the Arts, write or call:

> Director of the National Library Services
> for the Blind
> Library of Congress
> 1291 Taylor Street, NW
> Washington, DC 20542
> (202) 287-5100

Three other national service organizations serve deaf and disabled people. The Disabled Artists Network operates as an information exchange. Deaf Artists of America serves as a clearinghouse of information, and publishes a newsletter. And since 1974, Very Special Arts has coordinated arts programs for people with disabilities. Programs operate in every state and internationally, and offer opportunities for participation in festivals, workshops, and special projects. Professional artists with handicaps are especially encouraged to participate. Very Special Arts has a TDD phone number for hearing-impaired people.

The Museum of American Folk Art and the American Foundation for the Blind have prepared an *Arts Resources Directory for Blind and Visually Impaired People* (1988). This publication provides information concerning organizations, newsletters, classes, workshops, and competitions for visually impaired artists. The *Directory*, in large-print, braille, and cassette formats, includes information on art materials available on tape, large-print, or braille, and a list of museums and galleries with special facilities for the visually handi-

capped. For more information, contact the Museum of American Folk Art.

A service organization for elderly artists, the National Center on Arts and the Aging, maintains a slide registry of artists over fifty-five years of age. It also arranges exhibitions of older artists, offers seminars and workshops, and produces publications.

Educational Institutions

Most universities, especially those with graduate programs in the arts, have extensive resources available for their student and alumni artists, and some of these resources are also available for community residents. Many universities have an office or program specifically for the support of art activities. For example, MIT has its own arts council that operates a grants program and a technical assistance program to support and foster creative activity by students, faculty, and staff. During its first ten years of operation, the grants program made over 260 awards totaling $422,000 to artists and groups of artists who were students, faculty, or university staff members. Through the work of the Council staff, these awards have leveraged $726,000 in matching funds from corporations, foundations, public agencies, individuals, and other MIT departments. Numerous local artists were sponsored by student groups or university departments to create public works of art for dormitories, to give performances, to be in residence, or to supervise training workshops. A resource library with extensive information on funding opportunities is open to the public free of charge. The Council staff has also located performance space on campus for local choreographers and directors who have no space of their own and cannot afford to pay for any. In addition, many of the over forty performing arts groups at MIT employ young local professionals to participate in the Institute's concert series.

Many other universities operate similar programs or have special budgets or discretionary funds available for arts projects and presentations on campus. If you are a student at a university, you can usu-

ally arrange to have your department serve as an institutional sponsor. Most universities also have travel grants available for students and special travel or research grants for alumni. Resource libraries are also common at most universities, and many of the reference books mentioned in the Bibliography can be found there.

Clubs

A surprising number of clubs have funds especially for scholarship, career development, or travel. In some cases, this may require that you are related to, or nominated by one of the club members. If you consider the membership affiliations of your extended family, your neighbors, and close friends, you are certain to discover a number of connections to professional clubs, fraternal organizations, or societies. For example, the Lions and Rotary Clubs, and the Junior League have funds for travel and career development. Check your phone book to see if these clubs have branches in your area.

A private, all-male club would not be the most likely place to find an active program supporting fellowships to individual artists, but such is the case in at least one East Coast city. Each year, three or more young artists (male and female) receive project completion support. In the same town, there is a group of approximately one hundred women who meet monthly as members of the Women's Travel Club. If membership dues and contributions are substantial enough in a given year, a fellowship/travel grant is awarded. Recent grants have been to a woman filmmaker to travel and study in Japan and to an arts administrator to examine the link between industrial design and arts education in Italy. With both of these clubs, publicity is through word of mouth and a printed announcement sent to local arts educators or to arts organizations and public libraries.

Most grants from clubs are small—on the order of $500 to $1,500. Although the application procedures are usually minimal, the final report often involves a short presentation to a gathering of club members.

Churches

Church patronage for the arts has many historic precedents, ranging from Giotto's frescoes for the Arena Chapel in Padua, Italy, to Matisse's design and decor of the chapel for Dominican nuns in Vence, France. Contemporary church involvement with the arts became widespread in New York in the early 1970s, and it has now spread throughout the country. The movement has been primarily a Protestant one, with the most support coming from the Episcopalians and the Unitarian-Universalist Church. Support ranges from the use of space and resources to the incorporation of art and artists into the church service.

Examples of church support of the arts varies from one congregation to the next. The Judson Memorial Church in Greenwich Village is known for its pioneering gallery program and, more recently, the Judson Dance Theatre and the Judson Poet's Theatre. St. Peter's Church at 54th Street and Lexington Avenue has an active theatre and musical program and has commissioned works from painters and sculptors. Craig Mellow's article, "Sacred Support" (1984)—from which most of my information on churches is derived—notes the extremely active arts programs at Grace Cathedral in San Francisco, St. John's Cathedral in Spokane, St. Mark's in Seattle, the Washington Cathedral in Washington, D.C., and the Cathedral of St. John the Divine in New York City—the latter has "a $325,000 annual arts budget and half a dozen performing companies in residence" (Mellow, p.10).

Motivations for church support of the arts include the following: (1) it gives greater visibility to the church within the community; (2) it can be an "effective means of communicating spiritual messages" (Mellow, p.10); (3) it helps attract more young people to church services; and (4) it is an effective use of space for underutilized facilities.

Association with a church can be highly desirable for artists. The rent of church space is free or minimal; operating costs are low; and volunteers are plentiful. In addition, some of the most active churches have established separate foundations through which they

can attract grants to schedule more substantial arts programming rather than relying on private contributions and the church's own funds.

There are churches in almost every community that use their facilities for concert and dance performances and film screenings; most are noted in the arts pages of your local newspapers along with other listings. Church facilities are often so underutilized that most ministers welcome the opportunity to discuss their use by artists.

Identifying Service Organizations

Check first with your state arts council to learn what services they provide for individual artists. They will also be a good source of information about other service organizations in your state and nationwide. Older artists working in the same field as you are another good source of information about professional associations. You may also want to look through the *Encyclopedia of Associations* (Koek and Martin, 1988) and the *American Art Directory* (1986).

If all else fails, call, write, or schedule an appointment at the Center for Arts Information in New York City. This is yet another service organization that operates an information clearinghouse for and about the arts nationwide. In addition to over five thousand reference books, it has nearly four hundred files on service organizations and funding agencies. Its services are free.

Clearly, many opportunities exist for support for individual artists from foundations, corporations, government agencies, private individuals, and other organizations. The diversity and scope of these options are enormous, and they frequently overlap. You can only benefit from improving your knowledge of them and the opportunities they provide.

4

Seeking Support for Your Project

THE PLANNING STAGE

Seeking support for your project involves a lot more than just writing a proposal or submitting an application form. It's a process that begins with several preliminary planning steps. Let's assume that you're a visual artist and that for the past few months you've been developing what you believe is a good idea for an outdoor public art work. Your idea becomes an active project when you discover through a friend or through the network of information you've set up (using the principles described in Chapter 1) that an application deadline for funding is approaching at, say, your local arts council. What should you do next?

My recommendation would be:

1. Write an outline or abstract of your idea so that you can answer the questions concerning the *what, when, where, why, how, by whom, with whom, and for whom* about your project.
2. Call or write to the arts council to ask for their program guidelines and an application form.

3. If you have questions regarding this information when you receive it, call or write for answers.

4. Prepare your proposal or fill out the application form.

Notice that three of the four steps concern planning. This part of the process of seeking support is most frequently overlooked. No matter how creative or outstanding your idea may be and no matter how convincing your proposal, it will have little effect if you don't send it to the proper organization or individual. By planning ahead and identifying and contacting the appropriate funding sources, you greatly increase your chances of receiving support.

Recently, a noted experimental musician from out-of-state approached the Arts Council Office at MIT to sponsor a $100,000 grant proposal that had been enthusiastically encouraged by the state arts council. Unfortunately, her request came to us only a few days before the deadline. Although we accelerated our usual procedures, the details could not be worked out in time. Her lack of planning meant that she lost an opportunity for funding.

Project Description: Using a One-page Abstract

No architect would attempt to build a house without first preparing a blueprint or sketching a plan. Your blueprint should be a one-page project description or an abstract. It will help clarify the project in your own mind; it will greatly facilitate your conversation or correspondence with personnel of funding agencies; and it will be the basis for your proposal or application material. A clearly written abstract should include:

- *What* the project is.
- *How* it will be accomplished.
- *Who* will be responsible.
- *Who* will assist or collaborate.
- *Where* it will take place.
- *When* it will take place.

- *Why* it is important.
- *To whom* it is important.

If you cannot answer these questions in at least a hypothetical manner, you are not yet ready to contact potential sources of support or to continue to the final step—preparing the proposal itself.

Identifying Potential Sources of Support

As a project becomes more clearly defined, so do the appropriate sources of financial and material support. Once you have completed your abstract, use it creatively to help you identify potential funding sources. Ask yourself these questions:

- Are there specific equipment needs or materials and supplies that could be donated by a manufacturer? (Check the *Yellow Pages* for local manufacturers or consult the index of *Standard and Poor's Register of Corporations, Directors and Executives, United States and Canada* for a list of national manufacturers.)
- If your project is to take place in a specific community, are there any corporations or businesses nearby that might gain publicity from contributing funds or material to it?
- If your project involves a performance, would nearby corporations or businesses be interested in purchasing blocks of tickets for their employees?
- Are there individual patrons of the arts in the community who may be interested in contributing to your project?
- Have you considered both local and national foundations and government agencies?
- Are there local universities or colleges that might find your project attractive?
- Does your *alma mater* have alumni grants?
- Could part of your project be covered by a travel grant?
- Would a residency at an artist's colony enable you to begin or continue work on your project?
- If the theme of your work relates to a national theme, have you considered going to the appropriate consulate or local cultural insti-

tute for support, or to businesses that offer products associated with that nation? (Try scanning the telephone directory.)

• If your project involves travel, especially foreign travel, have you gone to the airlines, to the consulates, or to the U.S. Information Agency for support? (The USIA is responsible for most government sponsored educational and cultural exchanges with other countries.)

These questions allow you to build more effectively on the network of support described in Chapter 3. They should yield a list of potential sources of support appropriate for your particular project.

Avoid the temptation to squeeze your project into program guidelines that are not appropriate. It is much safer to be honest. Otherwise, you may end up with funds for a project that doesn't match your interests or suit your needs. For example, if a local corporation requires you to use their auditorium instead of a nearby theatre for your dance performance to receive funds from them, make certain that the additional expenses incurred by this change can be covered by the budget and that you feel comfortable with the artistic compromises that may be necessary. If you need fellowship support to help create new works and you are tempted to apply for a well-paid residency, carefully weigh the benefit of receiving funds versus the obligation of the residency. The funding may be welcome, but the requirements of the residency may considerably reduce the time available to you for creating new works.

Project "Packaging"

A clear statement describing your project will help segment it into smaller, individually fundable packages. For a project with a large budget, this will increase the number and types of organizations to which you can go for support. This can be done in several ways. Consider: (1) chronological packaging or requesting support from different sources for preproduction, production, and postproduction costs; (2) component packaging or requesting support for your project's various components, such as equipment, services, and pub-

licity, from different sources; and (3) locational packaging or request-
ing support for your project according to the various locations in
which it will be created, produced, or performed.

An independent filmmaker, Robert, described how he effectively
used a variety of packaging techniques to secure support for his most
recent film. He had shot one scene of the film in a plush corporate
boardroom and later went to that company's corporate foundation
for a grant to support the film. Robert was also able to expand his
funding base by going to agencies that do *not* fund individuals. He
had made special arrangements with a professional orchestra to per-
form and record commissioned music for the film. To cover the
orchestra's expenses, Robert wrote a proposal to a local corporate
foundation that made grants to organizations only. The proposal was
submitted by the orchestra and was reviewed favorably.

Robert had received initial funding (half his total project cost)
through an open competition at a local service organization for film-
makers and video makers. He had also asked a local arts administra-
tor (with whom he had worked in the past) for suggestions of indi-
vidual donors who might be interested in his film. When Robert had
some raw unedited film available, he called two potential donors who
had been referred to him. The result: two phone calls and one lun-
cheon raised $6,000 for production costs. At the same time, he
applied for project completion funds from the NEA.

If your project can be supported in full by a funding agency, there
is no need to package it. But if you do not receive full funding, or if
your project budget is larger than the average funds available from
the sources to which you are applying, consider splitting it into sep-
arate components.

MAKING THE INITIAL CONTACT

Many artists assume that the initial approach to a funding organi-
zation is a proposal—and a lengthy proposal at that. Without excep-
tion, personnel at funding agencies with whom I have spoken offer

two recommendations to artists: (1) phone the organization first to learn more about its interests and to request current guidelines; (2) *if* a proposal is required, make it short!

Because you have prepared a project statement, you know exactly what your project entails and can go directly to your information files (see Chapter 1) to identify the organizations that offer the type of support you are seeking and for which you are eligible. If you have additional directories or source materials, scan these for ideas as well. With this information, call or write each of the organizations you identify and request current information. A phone call to a receptionist is preferable. You will receive a prompt response and will have the opportunity to ask more specific questions. A letter of inquiry will serve the same purpose.

Ask for the following information: (1) current guidelines; (2) application forms; (3) application deadlines; and (4) an Annual Report. Many organizations will not have all this information. Although most will have guidelines, many do not have application forms. A few will have no specific deadlines but will accept applications throughout the year. Some funding organizations will not distribute Annual Reports; those that do will usually list all the grants made in the previous year—providing a good indication of their interests.

Carefully review all the information you've gathered and check for:

• *Eligibility Requirements.* Are there age or geographic restrictions? Does status as a student disqualify you?

• *Grant Histories.* Who has received funds in the past? What types of projects seem to be favored? (Keep in mind that the organizations's interests may change from year to year.)

• *Level of Support.* Is the available support sufficient for your needs? (If the funds are not sufficient, can your project be broken down into phases or components that would be attractive as separate funding packages?) Is the funding limit relevant to your needs? (Some funding agencies have a maximum grant allocation of less than $500, but they still demand detailed application materials.)

• *Deadlines*. Will the proposal deadlines and notification dates (the date when you learn whether or not you received a grant award) coincide with your project needs? (If the notification date is slightly later than the date that you must begin your project, call the organization and see whether you can be notified informally at an earlier date.)

If you determine that your project is eligible for funding from a particular organization, prepare a proposal or the appropriate application form (discussed later). If, on the other hand, you need more information concerning eligibility, call or write the organization.

Exploratory Phone Calls

For many arts projects, the initial discussion with a funding official is more important than the final written proposal. Be sure you set out your abstract and each of your questions in front of you before calling a funding organization about your project. (I once called a small corporation on Long Island and its President answered the phone.) Be prepared! Introduce yourself, briefly describe your project, and state your questions. Then ask to be referred to someone who can assist you. You will find the staff people very helpful. Giving out money is their business, and it is in their interest to get good applications. Ask for the staff person's name and add it to your files in case you need to call back later.

Among the most common questions you may have at this stage are:

• Does your project fall within the program guidelines or interests of the organization? What points should be emphasized? If the project is clearly not appropriate, could the organization suggest others you could contact?
• What is the maximum amount of money for which you may apply? (Note: "How much money can I ask for?" suggests that you

will apply for the maximum amount. Even if this is your intention, use a little tact!)

• What budget categories are acceptable? Will such costs as salary, travel, and equipment be covered?

• How long will it be until you receive notification from the organization? How soon will the funds be paid? What are the procedures for the receipt of funds? (Don't hesitate to talk frankly about money. The NEA, for example, will accelerate grant funds if requested.)

• If copyrightable material will result from your project, who will hold the copyright? (This is especially important in agreements with corporations; don't wait until you receive the funds to ask!)

When you have finished your questions, thank the person you are speaking to for their assistance.

Exploratory Letters

Some small organizations, especially foundations, have no listed telephone number and no staff. The only way to reach them is by a letter sent to the Director. Keep your letter short and succinct. Introduce yourself, describe your project, and request answers to specific questions. At this stage, there is usually no need to provide a budget, but don't hesitate to ask questions about budget criteria. Remember to make a copy of your letter for your own files.

Many larger foundations will request applicants to submit a one-page letter as a preliminary step before sending a proposal. This usually ensures a rapid response from its staff, and, if they are interested, they will often work with you to make your final proposal as strong as possible. Use your project abstract as a basis for this letter. You needn't mention budget figures; just include a detailed project description. If there is any way to highlight the innovative, unique, or unusual aspects of your proposal, take this opportunity to do so. Your letter is probably arriving with a dozen other requests—and a dozen more will arrive the next day. What can you do to highlight the distinguishing features of your project?

A sample letter for an initial inquiry follows:

June 2, 1990

Mr. Hamish Ramsey, President
Wattle Foundation
Chapel Hill, SC 47782

Dear Mr. Ramsey:*

I am an independent filmmaker with substantial experience in documentary filmmaking (see attached résumé). I would like to request support from the Wattle Foundation. I hope to document the ancient art of storytelling at the 10th Annual National Association for the Preservation of Storytelling Festival in Jonesborough, Tennessee. Storytellers from all over the country will be gathering there on October 8–10 to share their stories and discuss the technique of storytelling. My objective is to bring the story, the teller, and the listener together, and thus communicate visually my own story about these oral stories. Production will begin in early October and the editing should be completed by February.

If this project is eligible for funding under one of your programs, would you please send the appropriate application forms, indicating the relevant deadline(s)? I would also appreciate receiving the program guidelines and an Annual Report listing the average size of previous awards. Would you also add my name to your mailing list for future announcements?

If my project is ineligible for funding, perhaps you could refer me to a more appropriate source.

Thank you for your assistance.

Sincerely,
Theodore Wittlesey
Pembroke Downs
Belmont, CA 94002
(702) 487-8865

Enclosure: Résumé

*To Whom It May Concern is used only if the name of the President or program officer is unknown.

Note that there is no mention of a sum of money in this letter because there isn't any need to be specific until you hear from the Foundation. The amount of money you do request should depend on the response you receive. If the Foundation only makes grants of $5,000 and you need $15,000, there would be no point in asking for $15,000 and taking the risk of being turned down when you could have waited, learned about their funding guidelines, and applied for $5,000 to begin your project.

Although it is tempting to send supplementary material at this stage, especially visual materials, it is not necessary unless your project description is unclear without them or unless they are specifically requested. Also, remember that attached materials are usually not returned unless you send a stamped self-addressed envelope.

If you do not receive a response to your letter within three weeks, phone the person to whom you wrote or, if you don't have a phone number, send a follow-up letter.

How to Handle Borderline Projects

Some projects do not satisfy the criteria of any funding source. If this is true of your project, be persistent. Locate the funding organizations that support projects in a discipline close to your own and try to speak with a program officer or the Director of the organization. Describe your project and the problems you've had in identifying an appropriate source of support and ask for suggestions.

Some time ago, I was asked to meet with Wendy, a professional illustrator of archeological texts who claimed that no funding sources existed for her profession. To my knowledge, she was right. But I encouraged her to call the organizations that funded pure archeological research. After all, it should be in their interest that archeological texts have fine illustrations. She spent an entire afternoon pouring over the funding directories and came up with a few foundation names. One was a small, local foundation that I urged her to contact. To her surprise, the Director was intrigued with her particular problem and asked that she send some sample illustrations and a letter

describing her project and needs. Within one week, Wendy received a phone call and a grant of $5,000.

Projects that do not fit comfortably into the eligibility requirements of standard funding organizations for the arts demand especially bold and imaginative approaches. Do not hesitate to make inquiries and go directly to policymakers, such as foundation directors, for suggestions and assistance.

PERSONAL SOLICITATIONS

Although most requests for funding from foundations, corporations, and public agencies are made through submission of a written proposal, a request for support from private individuals or for in-kind gifts of equipment from corporations usually involves a solicitation, either by phone or in person. When requesting support or an appointment by phone, make certain that you are speaking to the right person.

Be brief, be positive, be persuasive, and be specific. First, introduce yourself. If you have an association with another organization, such as a professional, arts, or university affiliation, mention it. This serves to legitimize your project in the eyes of the potential donor. Explain why you are calling him or her. (Did someone refer you?)

After you introduce yourself, briefly describe your project, and how it will be used, distributed, or exhibited. Describe your needs; then ask for a specific sum of money, for a particular piece of donated equipment, for the use of space, or whatever it is you are seeking. Don't let too much time pass without telling your donor why you are approaching them; you don't want them to say, "Ah-ha. You must want money!"

Be specific. You are making a business proposition—be businesslike about it. Many people become intimidated and actually fail to request support. If you don't ask for something, no one can give you what you need. When seeking funds from private individuals,

remember to mention a specific sum of money. If you don't, they will often grasp the opportunity to mention a specific amount to you—and it will invariably be less than what you're asking for! If the amount you are requesting is too large for your potential donor to consider, he or she will tell you. In this case, ask for partial funding to get your project started.

State exactly what they can expect in return for their support (a private screening, an acknowledgment, helping make an impossible dream come true). Because it is difficult to describe a project by phone, ask your potential donor whether she or he would like to visit your studio or workshop or if you could stop by the donor's office to show your work. Always think of the phone call or personal interview from the perspective of the person to whom you are speaking. Assume that you are not the first artist who has called that day. Highlight the most attractive aspects of your project.

Offer to come in person to explain your project in detail and show your portfolio or whatever visual materials you have prepared. If you have a personal interview, *always* go with well-organized, neat visual materials. If you want to take a videotape, make sure a tape deck is available. Having visual materials helps reduce the awkwardness of the interview. Go slowly through the pages or the tape with your potential donor and explain the project and your professional experience as you go along. Whatever the response, end on a positive note, and ask if the person can recommend anyone else who might find your project of interest. If your potential donor needs more time to reflect or to consult others, ask when you might expect to hear a decision and make a note of this.

If your solicitation is for a contribution of equipment, call the manufacturer and, when you get the receptionist, ask to speak to a marketing representative. If it is a small company, ask for the President. You might say something like: "Hello, my name is Milton Mittlesdorf and I am a performance artist from Seattle. I've been working on a new outdoor piece for the Seattle Arts Festival that involves computer-controlled light and sound. The piece requires two hundred light panels, model K717, and I was wondering whether

there is any possibility that the BrightLite Company would be able to contribute them, or some of them. The panels are critical to the piece and they are featured prominently. Would it be possible for me to show you or some of your colleagues the work in my studio and to discuss whether an arrangement of this sort would be possible?"

If the answer is no or uncertain, try to speak with someone else in the corporation, preferably at a higher level. Always remember to thank the person to whom you are speaking for their time and assistance.

A filmmaker, Bruce, offered his own experience as an example of requesting financial assistance by phone. Bruce had indirectly received a matching grant of $6,200 from the Massachusetts Council on the Arts and Humanities, and needed to raise an additional $10,000 to complete his ten-minute film. (The funding was indirect because a local media arts organization submitted an application to the Massachusetts Council on the Arts and Humanities requesting funds to support four film projects, one of which was Bruce's film.) He called several local individuals who were generous arts patrons and were personally or professionally interested in broadcasting. The first thing he said after giving his name was, "I'm calling concerning a project for the state arts council." The response to this introduction was always more friendly than if he said, "I'm calling about a film that I'm doing." As Bruce commented, "If ten people called you and only one left some form of identification, who would you call back? " He added, after some thought, "It may be manipulative, but it's honest." It is good business and marketing sense.

Bruce received a grant of $4,000 after a luncheon appointment with one of his potential donors. He was able to channel this check through his original funding source, the state arts council, thereby enabling his donor to receive a tax deduction. Bruce remembered to ask his patron whether he could suggest any other people who might be interested in supporting his film; he also inquired if he could use his patron's name as a reference. In Bruce's phone calls to these peo-

ple, he was able to say that "Mr. Sotheby-Smyth suggested that I call." He was also able to mention that Mr. Sotheby-Smyth had contributed to his film; because Mr. Sotheby-Smyth is a prominent business leader in the Boston area, his name helps give the same stamp of approval and legitimacy as that of the state arts council.

In phone calls or personal interviews, always offer to send written information describing your project and always remember to thank the person for their time. If your personal interview does not produce support for your project, it is all the more important to write a thank you note. You may want to return to the same person for another project request at a later date, especially as you now know his or her interests. If your phone call or interview is successful in gaining support, your donor will need a written project description and budget for his or her records.

WRITTEN PROPOSALS

Ideally, any organization to which artists can apply for funds should base their funding decisions primarily on the artist's work, not on a written description. A written proposal or an application form should supplement the artist's work, not substitute for it. In reality, a written proposal is a necessary complement. A proposal serves as a written representation of a proposed project, it is a request, a means of persuasion, a commitment, and a plan. A well-written proposal can never substitute for a mediocre project. However, when the choice is between two excellent projects, the one receiving funds will be the one that is presented in the most clear, concise manner.

Although communicating the content of a project, a proposal also expresses the writer's personality through the style in which it is written. Would you be inclined to support the artist who wrote: "My ceramic work has been exhibited and has been critically acclaimed in every major city in the United States except Denver. I now feel it is time to give art collectors in Colorado the chance to see my artistry

firsthand. In the world of contemporary ceramics, my work is considered to be some of the finest. I hereby offer the Pocket Foundation the first opportunity to fund it." The style is pompous and pretentious. By contrast, the next example, which is written in the passive voice, provides little to make potential donors enthusiastic: "As to implementation, the piece will be realized at the Becks Studio. A pilot grant has already been received, but matching funds are requested for copying and recording costs. The artist intends to complete the piece by September." Don't write as if you and the applicant are two separate persons. Be direct; express yourself in writing as you would in speech. Keep your sentences short. Put statements in a positive and persuasive form. The writing style I use in this book is simple and direct. Perhaps you could follow it as a guide.

At a recent panel review of applications from artists for fellowship support, the Director of a museum of contemporary art commented that, in his experience, the quality of the written proposal was often inversely related to the quality of an artist's work. Therefore, he would never make a decision based on the written proposal alone. Arts professionals in general are well aware that most artists, with the exception of poets and writers, do not have good writing skills and that aesthetic decisions should be based on the art work alone. But this applies primarily to applications for fellowship support where the panel members make their decision based on your past work, not your ability to carry out a proposed project. For project requests, the decision depends to a greater extent on your written proposal.

Written proposals are just as unpopular with those who have to read them as with those who have to write them. Imagine the circumstances of the NEA panelist reviewing grant applications in the fellowship category of the Design Arts Program. Each panelist receives a large notebook filled with over three hundred proposals. Because it is easy for a panelist to lose interest in a poorly written, lengthy proposal, keep your proposal brief, succinct, and interesting. But be careful not to let your enthusiasm translate itself into lengthy prose.

Proposal Guidelines

Some funding organizations will send you an application form with a series of questions to be answered. Others request only a one-page outline; still others leave the proposal format up to you. A proposal to a private individual, or a request for equipment from a corporation is usually in a format of your own creation. Whatever the case, the following guidelines should be helpful; you can use this suggested format for a proposal as a guide.

Follow Instructions

Read the guidelines and instructions and follow them to the letter. If they say not to exceed two typewritten pages, don't leave your conclusion or budget for the third page. If ten slides are requested, don't assume that twenty slides will be twice as good. If a self-addressed stamped envelope is required, remember to include it. If three recommendations are requested, don't send five unless you ask for permission to do so. If you exceed the page limit or send two folios of slides rather than one, you risk having an incomplete application sent to the panelists.

Panelists tend to base their final recommendations about your project on their initial reaction to the written proposal. Make certain that the material they receive is complete. If you are including additional visual materials, refer to it in the body of your proposal. Because supplementary materials are rarely reproduced for each panelist, they will at least be aware that more information is available, and may refrain from making a preliminary judgment until they have seen it.

Be Brief

Whether you are filling in an application form or developing a proposal of your own format, keep the written material short. Try not to exceed three pages, including the budget. I am convinced that any

proposal is improved by reducing it to this length. Furthermore, you will increase the chances that your proposal will be read in full.

Define Your Terms

What is obvious to you is not necessarily obvious to a foundation trustee or the members of a review panel. For example, a local film and video artist, applying to a major foundation for a project completion grant, neglected to include in his proposal the fact that he had access during off-hours to specialized editing equipment at a TV studio and a university. His proposal described an extensive project but never mentioned where he would be doing the postproduction work and how he had access to expensive SMPTE editing equipment—he didn't even define SMPTE (Society of Motion Picture and Television Engineers) when he mentioned it. Thus, there was no explanation for the obvious question of why the budget for the postproduction phase of his project was so small. Fortunately for him, the people reading his proposal took the time to phone and request more information. But, in most cases, if the information on the application is incomplete, the proposal will not be funded.

Another example is from an application submitted to the Music Program of the NEA by a group of experimental musicians. Their proposal reads: "We wish to purchase a combined A-D and D-A device of fully professional quality The 2/4 configuration cost, including digital interfacing, computer-selectable analog I/O filters, is $28,000." A wee bit of definition here would have helped.

Use Graphic Descriptions

Artists often find it difficult to express in writing what they believe is self-evident in their creative work. Using one art form (writing) to explain another is never easy. But because of the nature and number of funding sources and applicants, the written proposal is the most economical and efficient form of communication. Try to be as creative in your proposal as you are in your work. Paint a verbal picture

of your proposed project. Describe to the reader what she or he will see, hear, or learn when the project is completed. Use details, examples, and statistics whenever possible. Try to make the proposal as lively as the project itself.

The following example is taken from a proposal to install a temporary "Primrose Path" in place of a dirt path created by MIT students who cut across an oval grass lawn in front of the Student Center. "Where their sneakered feet usually trample on the forbidden path, I want to create a sudden and unexpected lushly blooming ribbon of primroses. . . . It may create in the minds of those who see it a sudden, totally unexpected and unpredictable shift of perception or consciousness, taking them away from the ordinariness of a usual moment in a usual day. What! A radiant strip of living color where yesterday their feet were packing down the earth and insuring, step by step, that nothing would ever grow." Although the applicant also submitted a colorful picture of the proposed "Primrose Path," it is the verbal description of what a passerby might see and experience that brings the project to life and creates the feeling of being there.

Be Neat and Clear in Your Presentation

The visual appearance of your proposal is important. If it is dog-eared with corrections throughout, the reader is led to believe that the project for which you are seeking funds will be executed just as sloppily. Finally, type your proposal.

Use subdivisions and headings in your proposal. Underline important facts and figures. Don't frustrate a panel member who is trying to defend your project at a meeting and is searching through your proposal for an especially compelling point. Highlight the important information!

At a recent panel session of a community arts council, the members found one of the proposals illegible. They sent it back to the applicant to be rewritten and resubmitted for the next deadline. The applicant had mechanically reduced the size of the type so much (to include twice the amount of information) that a magnifying glass was needed to read it! Don't defeat your purpose.

Proposal Format

For an artist, proposal writing is often the most intimidating part of applying for a grant. It needn't be. If you are not a good writer, ask a friend or a relative to help write the proposal for you. Before you begin, read the guidelines of the program that you are applying to as well as the recommended proposal format below. You should describe your project out loud, following these suggestions, and your "ghostwriter" can create a rough draft to be reviewed and edited by each of you.

Most proposals prepared by individual artists should include these seven parts: the proposal identification, an introduction, a project description, a budget, an evaluation plan, a conclusion, and appended materials.

Proposal Identification

Either the heading or the first line of a proposal should identify the nature or title of your project, your name and address, the name of the funding source or funding program, and the date. Don't use a separate title page for this. If you are including the proposal identification in a cover letter, repeat it in the proposal. Five lines will suffice:

> A Proposal for Postproduction Costs
> Submitted to the Saturn Foundation
> By Reginald Oliver Weatherbee
> 16 Center Street, Kansas City, MO
> March 18, 1989

Introduction

The opening paragraph of your proposal should state your objectives and provide the necessary background information about the project and about your ability to undertake it.

- *Objectives.* State your short- and long-term objectives, and the anticipated outcome. What do you hope to accomplish? Why is the project important to you and to your career?
- *Background Information.* Give the reader a better understanding of the reason for, and the purpose of, your project. Have other artists done similar projects? How is your project different from theirs? How are you particularly qualified to undertake this project?

Project Description

Use your abstract for this section. Be specific and detailed.

- *What* do you propose to do?
- *How* do you propose to do it?
- *Who* will participate or collaborate with you? (Include a brief description of their qualifications, explaining why they are suitable for this project.)
- *When* will your project take place? If appropriate, give a time schedule that represents the project sequence and duration.
- *Where* will it take place? Do you have permission to use special facilities?
- *How* will it be distributed or publicized?
- *Why* is your project significant? Who will benefit and how? What is the potential audience? What is the anticipated outcome? (Don't exaggerate, don't understate: be realistic.) Remember, for many funding sources, your project must have educationally or socially compelling elements as well as artistic ones.

If the success of your project depends on the participation of another individual or the use of a particular space or a specialized piece of equipment, you must secure tentative commitments from the people concerned and note it in your proposal. Simply ask the person if they would be willing to assist or collaborate with you contingent on the receipt of funds. Without this extra effort on your part, the people who review your proposal do not have enough information to know that your project can be completed as promised—and neither do you.

Budget

Prepare a budget that has several different items, such as equipment, supplies and materials, travel, salaries, and contingencies. Always give a *total* project budget, even if you are only requesting support for a portion of it. If you have matching funds or in-kind contributions, include these in the total project budget as well. Check your addition to make sure it is correct! (More details on budget preparation are provided in the next section.)

Evaluation Plan

Do you have a method to determine whether the project, on completion, will have achieved the objectives you have set? Are the results measurable? By what methods? How will the results be used? By whom?

Conclusion

End on a positive note. What will the project achieve? For the artist? For others? Will there be any continuation of the project? Will there be any direct returns for the donor or funding organization as a result of their support of your project?

Appended Materials

Do not attach unnecessary or unsolicited materials. The Program Director of the Bush Foundation in Minnesota noted that (in her experience) the most frequent mistake made by applicants is that they "send too much support material." Consider submitting photographs, slides, tapes, or visual documents. But be selective. Before you send expensive visual materials, make certain they will be returned. Many organizations will not return materials; some will only do so if a stamped self-addressed envelope is enclosed.

Articles about and critical reviews of your work give some sense

of your reputation. A résumé is helpful to show how your career has developed. Include letters of endorsement or support from people whose assistance or cooperation will be needed for your project to take place. Also, include letters of recommendation from artists or recognized authorities who can comment on your ability to carry out the proposed activity. (If these are mailed separately, make a note of it in your cover letter and remember that it is your responsibility to ensure that they arrive on time.) If you have agreements from other agencies, organizations, or individuals to match or share project costs, include these also.

When you reread your proposal or application, try to put yourself in the place of the person who will eventually read it. Can your project description be understood by someone who is unfamiliar with your artistic medium? What aspects of your project might be especially appealing to your prospective donor? Have you emphasized them? What does your project offer to the potential funding organization or donor? Can you give them publicity through your project? If so, did you mention this? How is your project different? Is it innovative, experimental, or pioneering? If so, did you address this sufficiently in your project description?

Ask yourself whether your project is realistic. Can it be completed in the time allotted? In the sequence proposed? With the budget requested?

Check your proposal for grammatical, spelling, and mathematical errors. Rather than spending your time editing it, ask someone else—a friend or a relative—to do it for you. They will be more objective; they will do it for free; and it is one thing less for you to do.

If there is a university press in your vicinity, do not hesitate to call and solicit the assistance of a copy editor to help with your proposal. She or he would more than likely read and comment on a one-page proposal for free. If your proposal is two or more pages in length, offer $10 or $15 for each half-hour of the editor's time: to check for grammar and spelling mistakes and assist with the writing and style.

Type a fresh copy or have someone type it for you. A clear, clean copy is well worth the money. Remember to make a copy for your-

self. Attach a cover letter if necessary. This should be used to recall previous contacts with the funding agency or to draw attention to a particular point. In either case, the letter should be short and type-written. Mail the proposal.

If you are sending a similar proposal to two or more potential funding sources, you will probably need to change some sections of your proposal. Reread the guidelines and objectives of each organization, then rewrite your proposal to emphasize the parts that most clearly meet the objectives of each funding source.

A Sample Budget

The following budget formats, prepared for a proposal to a hypo-thetical foundation, are equally acceptable.

The budget should be broken down into separate items, and used with subheadings (if appropriate) under each. For instance, in the example below, postproduction costs might be broken down as follows:

Postproduction costs	
Editing: 200 hours @ $10	$2,000
Titles	200
Total: Postproduction	$2,200

Common budget items and definitions are as follows.

• *Equipment*: Equipment is defined, by the NEA, as purchased equipment that costs more than $500 and has a life expectancy of two years or more.

• *Supplies and Materials*: Supplies and materials are items that will be used up during the course of your project, such as postage, phone calls, copying costs, tapes and slides, and rental of space.

• *Salary*: Note the salary and title of each person. If you are requesting the funding organization to pay for employee benefits, use the standard negotiated rate established by the employee's insti-tution and enter this figure on a separate line of the budget. Some funding organizations and donors hesitate to fund the most impor-

BUDGET

Expenses		Income	
Travel (2 R/T flights: NYC)	$ 800	Requested from Acme Foundation	$3,000
Video Camera, Model Z3	1,000	VIDCA Corporation (in-kind)*	1,000
Postproduction costs	2,200		
Total Project Cost	$4,000	Total Income	$4,000

*Confirmed by telephone with Mr. Arnold Justin, Executive VP, VIDCA Corporation, contingent on grant from the Acme Foundation.

BUDGET

	Requested from Acme Foundation	VIDCA Corp. (in-kind)*	Total
Travel (2 R/T flights: NYC)	$ 800	$ 0	$ 800
Video Camera, Model Z3	0	1,000	1,000
Postproduction costs	2,200	0	2,200
TOTAL	$3,000	$1,000	$4,000

*Confirmed by telephone with Mr. Arnold Justin, Executive VP, VIDCA Corporation, contingent on grant from the Acme Foundation.

tant part of the budget, your salary or honorarium. (Perhaps they think that artists love their work so much that they are willing to work for free. It has never ceased to amaze me how these organizations and donors think that an artist must have other sources of funds to pay for food and rent.) If you suspect that this might be the case, I suggest that you rearrange the budget so that your salary is divided up into the various sections of your project budget (e.g., preproduction, postproduction, etc.) instead of placing it on a separate line. Don't label it salary, just use one lump figure or a breakdown such as 15 hours at $10 per hour. The total budget figure won't change, but your salary figure is less noticeable and slightly more difficult for the donor to extract. It also helps reinforce the fact that a good project cannot be accomplished without time and labor on your part.

• *Travel*: Usually, no foreign travel expenses will be covered by a funding organization—and certainly no first class travel. Exceptions include grants specifically for travel abroad, for attendance at an international conference or festival, and so on. To calculate acceptable per diem expenses for room and board, call the organization to which you are applying or the Grants Office of the NEA.

• *In-kind Contributions*: To prepare a budget that represents the total project cost, use an estimated dollar amount for all in-kind contributions. If you are receiving free use of a theatre, for example, include a figure representing the rental cost as a separate line item of your total budget. The manager of the theatre will be able to give you the standard rental cost. If you or anyone else is contributing their time toward the project, include this in your budget, using an hourly rate based on annual wages. If you were able to secure the use of necessary equipment for your project as an in-kind contribution (e.g., the loan of a computer or the use of some specialized film editing equipment), attach a reasonable, negotiated price to the contribution.

• *Other*: This might include consultant fees, rentals, and services (e.g., printing and distribution costs).

If there are any unusual or inordinately expensive items in your budget, justify them in writing at the end of the budget section. Check to make sure that each item listed in your budget has been

previously referred to in the project description. For example, if no mention was made in your project description of travel to Houston to use special recording facilities, then there should be no line item for air flight to Houston and per diem in your budget.

If your project will continue beyond the period covered by the requested funding, describe how you plan to secure additional funding.

Notice the asterisk in the budget examples above. Many organizations will offer you support *contingent on* your successful receipt of a cash or in-kind gift from another funding source. If you anticipate funds or in-kind contributions of this nature, note this in your budget. This is an informal adaptation of the matching support concept. Most funding sources, especially foundations, will be more likely to provide support if there are already some funds or in-kind support or if there is an indication that their funds will result in additional support from other sources. In the last case, note the organizations to which you intend to go for support or with which you have already made preliminary contact. Clearly, this enables the foundation to achieve more impact for the same amount of money. Although the matching principle is not commonly applied *to* individual artists, it is now being more commonly employed *by* individual artists. It indicates that someone else believes that your project is worthy of funding. This, in itself, gives added weight to your proposal.

If you intend to request matching support from other funding organizations, note this on your application and list the organizations to which you are applying. Don't hesitate to seek matching funds from more than one source; if you should be fortunate enough to receive more funds than you need, you can always return them or negotiate their use for another project. The federal government usually *requires* that applicants indicate whether they are applying to other government agencies for support of the same project. This is *not* to prevent you from applying to two or more government agencies; it simply is to avoid duplicate funding of the same project by two government agencies, which is illegal.

Many people pad their budgets by inflating the cost of the project on the assumption that the funding organization will not approve the amount requested. *Do not do this.* Budgets are always carefully scrutinized. If you have reason to believe that the cost of some items will increase by the time you receive notification of funding or if some of your expenses are uncertain, you should add a line in your budget for Inflation, or Contingencies. If you anticipate numerous out-of-pocket expenses that are too small to include under Supplies and Materials, include a line in your budget for Miscellaneous Costs. Some people try to be impressive by being too economical in their budget. This usually leads to compromises in the quality of your project. Be realistic and cost out each item, using current figures and price lists. Don't ask for $8,000 if you need $11,000 to do your project properly. It is not in your interest, nor is it in the interest of the funding organization.

Budget prepatation for public art projects can be difficult, especially if your project is part of construction activity. The latter often involves contracting and subcontracting, and frequently takes much longer to complete than artists anticipate. To avoid paying unexpected project expenses from your own salary, request written estimates for all project expenses and services. Remember to add a line item for inflation if the project is to be completed over the course of a few years, since your estimates are in current dollars and will not purchase as much in two ot three years. To prepare a budget for a complex public art project, seek the advice of other artists who have been through a similar experience or refer to some of the publications cited in Chapter 2.

Never express urgency about your need for funds. It shows that your proposal is not well planned or that you didn't think far enough ahead. However, if you have applied to another organization and did not receive funds and are, therefore, trying again, at the last minute, to secure funds for a project that is scheduled to begin soon, make a note of this in your proposal. Remember that no one wants to feel that they are bailing you out of an emergency situation. Consider it a rule of thumb that people like to fund winning causes, not sinking ships.

Sample Proposals

The following sample proposal is from an application submitted by a noted American violist to a local arts council. The application form was simple; it requested the name, address, and phone number of the applicant, the amount requested, and other sources of support, if any. It also asked for a project description and budget, and it stated, "DO NOT exceed more than one additional page."

James McClintock, Violist
4125 Fields Drive
Rochester, NY 14620
May 31, 1990
(716)244-4502

Amount requested: $3,650
Matching support: None

Funds are requested to pay commission, copying, and recording costs of a new work for viola and piano by the renowned composer, organist, and pianist, Raymond Pringle. The premieres are scheduled to be in Rochester this fall and prior to that at the Williamstown Music Festival, Williamstown, Mass., in August 1991, both of which will draw national and regional press attention.

Born in May 1944, Raymond Pringle is known most widely in the United States as an organ virtuoso who has thirteen Columbia Masterworks solo recordings to his credit. He has toured with the Philadelphia Orchestra and has made more than twenty-five solo appearances in Lincoln Center in the past six years. His works have been premiered by the Indianapolis Symphony and the American Composers Alliance. His articles are widely published in music journals and his activities as both composer and performer have been the subject of articles in the New York Times and the New Yorker. He has studied composition with some of the leading teachers and composers of our time: Nadia Boulanger, Leon Kirchner, Luciano Berio, and Gardner Read. Three of his works have been published by Schirmers. He is a member of the Music faculties of The Curtis Institute and Princeton University.

This present work will be approximately twenty minutes. It will have three movements and include variations on the hymn tune

"Praise to Thee, Almighty." Mr. Pringle assures me that since he is limiting his future composition plans in favor of performance, he intends to make each of his newer works as fine an example of his art as possible. I have asked him to write a work for us to play (he will be the pianist) for a number of reasons. First of all, I like the energy and sound of his music. Second, the best way of getting to know any artist is through artistic collaboration. And third, the piece will be an artifact that I can use as a vehicle for personal artistic expression and visibility while expanding the literature for my instrument, the viola.

Over the past few years, I have sometimes used my own funds to augment the limited solo repertoire for the viola and have been rewarded with works by Alan Leichtling, Andrew Nadelson, and Barry Vercoe. I have received positive responses for new works from Tison Street, Donald Sur, George Walker, and Mario Davidovsky. Obviously, personal funds are limited and since receiving an NEA solo recitalist grant last fall, I am ineligible for further support from that agency for several years. The New York State Arts Council does not support grants to individuals for this purpose. For a solo violist such as I, who has played five recitals in NYC in the past decade, the production of new musical resources is vital to the performing career. If the Arts Council funds this work, its contribution will be mentioned with gratitude in the printed programs of all performances, on recordings and in all subsequent printings of the work.

BUDGET: $2,500 Sonata
 150 Copying costs
 1,000 Recording and editing fees
 $3,650 Total

Accompanying this application was a résumé for James McClintock.

I have chosen this application as an example because it is simple, clear, and fairly well written. James emphasized those aspects of the project that would be most appealing to the Arts Council. He also justifies why he wants to commission Mr. Pringle rather than another

composer. Furthermore, he states why he is coming to the Arts Council for support of this project and why he is requesting the full amount rather than matching support. Either James or his typist forgot to underline the *New York Times* and *The New Yorker*, and should have checked a style sheet for the correct handling of "Praise to Thee, Almighty." Also, the budget would have been clearer if the first item was listed as Sonata Commission.

The second proposal was prepared for a small foundation that "supports original works in the realms of scholarship and the arts." Their letter to prospective applicants reads: "We do not have a formal application form. To apply for a grant, submit a typed, one-page outline of your proposal stating the amount requested, and include a résumé. Please do not include unsolicited supporting material. We will advise you if further consideration can be given to your request."

Proposal to the Jupiter Foundation
For Research and Manuscript Preparation
From Deborah A. Hoover, 20 Ames Street, Cambridge, MA
November 16, 1983

I am currently engaged in research and manuscript preparation for a book that will be a resource for artists working in every discipline—music, film, dance, photography, visual art, etc. *Supporting Yourself as an Artist* is based on a course I taught at MIT. It will serve as a handbook and reference for practical information about financial resources and technical assistance programs available for individual artists. I would like to request a grant of $2,000 from the Jupiter Foundation to help cover travel, materials, and research expenses associated with the writing of this manuscript. Oxford University Press has agreed to publish the book.

Supporting Yourself as an Artist will recommend appropriate methods by which artists can seek current information about funding and service organizations; it will not list the names of these organizations, as this information is easily accessible. Whenever possible, specific examples will be used, whether they are taken from interviews with key officials nationwide or from case studies

derived from artists. Observations from foundation staffers, corpo-
rate officers, individual donors, and public officials will lend the
book verisimilitude and give artists a glimpse of support structures
from the inside.

To my knowledge, the existing literature written for artists
includes: (1) listings of foundation and government agencies that
provide support for nonprofit organizations and individuals (inevit-
ably out of date and poorly indexed); (2) nonprofit organizations
that offer technical assistance programs for a fee; (3) professional
consultants or managers/agents; (4) books or pamphlets about pro-
posal writing; and (5) other artists. None of these is either adequate
or comprehensive. Of the handful of books written specifically for
artists, none helps an artist determine the support structure and cat-
egory most appropriate for a specific project and few discuss means
of support other than grants. As an alternative, my book will outline
a logical and creative method of targeting resources for a particular
project or problem and of approaching an organization or individual
in person, by letter, or through a proposal. Although many specific
questions cannot be answered, those organizations, programs,
books, and magazines that offer this information will be recom-
mended throughout the book and in the appendices.

Most books written about financial and technical assistance are
directed toward arts organizations and not artists. Many of these
books, and many of my colleagues, assume that both the problems
and the means of securing support for arts organizations and indi-
vidual artists are identical. My research and experience indicate sur-
prisingly different information. I therefore anticipate that *Supporting
Yourself as an Artist* will be useful and informative for artists, arts
administrators, arts educators, and for foundation, corporate, and
government officials.

Seven years of working with grant-making organizations oriented
toward individual artists, both at the National Endowment for the
Arts and at the Council for the Arts at MIT, will inform and enrich
the book.

A résumé was attached to this one-page proposal. Notice that
there is no detailed budget. Because the letter from the Foundation

asked only for "the amount requested," that's all that was included. However, it may have been wise to phone or write the Foundation to confirm this or to add a sentence giving more detail about "travel, research, and materials." There is also no indication of when the book is scheduled for completion and whether the author is engaged in this project on a full-time or part-time basis. Only one sentence, the last, describes Deborah's qualifications, but because a résumé is attached, this is probably sufficient. Finally, the proposal would have been strengthened if Deborah had added that the Jupiter Foundation would be acknowledged for their support in the preface of her book. This might be considered obvious, but without stating it in writing, it is not a commitment to the funding agency.

Neither of the two proposals follow the suggested format in detail, but each includes the necessary ingredients. Both are clear in purpose, well organized, and cohesively developed. And both provide the information that is requested.

OVERVIEW

The process of seeking support can be as imaginative as the activity for which you are seeking it. Writing your proposal or calling a potential donor by phone can be done quite easily and with a relatively small investment of time. Having been done once, it becomes easier to do again. The early planning stage is crucial. Without sufficient planning, your efforts will be undirected, your opportunity of receiving support will be reduced, and the probability that you receive rejection letters will be increased. The planning stage need not be time consuming; it usually involves a few phone calls and a few letters, lots of creative thinking, and the completion of a brief outline. But it is important that this process take place over an extended period of time so that you can generate more ideas for potential sources of funds, you can meet more deadlines, and you can seek advice from others. Individual artists have many options for support, but it is often difficult to identify them. Give yourself time to explore as many as possible. It is well worth the effort!

5

Follow-
through

THE REVIEW PROCESS

There is no standard review process. Each different funding source
has its own particular method of reviewing requests for support, and
each does so according to its own timetable. Usually, the material
reviewed is limited to the applicant's proposal and letters of recom-
mendation. Personal interviews or site visits with each applicant are
uncommon, primarily because of the expense and time involved.
Apart from the unfairness of giving some applicants the opportunity
to present their work in person and excluding others, this practice
diverts the limited funds available from supporting creative work.

 In a corporation with a small budget for charitable giving, the
President often makes decisions concerning all requests. He or she
may simply read the mail and separate the "yes" pile from the "no"
pile. Corporate foundations generally have a contributions commit-
tee consisting of employees who volunteer to review applications,
discuss them, and make recommendations to the President of the
corporation or the Director of the corporate foundation. Requests for
in-kind donations are usually reviewed by the same committee or, in

some cases, by the Vice President in charge of the division that manufactures the requested product.

In large foundations, the staff and the Director have a good deal of weight in the decision-making process, although the Trustees usually make the final decision. With small foundations—where the Trustees may be a husband and wife or two brothers and a sister—the decision may be made in a living room one Sunday afternoon or during a late night telephone call. Individual donors can usually make their decisions based on a quick look at the figure they budgeted for charitable contributions during that tax year.

Government agencies, such as the NEA, state arts councils, and local arts councils, generally use the peer review system. Artists working in a similar discipline are asked to review the proposals and attend meetings to discuss them and arrive at a group decision. Recommendations of the panel are then sent to the Board of Trustees or the Foundation Director for the final decision. Although the panel decisions may be contested by the Trustees or the Director, their recommendations are rarely changed without further consultation. A few government agencies do not use the panel system; members of the state arts commission in West Virginia and Oregon, for example, review and act on each application.

If you have ever applied for government funds, you probably will want to know who makes the final decision about your proposal. If this information is not given in the guidelines, feel free to ask the personnel at the funding agency. Sometimes this information is willingly divulged; sometimes it is not. If it is, use the information judiciously. Although panelists often go out of their way to become familiar with the applicant's work, I would not recommend that you try to discover the names of the review panelists or trustees for the purpose of advocating your proposal. More often than not, this will work against you.

If you submit visual or audio materials or a manuscript with your proposal, be selective. Include a representative sampling—not just your most recent work. If you are unclear about the amount of work you should include, enquire. If you find it difficult to chose a repre-

sentative sample, ask a friend to help you. Remember that some organizations will not return your work unless a self-addressed stamped envelope is enclosed and some smaller organizations will take no responsibility for the return of your work. Find out their return policy before sending anything.

Be certain that the organization has the equipment necessary to properly view your slides, tapes, or films or listen to your recordings. If your work is not easily reproducible, discuss possible alternatives with the staff. Some years ago I assisted a holographer who was requesting fellowship support by arranging for her to set up her laser equipment in a seminar room of the NEA so that staff members of the Visual Arts Program could see her work. Photographs or slides of holograms give no sense of the third dimension. Her alternatives were to request that the NEA send a staff or panel representative to see her holograms, that they ask one or more local arts professionals to send a written report to the panelists, that she show the original work herself, or that the panelists base their decision on slides alone. She chose the third option.

Decision making based on peer review is remarkably fair. Artists' work is reviewed two and three times and written proposals are reviewed over and over in detail. At the end of a panel session for the Cambridge Arts Council's CITY ARTS grants that extended over five weeks and included many five-hour sessions, a young painter and member of the panel commented that the process should have been taped for the benefit of the applicants who, like himself, often believe that their proposals are not reviewed in an objective manner. His apprehensions about the fairness of the process had disappeared after his participation on the panel.

Review Criteria

The most common criteria used to review proposals from artists are:

1. The quality of the artist's work.
2. The degree to which the project meets the objectives of the funding agency.

3. The degree to which the project makes the best use of program funds.

A fact unknown to many applicants is that the most common reason proposals are rejected is not lack of quality but the failure of the proposed project to meet the objectives of the funding program. In nationwide interviews with funding officials, I have found six common reasons why applications from individual artists are rejected.

1. *The application does not meet the criteria stated in the guidelines.* The guidelines for the MIT Arts Council's grants program, for example, require "broad student participation, performance, or exhibition." And yet, we often receive project proposals requesting support for creation or production costs, with no mention of dissemination or presentation.

2. *Lack of funds.* If the guidelines state that the maximum request for fellowship support is $2,500, don't request $2,825.

3. *Poorly prepared applications with insufficient information.* The applicants frequently do not state the significance of their project— to themselves and to a larger audience—and do not explain why they are particularly qualified to undertake the project. A common mistake in preparing proposals is to omit important information—material that you take for granted, but reviewers do not. For example, a filmmaker submitted an application to his state arts agency and described how his proposed project required extensive computer equipment and expertise in computer animation and special effects. Yet, there was no indication that he had access to the equipment or that he had the necessary experience. Consequently, the application was rejected. To avoid such a situation, have a friend or relative read your proposal. Also, try to submit your application early and ask the staff member to whom it is addressed to let you know if any information is missing.

4. *Inaccurate budgets.* Budgets frequently do not relate to the project description and are unconvincing. If your application states that your solo dance performance will be publicized through mailings and posters, your budget should include a line item for printing, design, and mailing. If your design or printing costs are being

donated by a friend or a corporation, make a note of it in your budget instead of omitting the expense altogether.

5. *Applications do not provide the information requested.* For example, the MIT Arts Council application forms state, "Include project dates." Yet, many applicants simply write that there will be "two performances" or a "six week exhibition," but they give no indication when the performance or exhibition will take place.

6. *The artist assumes that the reader is familiar with the project and predisposed to support it.* Consider an application that reads

> I have accepted an invitation to be part of the international ARS ELECTRA 1983 exhibition in Paris. At the last minute the French Government has cut their funds and I therefore must appeal to the Merlin Foundation to sponsor my participation— enabling me to provide kinetic features for display at the Museum.

The circumstances are understandable, but there is no description of ARS ELECTRA or "kinetic features." Neither is it clear why the applicant "must" seek the support of this particular foundation.

Notice that not one of these reasons for the rejection of proposals from individual applicants relates to the merit of the proposed project or activity. They are statements about the quality of the proposal preparation, not about the quality of the work.

PEER REVIEW PANELS: AN EXAMPLE FROM THE NEA

Although there is no standard review process, most government art agencies and a growing number of other funding organizations employ the peer review system, for which the prototype is the NEA. The following description is a report of a panel review session from the Visual Arts Program of the NEA in 1980. This particular meeting was to review applications for fellowships from painters and sculptors and to decide on finalists. As in most fellowship review panels, the decisions are based primarily on the art work itself—in this

case, slides. The same open and frank discussion is familiar to the review of written proposals. Notice that, even without a written proposal, you can increase your chances of receiving support by giving special consideration to the quality and the selection of your representative art work, whether it is slides, tape, film, or manuscript.

The report quoted here is from a longer article, "Behind Closed Doors," by Stephen Sinclair (1980). Note in particular the composition of the panel members, the detailed discussion, the checks and balances that exist, and the importance of good visual materials. As with most panel meetings, members first decide on the process they want to use—how they want to review the material and make decisions.

February 4. The pre-screening committee of the panel convened. Its members were Thomas Garver, director of the Newport Harbor Art Museum in California; Nilda Peraza, executive director of Friends of Puerto Rico and its Cayman Gallery, a nonprofit artists' space in SoHo; Katherine Porter, a non-representational painter from Maine; and Martin Puryear, a sculptor and teacher from Chicago.

Visual Arts Program Director James Melchert told the group that they were members of the fourth artists' fellowships panel for 1980. Panels on video art, conceptual and performance art, and printmaking and drawing had already met and chosen grantees. Because painters and sculptors make up the largest group of applicants, the program set aside three days for pre-screening and four days two weeks later for the final selection.

"Each application-review panel, unlike our policy panel, is an ad hoc group that meets only for a short period to choose grantees," Melchert explained. "By having different application-review panels each year, more artists and curators have a chance to participate; rotation allows us to bring in a larger number of different aesthetic positions. One year an artist's work may be rejected, but the next year a different set of eyes will review it and may look favorably toward it.

Nancy Drew, coordinator for individual artist programs, told the panelists that they would be viewing seven slides of each artist's

work. "Go at your own pace, marking the names on your score sheets as *in* or *out*. Two votes for *in* will keep an artist in the running. If you feel very strongly for something, mark the name with a capital *I*, and it will be kept in despite other votes. You can abstain if for any reason you feel uncomfortable about voting on any artist."

Melchert offered a final reminder: "We're looking at the quality of the material. The purpose of these grants is 'to stimulate creative activity'— as the Endowment's legislation puts it. Grant-giving is not a charitable activity; we don't award a fellowship to an artist because he desperately needs money. We usually don't even know that. We just assume that everyone who applies needs a grant."

The panel set to work. Each of the four panelists had a light box in front of him on which he looked at sheets of slides. Since each panelist was looking at a different set of slides at any single moment, no discussion took place.

February 5. "It is very tiring physically," said Katherine Porter. "We were here until 10:30 last night."

February 6. By 6:00 p.m., the pre-screening was over. About 1,100 out of the original 3,700 applicants remained to be considered by the full panel.

"I was disappointed in the quality of some of the slides," Garver said. "It's bad enough looking at good slides of artworks—it's like listening to a symphony over the telephone. But slides that are hard to see—because, say, they're not lit right or because it's a pattern painting against a brick wall—are a real mistake. When they have the chance of receiving thousands of dollars, artists should invest in better slides."

February 19. The four pre-screeners were joined by Alex Katz, a representational painter from New York; Nancy Holt, an environmental artist and sculptor, also from New York; and Ed Levine, chairman of the Visual Arts Program's Policy Panel, who sat in on three days of the meeting but did not vote.

Melchert reminded the panel that all the decisions were theirs, that the Endowment staff were on hand only to provide information and keep score. Drew told them that at this point, they would decide which of the 1,100 remaining artists to eliminate by

writing down a score of one to five for each artist. The staff would take the average mean scores, and those with three or higher would stay in the running.

Together the full panel looked at slides. All seven slides submitted by each artist were projected simultaneously As each set of slides came up, a staff member read aloud the name, age, and city of the artist, the medium and dimensions of one of the works, and the time span during which the works were created.

Panelists seemed reticent in their reactions, though they occasionally exclaimed in awe or dismay, laughed or groaned. Once in a while, a panelist would describe the technique or intention of an artist's work, especially if the slides seemed misleading.

February 20. By the second day, the panel was more talkative. Almost every set of slides provoked comment.

Nancy Holt informed the panel that one environmental artist's work was much better when actually seen. "It has a kind of science-fiction, UFO feeling. He really can create an eerie effect."

Peraza wondered "why [another artist] submitted slides of his paintings. His sculpture is really much better."

Katz said another painter's works "keep moving with the light when you actually see them. They look a lot more substantial; these slides murder them."

Garver, conscious of being from the West Coast, took pains to put the works of many of the Western artists in the contexts of their other work and the art communities they live in.

February 21. By mid-day, the panel had looked at all 7,700 slides. After lunch, Melchert spoke to the panel about the next stage in the process: paring down the remaining 350 artists to about half that number—a painful task required by the number of dollars budgeted for fellowships.

Drew also told the panel that though there were two grant amounts—$3,000 and $10,000—they should now concentrate only on who should receive grants, and not how much they would get.

At this point the panelists voted aloud. One artist's work provoked Katz to say, "I'm ashamed of myself, but I like it."

Holt reached a pitch of exasperation about paintings when confronted with some very bright, cartoon-like works. "I think these are dreadful. I wouldn't hang one anywhere near me. You'll have to explain this to me." Katz's reply: "They're punchy, snappy, decorative. Really, there's a lot going on in these pictures, and they're very well painted."

At another point, Holt defended a sculptor whom Porter accused of being "merely titillating," and another whose highly intellectual works are "about time and stilled motion." In one case, Katz told Holt, "I'll vote for it on the basis of what you say, since you are a sculptor and understand this better than I."

February 22. Continuing the final review, the panel eliminated about 150 applicants. The final results: 96 grants at $10,000; 120 grants at $3,000 and a satisfied panel and staff.

"I think it was really very fair," said Porter. "Some artists whom I thought deserved grants didn't get them, but they were considered and rejected on their merits." (Sinclair, 1980, pp. 6–9)

NOTIFICATION

The notification period (the time between proposal submission and notification) can vary as much as the review process. For some small foundations, individual donors, and corporations, the turnaround time is rapid. For corporate foundations, government agencies, and many foundations with a large staff, it usually takes from one to six months.

If a funding organization has submission guidelines, there will be a notification period or a notification date. If it is listed as April, or spring, wait until April or early spring and then inquire as to when you might expect to hear from them. Don't make a nuisance of yourself by calling every week to see if any action has been taken on your proposal. One phone call should be sufficient. In the unlikely circumstance that no notification period is listed, call or write and inquire when you might expect to hear from them. Similarly, if you requested support from an individual or a corporation and have not

had a response within two or three weeks, call the person to whom you spoke. Ask if they have had an opportunity to review your proposal or request and inquire when you might expect to hear from them.

Sometimes a program officer or a panelist will let an applicant know before they have received written notice that their work was favorably reviewed. If this should happen to you, do *not* begin work on your project until you have written notification in hand. The panel decision can be changed or the amount you were awarded may be different from what you had requested. Also, if there is a specific project starting date, budget expenses incurred before this date may not be covered by the grant.

A video artist from Minneapolis who had submitted a grant application to the Media Arts Program of the NEA heard from a staff member that his proposal had been favorably reviewed. The artist began to order equipment and materials and then received a letter saying that his grant was for half the amount requested. Apparently, the panel had received so many good applications that they decided to award twice as many grants for half the stated amount. Try to avoid this type of situation by waiting for the notification letter before beginning your project.

Success: Its Responsibilities

Should you receive a grant award, celebrate: then go back and reread your original proposal. Review the commitments you have made and the time schedule for the project. Also reread the award letter. What are your obligations to the funding organization? What are the instructions concerning allocation of funds? If your project involves other people, contact them immediately and send them a copy of the proposal, the grant announcement, and the accompanying information.

Accepting a grant award or an in-kind contribution means accepting the responsibility to properly account for its use. Keep your funding agency or donor informed of your progress, even if it is only twice

a year. And maintain records of all expenses for your project on a daily basis. You should have a special folder or notebook for each project you are engaged in. For fellowships, you usually will not need to account for your expenses as part of your final report. But, for project grants, you will be expected to submit a full account of your expenses. To further complicate matters, some grants will only be paid on a reimbursable basis after you incur the expenses. If you have no receipts, you will receive no money from the granting organization. Fortunately, most grants to individual artists are awarded in one lump sum and you only have to account for your expenditure when the project is completed.

Regardless of the method required to receive funds or account for expenses, you should keep accurate records for your income tax forms. More information about taxes and record keeping is given in the last section of Chapter 2 and in *The Art of Filing* (Messman, 1987).

Rejection Letters: Learning from Them

If you receive a letter saying you were not awarded funds, don't despair. Read the letter again carefully, and try to understand what it means. Some are straightforward letters of rejection leaving no possibility for discussion, but others leave the opportunity for negotiation or resubmission. There is often more stated in the letter than you grasp at first reading. The following examples will serve to illustrate the most common statements found in rejection letters, and I will outline your options in each case.

A straightforward letter of rejection is brief and usually gives no explanation for the decision. I once received the following 3 × 5 card from a small foundation:

> The T Foundation, Inc., acknowledges with thanks the receipt of your appeal to which it has given careful consideration. The Foundation regrets sincerely that it cannot respond favorably to your request.

There was no personalization whatsoever on the card, and no signature. One wonders how any foundation that has such a depersonalized approach could give careful consideration to anything, let alone express feelings of regret. Even though the foundation personnel did not take time to write out a one-sentence explanation, the meaning is clear. Don't bother to apply again!

Occasionally, the response from a funding agency will be more personal and descriptive:

> Many facets of your endeavor are of interest to the Trustees; however, we are supporting only community-based projects within the state of Arkansas. We thank you for giving us the opportunity to review your proposal and we wish you every success.

Even though the answer is still a definite no, you are at least assured that someone read your proposal and that their reaction was positive. Furthermore, if you should develop a project that fits within their guidelines in the future, you would probably submit it, whereas it is improbable that you would want to have any future contact with the T Foundation.

It is common to receive a rejection letter that reads: "Due to the lack of funds . . . " or "Because of the large number of exemplary applications, we were unable to recommend approval of your request. . . . " This does not mean that your proposal is not a good one or that there is no potential for funding from this organization. It means only that the demand for funds is much greater than the supply and that there may be some room for improvement in your proposal or your proposed activity. If a telephone number is given, call to inquire if the agency's staff can offer more information to help you rethink your proposal, and whether they recommend that you resubmit it. Most funding agencies will be cooperative and helpful. On request, government agencies, under the Freedom of Information Act, will also provide comments from reviewers. Give careful thought to these comments and consider making changes in your proposal. Then resubmit it to this agency or others.

Suppose that you are unable to obtain specific reasons for not receiving support or that the reasons given clearly indicate that your project does not meet the criteria of the funding agency. Reread the agency guidelines. If your project does not fall within their mandate, it cannot be funded by them, no matter how good it is. Reevaluate your proposal. Seek the counsel of a local arts administrator who can be objective about the quality of your proposed activity, its presentation, and its appropriateness for the funding agency you chose. Decide together whether your project should be resubmitted, resubmitted with changes, submitted to other funding organizations, or abandoned.

If the only reason given for the rejection of your proposal is "lack of funds," resubmit it. Sometimes the letter itself will suggest that you resubmit your proposal. Or if you call a staff officer, she or he may discuss possible changes in your proposal and suggest that you resubmit it for the next deadline. If this happens, by all means follow their advice. At government agencies, insufficient funding is the rule, and there are always many more excellent applications than can be funded. Don't let your pride stand in your way. No funding organization will ask you to resubmit a proposal unless its staff has every intention of giving it serious consideration.

In Fiscal 1987 the Visual Arts Program of the NEA received 5,266 fellowship applications but were only able to fund 251, or 4.8 percent. The program director was the first to admit that there were many more than 251 artists worthy of fellowship support. When I worked at the NEA, I was continually surprised at the number of artists who did not resubmit their proposals when they were advised to do so. Their chances of receiving funds were extremely high, and yet their misunderstanding of the review process caused them to lose confidence in their work and miss an opportunity for potential support.

Some rejection letters are extremely constructive, helpful, and genuine in their interest. One I received as Director of the Council for the Arts at MIT from the Director of a government agency stated, "When your project proceeds beyond the preliminary stages to a series of concerts, we would be interested in talking about a

proposal." It then went on to suggest three other potential sources of funds for the preliminary research and ended, "I hope this information is useful, and I am sorry I cannot be of more help. Please keep me informed as to your success in securing funds, and please let me know if I can help in any other way." My response was to follow up on every suggestion and to use the Director's name as an introduction. I also called him later to report on my progress, and he continued to offer more suggestions.

Keep in mind that the most difficult part of the job for, say, a staff member at the NEA, is explaining to disappointed (often angry) applicants why their proposal was not funded. NEA staff can be extremely helpful to you if you let them. It is their job to encourage top quality proposals, and they will go out of their way to assist you if your proposal meets the guidelines. Frequently, they are highly knowledgeable in your field; many times they are part-time artists or amateur artists, and they may have excellent suggestions. Use the rejection letter as an opportunity to learn. It may be easy to become frustrated, but this will not help secure funds for your project. If you believe in the quality of your work, you should make every effort to explore all possible options. Above all, remember that a good proposal writer has usually written many unsuccessful proposals.

All artists—the known and the lesser known—have received their share of rejection letters, even when the projects were worthy of funding and appropriate for the guidelines. Every artist has gone through long periods with little success and no reassurance from outside. After a recent reading of her short stories to a standing-room-only crowd at MIT, the writer Grace Paley remarked: "All of the stories in my first book came back [from the publishers] fifteen times." Be persistent and have confidence in your work. It may be that sixteenth time that you receive adequate support and recognition.

The Imprudent Decision: What to Do

Suppose you were that video artist from Minneapolis and you discovered too late that you did not receive full funding. Or suppose

that you were depending on funding, you begin your project, and then discover that your application is rejected. You realize that you would never have been in this situation if you had followed my advice and waited for the letter of notification, but what do you do now? Consider three options.

1. Reduce the scope of your project. Are there aspects that could be changed without severely affecting the project's quality? Could you divide your project into sections, and begin the first phase while seeking support for the next phase, or for its completion?

2. Seek the advice of personnel at the funding agency that turned down your proposal. What suggestions or comments can they offer? Can they recommend other sources of support that would be more appropriate?

3. Consider other sources, such as those that provide project completion funds and loans. Call your local arts agency, state arts agency, the NEA, and the Center for Arts Information in New York City for suggestions and information about funds and loans or reread *Loans and Emergency Funds* in Chapter 2.

DONOR RELATIONS

Communications

How would you feel if you contributed funds to an artist's project and then she or he seemingly disappeared from the face of the earth? You certainly would not consider another request from that artist. By not acknowledging support received from an organization or donor, you are reducing your chances of obtaining further support.

The media artist, Nam June Paik, is well known for the postcards he sends to people and organizations that support his projects. With just a line or two about his latest videotape or thoughts about a new project, he maintains a warm relationship with the people who fund him. I recently received a postcard from a visual artist who had

obtained exhibition support from the Council for the Arts at MIT.
It read:

> To all at the Council—My return trip was delayed due to visa
> problems but I'll be back in Cambridge from Feb. 10 to May 10,
> then back to Europe for 3 exhibitions, 1 lecture, and 2 conferences
> scheduled already. Plans for the MIT exhibition are unfolding
> nicely. Very best wishes, Marc. Sending separate sample of one
> of my numerous European activities.

Because one of your best sources and suggestions for future fund-
ing is your present and past contributors, it's worth the postage to
keep in touch. Postcards are better than phone calls because they will
inevitably be added to your permanent file, and your effort to remain
in touch will be the first thing a staff person sees when they open
your file.

Acknowledgments

Always acknowledge your donor or sponsoring organization unless
they request anonymity. Whether a funding agency, corporation, or
individual provides you with financial or in-kind support, you should
give them the appropriate credit for their assistance.

The most common way to formally acknowledge your donors is to
add a credit line to all written publicity material and publicly dis-
tributed material. This includes posters, catalogs, invitations, pro-
grams, films, tapes, recordings, and advertisements. Most credit lines
are given at the bottom of posters, the back of programs, or the end
of tapes; in books and catalogs there is usually a special page for
acknowledgments at the beginning. The most common credit lines
are: "Made possible with support of Venture Electronics, Inc." or
"Supported in part by a grant from the J. Pringle Foundation" or
"Sponsored by Cortland Computers, Inc., and Mr. and Mrs. Vin-
cenzo Evergood." If you ask, the donor organization will provide the
wording it prefers.

You can also acknowledge your donors in a more personal way. If you are scheduling a special prescreening of your work or an opening night reception, invite your donors. If you have many donors, consider scheduling a special screening or gathering. Write or call them to say thank you. Invite them over to your studio for a drink. The little things sometimes mean the most, and it all contributes toward a continuing relationship.

NEGOTIATION

There are always variables in a project that are subject to change. You may receive funding and then learn that a crucial, specialized piece of equipment is no longer commercially available or that a key person is not able to coordinate his or her schedule with your own. You may discover halfway through the project that you will not be able to complete it or to meet the objectives stated in your proposal. What do you do?

The best approach is to be frank. Call or write the funding agency; if you have developed a relationship with someone on the staff, speak directly with them. Let them know exactly what has happened and what your alternatives are. If useful, send a full account of the funds you have spent to date. For minor changes in your project, a letter describing the changes will be sufficient notification for the funding agency. For major changes that alter the nature of your project, you must seek approval, usually in writing, from the funding agency. If the project cannot be completed as originally outlined, its staff may have helpful suggestions or they may be willing and able to allocate additional funds to bring the project to a successful completion.

Your funding agency has a vested interest in your project, and its staff is just as interested in the project's success as you are. From the moment you receive support, consider the funding agency as an ally and a partner. If your project fails, you both stand to lose. If it succeeds, you both gain. The funding agency can be proud of its role in

making the project possible, and your chances of receiving support from them in the future may be increased.

PROJECT REPORTS

I know from experience that after putting your time and energy into a proposal, one of the last things you need is to write more about your project. You want all of your time for your work. But no one should expect to receive funding and not have to account for it. Whether or not you are formally asked to submit a final or interim report, you should do it as a matter of course. Most organizations request final reports in their letter announcing a grant or support; others state it in their instructions. The NEA usually includes a sentence in their program guidelines stating, "Failure to submit reports may affect a grantee's chance of receiving future funding." Because the term final report is rarely defined, there are several ways to fulfill this requirement with little effort.

A final or interim report should consist of two parts—a financial and a descriptive report. Your descriptive report does not always have to be written; nor does it have to be extensive. It could consist of a photograph of the completed project or a program from the performance. It could be a newspaper review or publicity material. If you prefer a written statement or if one is requested, it can be one paragraph long. The organization or donor simply needs to know whether the project was completed and whether it met your stated objectives.

John David Mooney, the environmental artist from Chicago, firmly believes that comprehensive and beautiful presentations about his work are the key to continued and future funding. From the many projects in progress in his studio, his presentations seem to pay off quite handsomely. As a means of appreciation and documentation for organizations or individuals that have provided major funding for his projects, he prepares a comprehensive portfolio of photographs and

plans enclosed in a specially designed wooden case. He also makes a duplicate copy for his own use to show to potential funding agencies and patrons. The careful preparation he puts into these reports is a clear indication to potential donors that if they choose to commission or support his work, the result will be equally as well executed. In essence, John David has successfully applied his artistic talent and aesthetic sense to the task of obtaining his support.

The financial report can be simple. For tax reasons, you will already be accounting for each of your expenses on a project basis. An easy way to organize your financial report might be to keep a large manila envelope for each project, recording every expense in appropriate columns on the outside of the envelope or on a separate sheet of paper that you can store with the receipts. In this manner, you can use different columns for various categories of expenses, for example, one for equipment, one for supplies and material, one for travel, and one for your own time. Add up the figures when you have completed the project, and you have your financial report.

OVERVIEW

Seeking support for your project doesn't end with the proposal or the solicitation. It doesn't end at all. The process illustrated in the schematic representation in the Introduction is a continuous cycle. The follow-through, or the personal communication with the funding agency or donor, leads right back into the planning stage and the search for further funding. The proposal or the solicitation of a potential donor is the midpoint in this process; although it provides the primary point of connection, it is to your advantage that it not remain the only one.

~ 6

Looking Ahead

What chance do artists have of earning a living from their creative work in the United States today? If you are an artist with several years' experience, the answer may not surprise you: your chance is low. To illustrate, recent data on the economic status of visual artists, craft artists, media artists, choreographers, composers, playwrights, musicians, dancers, actors, and theatre production personnel in New England showed that in 1981 the average yearly income of an artist was $6,420. To earn this income, an artist incurred nonreimbursed expenses of $3,554. The average income of an artist from all sources was $15,644, and the average household income (including earnings of other household members) was $27,297 (Wassall, 1983, p.21).

Several conclusions can be derived from these data. First, the level of financial support for artists is low. Second, the creation and sale of art is not very profitable on average. Third, the number of artists competing for funds is much greater than can be sustained by the current limited pool of funds. Fourth, many artists may not have the appropriate skills to handle the business aspects of their career. The first three points raise issues of the role of the arts and artists in society and the willingness of private individuals, foundations, cor-

porations, and different levels of government to provide support. These are longer term policy questions outside the scope of this book. The remainder of this chapter will address the fourth point and explore what artists and those concerned with promoting the arts and supporting artists can do on their own and collectively.

While there is an obvious need to encourage greater support for individual artists from both private and public sources, it is also clear that greater attention has to be given to the structure of the education system and the training opportunities for artists. My experience as an arts administrator has shown that many artists either do not effectively draw on the support available to them or do not know how to do so. As a result, some of our finest artists are suffering severe financial limitations that reduce the scope, the quantity, and no doubt the quality of their work. Some artists have taken the opposite route by developing the entrepreneurial skills to use an institutionalized system that encourages consumerism and mass taste. The majority of artists are educationally unprepared to manage and support their careers in a manner that allows them to retain their standards of individual endeavor and to work responsibly as a professional.

Artists require preparation for the business aspects of their career: they need to understand how to recognize a legal or business problem, how to take advantage of the institutional and other opportunities that are available to them, and how to increase their potential pool of support and funds. The demand for this information might best come from artists themselves. Just because it isn't taught at art school doesn't mean that it isn't necessary.

My objective in this book has been to provide you, the artist, with a set of procedures that will help you increase your chances of identifying and securing the support you need as well as broaden your knowledge of the resources available to assist you in securing this support. The model presented in the Introduction provides the framework for the entire text. The procedures I recommend are iterative. Once begun, they build on themselves. You initiate the process by your decision to undertake a new project—for example, to

study dance with a European master, to set aside time to write poetry, or to experiment with new materials, such as lasers or video-discs. Having defined the project, you can begin to identify potential sources of support by using some of the techniques I suggest—drawing on your existing knowledge and contacts and on the new sources that emerge as the search progresses. As you have seen, the process of identifying sources of support itself uncovers new information and contacts that add to your potential support network. Having identified a potential funding source, prepare a proposal or request support in whatever form is appropriate. No matter what the outcome of the request, you should make every effort to obtain more information to help redefine your project, identify alternative sources of support, and assist you with future projects.

The support structures described in this book are diverse and complex—reflecting the pluralism in our society. The procedures followed by the five major sources of support—foundations; corporations; local, state, and federal governments; private donors; and arts service agencies—are often difficult to understand because very few consistencies exist between one foundation and the next, or one corporation and another. However, it is not necessary for artists to become experts on the procedures for each of these sources of support. What they should know is how to ask questions relevant to their needs and to whom these questions should be addressed. There are many more sources of funding and assistance than are currently being effectively canvassed by most artists, and many nonfinancial resources could be utilized by artists to secure and protect the resources they have.

A favorite argument of those who, for various reasons, object to public support for the arts is that art has always been created no matter what material conditions the artist has had to endure. Undoubtedly, others will continue to make the same point because there are numerous famous examples to support it. Artists such as Balzac, Bartók, Gauguin, Keats, Jean-François Millet, Mozart, Musorgsky, and Schubert received little or no recognition and remuneration for their work during their lifetime. Though this may have

been the case, in my view, we should turn the question around and ask what other works of art these artists might have created had they not been deprived to such an extent or had they even been encouraged somewhat. Rarely have we inquired what it might mean to our cultural development if artistic activity were to be widely encouraged and adequately supported. Later in this chapter, I will explore specific ways the arts community can contribute to this type of cultural development: (1) by providing a more suitable education in the arts for both artists and audience; (2) by increasing the opportunities for artists to create, through changes in legislation and through greater flexibility and imagination in the support provided; and (3) by helping artists become more aware of their personal and professional rights.

Although artists have a responsibility to manage their affairs efficiently and take advantage of all opportunities of support available, they will have many difficulties doing these things effectively without the cooperation and dedication of the people and institutions who provide the support. To this end, I would like to confine my closing remarks to some observations about this support and possible recommendations for change. I hope this book will encourage arts administrators, arts educators, funding organizations, and advocates for the arts to reevaluate and, if necessary, restructure their current funding and training programs and lobbying efforts.

Many inconsistencies exist between the support structure for individual artists and their practical needs. Most funding for artists in the United States is formulated on a project basis. The artist is expected to live from project to project with no certainty that support for the next project will materialize. Furthermore, it is often much more difficult to get support to cover living expenses than it is to raise funds for equipment and materials. The time needed to raise these funds is often inordinately long. The information about available resources is inadequate and unnecessarily complicated. Moreover, there are few opportunities for artists, early in their careers, to learn about or seek assistance to develop their financial and administrative skills.

RECOMMENDATIONS FOR STRENGTHENING SUPPORT OF THE INDEPENDENT ARTIST

To strengthen the support for individual artists and encourage their efforts, there is a need to address the *process* through which the artist interacts with the individuals and institutions that provide support. Fundamental to this process are the linkages among artists, arts administrators, and arts educators. Although members of the second and third groups can provide artists with information, resources, and support, their effectiveness will be limited unless they fully understand the needs of practicing artists. None of the three—artists, arts administrators, or arts educators—can function effectively without the others.

If artists are to have more time for creative activity, they should make their needs and concerns known to arts administrators and arts educators who, in turn, should begin to address these needs through programming activities and instruction based on a deeper understanding of artists' economic, aesthetic, and practical problems. The challenge for the three groups is to establish a creative dialogue designed to expand and improve the support available for artists.

For arts administrators to assist artists more effectively, it is essential that they, too, actively seek the suggestions of individual artists and create more opportunities to hear, see, and understand the day-by-day realities of an artist's life. Just as some artists may be tempted to remain all day in their studio or workspace, leaving it to others to press for changes in support systems, arts administrators may be tempted to focus on their immediate administrative concerns rather than spend time meeting with practicing artists. It is easy for both artists and arts administrators to become centered on their own respective concerns and not initiate a dialogue. Ways of encouraging this mutual exchange include having artists on the boards of arts organizations, encouraging other board members to seek the counsel of artists, and opening policy meetings to artists.

Similarly, for arts educators to more effectively assist their students, it is important to reassess the curriculum and base it on the

career *realities* of young alumni, many of whom are now entering the profession ill prepared. It may be convenient for arts educators to play down the more technical and practical aspects of their students' education, but this is not in the best interest of the students. And it is certainly not consistent with the aims of providing artists with a "proper" education.

The recommendations that follow are intended to strengthen the relationship among individual artists, arts administrators, and arts educators. They relate to three areas: the education of artists, arts administrators, and audiences; opportunities for artists; and artists' rights.

Education

The Training of Arts Administrators

Currently almost thirty graduate arts administration training programs exist in the United States and Canada. The curricula indicate that students receive training in accounting, management, and marketing for nonprofit organizations. The graduates of these programs have to assist artists—either in one-to-one situations or as policy makers. Yet, because their training focuses almost exclusively on the arts and not the artists, these graduates are relatively unprepared for one of the major tasks they face as arts administrators. The information they learn about how to manage arts organizations is inappropriate when applied to the problems confronted by the individual artist. And even if some of the problems that the artist and the arts organization face are similar, the solutions, as my research has illustrated, are often different.

I urge that those in charge of these graduate programs in arts administration reassess their curricula to ensure that they provide opportunities for students to learn about and understand the needs and concerns of individual artists through direct contact with independent professional artists. This can be accomplished in several ways. Practicing professional artists might be included among the

visiting faculty, or as advisors to the program in the capacity of a visiting committee. Internship opportunities could be made available in artists' studios. A required course could relate exclusively to the needs of individual artists and the opportunities available to support them; established artists of various disciplines could be invited to participate—not to "perform" but to talk about the problems they have encountered throughout their career and the suggestions they have for addressing them. Alternatively, each student could be assigned to work with a professional independent artist for several hours a week—identifying sources of funding, helping to write proposals, exploring marketing opportunities, and, most important, learning firsthand the positive aspects and drawbacks of being an artist.

I have, at times, found it hard not to be impatient with artists who don't understand how government agencies or foundations work and that you usually must plan at least six months ahead for proposal requests. Yet it took me a while to realize some very basic facts about the manner in which artists function—they, for example, do not have an organization to provide their social security, pension, or insurance. Most arts administrators are not familiar with the statistics quoted at the beginning of this chapter and, consequently—often without knowing it—require inordinate sacrifices of artists. A good arts administrator should understand the problems, concerns, and needs of the individual artist. One of the most direct ways of doing this is to begin to expose students to these issues in arts administration training programs.

Increased Understanding of Contemporary Art

One way to ensure greater support for the independent artist is to expand the audience for contemporary art through education. We need to encourage more collaboration between arts administrators and teachers of primary and secondary schoolchildren to develop programming that will engage young students with the work of living artists. Two methods have been used to date—taking the stu-

dents to the places where artists work and perform and bringing artists into the classrooms. Schoolteachers have traditionally taken their students to visit the local art museum or to attend a performance of the symphony orchestra. These institutions have developed education programs for the schools and prepare both teacher training packets and materials for each child. To encourage teachers to visit the contemporary art museum, a concert of experimental music, or an artist's studio, we need to encourage and support educational programs at these institutions or with these artists.

Students of every age might be encouraged to experiment aesthetically and sharpen their perceptive skills. The long-run benefit of educating the public in arts appreciation, especially contemporary arts appreciation, is to stimulate public demand for work and services that artists have the capacity to create. As the future audience and patron of art and artists, the educated public are more likely to be receptive to contemporary work and provide greater support so artists can expand their contribution to our society and culture.

The Education of Artists

It is not unusual to find an artist who is highly creative but has little understanding of business or management. Whether artists are self-trained or attending a conservatory or arts school, they need to learn how to deal with the problems of day-to-day existence, such as obtaining financial support, maintaining accurate records, and arranging for adequate insurance. Many arts educators believe that the economic, management, and financial problems of being an artist are too technical or practical to be included in an artist's education. Other arts educators feel personally challenged when an outsider suggests that their students will not be adequately prepared for their career unless they have some training concerning opportunities for support, financial management, and legal problems. I suggest that training schools for artists begin to address these issues in a thorough and professional manner. Some schools offer optional seminars in this

area; others engage the services of the local VLA to teach one or two sessions on a special topic. This is a start, but it is by no means sufficient. At the minimum, student artists might be offered a full semester course—perhaps even a required course—which addresses the issues discussed in this book.

Other disciplines have developed entire courses designed to prepare the young professional to manage and secure her or his future career. Artists deserve no less! Law schools include classes, such as The Legal Profession and Legal Writing. Classes in Management Skills are designed to improve writing and speaking skills of graduates in public administration. Health care training programs include courses in Government and Private Funding for Research and Health Care Programs and require students to take clerkships. In other disciplines, graduate students work with their professors on proposals and research projects and coauthor articles for publication, thereby learning valuable skills that help them as they establish their own careers. Courses such as Management Skills or Funding for Artists should be equally as commonplace in the curriculum for artists.

Most young students are not yet aware of the problems and dilemmas they will confront; therefore, the demand for these courses cannot be expected to come from them. Rather, it may more appropriately be alumni, visiting committees, and deans who insist on these additions to the curriculum.

Professional career training for artists can be provided in at least four ways.

1. Agencies that serve artists could develop a series of lecture/presentations to be delivered by a trained staff member who might adapt relevant material to the specific needs of the audience. These presentations could also be videotaped and made available to educational institutions and artists' groups throughout the country; the agency could suggest local professionals who could attend the videotape screening and address questions. Similar material might be broadcast over local cable networks. Some organizations, such as the

Philadelphia Volunteer Lawyers for the Arts, already have begun small programs of this nature.

2. As part of their training, student artists could be required to serve an internship with active professional artists—artists who express an interest in having such assistance. The students would participate directly in the daily demands of marketing, promotion, and meeting financial and material needs. By doing so, they would also be providing valuable assistance to the professional artists.

3. University administrative units in the arts could establish centers to assist student and faculty artists in their search for funding and marketing opportunities. These centers would also assist with the preparation of proposals and, if possible, solicit major funding for a university grants program to support fellowships, research, and new works in the Arts. A model for such a center is the Grants Program and Technical Assistance Program of the Council for the Arts at MIT (Hoover, 1984).

4. Faculty in arts administration might prepare a course specifically for artists, drawing on the variety of available written material. To supplement class discussions, they could invite outside professionals to present their own points of view. They may include local representatives from foundations, government agencies, corporations, and arts service organizations, as well as lawyers and accountants.

Accessibility and Accountability of Funding Organizations

Any funding agency, whether public or private, has the responsibility of providing adequate information about their programs—and to provide it, when requested, in a timely fashion. A recent publication by the Council on Foundations noted that, "Fewer than 600 foundations issue an annual public report. Only a handful of nonfoundation corporate contributors publish any information about their grantmaking" (Council on Foundations, 1982, p.120). My own experience with small foundations has been particularly frustrating. Letters to them often go unanswered, and information of any sort about program guidelines and funding criteria is nonexistent. Responsible

grantmaking should go hand in hand with public reporting of funding programs and priorities.

I do not suggest that costly administrative effort should go toward providing information of this type. I would rather have as much of the organization's funds as possible directed toward philanthropic efforts. Information in the form of guidelines and annual reports is relatively inexpensive to provide. Basic guidelines describing an organization and its funding procedures can be extremely beneficial both for the individual artist and the funding organization. By discouraging unrealistic proposals, these reports promote a more efficient grantmaking program.

Opportunities for Artists

Increased Teaching Opportunities for Artists

It is unrealistic to think that in the near future public support will be increased to a level where full funding is provided for a large number of professional artists, therefore, a more practical and immediate solution is to increase opportunities in the area that presently provides the primary source of income for many professional artists—teaching.

There are a number of ways in which this can be done.

1. Artist-in-residence programs could be expanded to provide more opportunities and to include artists of every artistic discipline. Funding could come from corporations, federal agencies, and social institutions. Building on the success of existing artist-in-residence programs and organizations, such as Affiliate Artists, opportunities for artist residencies could be expanded to include more public and private institutions, factories, corporations, and neighborhoods and be expanded to last for longer periods of time.

2. Institutions of higher learning and training schools for artists could engage on their faculties both professional educators and professional artists for the teaching of art and the training of artists. My own institution, MIT, seeks practicing artists for its faculty in

the arts and architecture, with the result that teaching and research are firmly rooted in everyday experience. A young, budding composer would be more likely to be exposed to the *realities* of being a composer from an active composer/instructor than from an arts educator or historian whose experience has largely been defined academically. These benefits might accrue to the young undergraduate majoring in mathematics as well as the music major: both students would learn to appreciate not only music but also musicians.

The benefit of such proposals to the community, to students, and to artists is clear. More people—whether students or employees of a corporation—would be given the opportunity to participate in and appreciate the arts through an intimate experience with an individual artist.

Increased State Support for Artists

Each state arts council should work with both its legislature or the private sector to initiate or increase direct support for individual artists. Priority should be given to multiyear fellowships that provide funds for career development. In this manner, a small number of outstanding artists would have the opportunity to work for a period of, say, three years, in a secure financial environment where they are free to take risks and explore more ambitious goals. For similar reasons, additional funds might support grants for travel and for longer-term residencies. At present, thirty-four states offer fellowships for artists, but only Ohio, Massachusetts, Minnesota, and New York have developed multiyear funding programs. Seven states offer travel funds for artists.

In states where legislation prevents the arts council from making grants to individual artists, other models of support could be explored. For example, in Massachusetts, the Artists Foundation, Inc., an independent agency, provides direct support to individual artists. It attracts funding from the state arts council, corporations, and private foundations. This has allowed foundations and corpora-

tions that are otherwise discouraged from providing direct support to individual artists to accomplish the same objective through the Artists Foundation.

Imaginative Means of Corporate Support for Artists

Although many corporations provide support to individual artists, very few corporations do so through a formal publicized program. Most corporations do not have staff trained to make the artistic judgments necessary to decide between one artist's proposal and the next. Therefore, funding individual artists is an understandably risky enterprise for most corporations. With a little imagination on the part of arts administrators, this risk can be overcome.

Frank Conroy, former director of the Literature Program of the NEA, suggested such a collaborative arrangement to the Wang Corporation of Lowell, Massachusetts. Fifty of the 1985 Fellowship recipients, including fiction writers, creative prose writers, and some translators, received not only a fellowship from the NEA but also a year-long loan of a Wang word processor. Mr. Conroy noted that the majority of the 1985 fellowship applicants wrote in their NEA proposals that they were planning to purchase a word processor if awarded a grant. By proposing this imaginative matching arrangement to the Wang Corporation, Mr. Conroy was able to offer the fellowship recipients money, which buys time, and a word processor, which enables them to use their time effectively. The Wang Corporation is not in the position to decide which of the many artist/applicants writing to them for word processors are qualified recipients of an in-kind gift. The proposal from the NEA's Literature Program solves this problem and also enables the Wang Corporation to take a tax write-off for their gift.

This type of opportunity, whether involving contributions in-kind or in cash from corporations, has great potential for the support of individual artists. The initiative could originate with imaginative arts administrators who are operating existing programs of support for individual artists.

Intermediary Artist Service Agencies

Many professions have training programs or other mechanisms designed to give structure to the difficult years of career entry. The arts, as yet, offer no such program, even though there is a great need for it. I propose a new type of arts organization to serve as an intermediary artist service agency—intermediate between the young individual artist and organizations that can potentially provide the artist with resources. The agency would serve as a nonprofit "agent" for artists of every discipline who are just beginning their careers.

Among the services it might provide are:

1. Facilitate the artist's move into his or her particular market by arranging for performing, screening, distribution, publication, and exhibition opportunities.

2. Assist the artist in securing financial support and material and technical resources.

3. Develop promotional materials for the artist, including a résumé.

4. Help the artist in the negotiation and understanding of legal contracts.

5. Serve as an institutional sponsor for the artist.

The agency would be responsible for providing management and educational services to artists for a negotiated fee. As a nonprofit, tax-exempt organization, it would have the additional benefit of being able to attract funds from individual donors, foundations, and corporations. And as a nonprofit organization, its sole interest would be that of the artists it serves. With a year or two of this type of assistance, the artist should be able to manage his or her own career. The artist will then know not only the questions to ask but where to go to get answers.

The type of intermediary artist service agency I recommend might be supported in part by the state arts agencies within the region they serve. Artist eligibility could be on a competitive basis, possibly

linked with state arts council fellowship recipients or through inde-
pendent panels of professionals from each field.

Marketing Information and Assistance

There is little up-to-date marketing information for artists who are
trying to sell or distribute their art work. Artists of every discipline
would be well served by accessible, affordable, and accurate infor-
mation about marketing opportunities as well as guidelines for
addressing questions concerning pricing, distribution, and deciding
whether and how to work with an agent.

A few prototype examples exist of publications listing marketing
opportunities. The Artists Foundation, Inc., in Boston, for example,
announced such a publication for fine artists, *Artists Guide to New
England Galleries* (1984)—"a directory of more than 200 commer-
cial, nonprofit university galleries, crafts shops, and exhibiting artists'
associations in the six state New England area." This type of publi-
cation could serve as a model for others focusing on media artists,
literary artists, and performing artists. To best serve artists, the most
appropriate producers of these publications may be the seven
regional arts groups—Arts Midwest, the Consortium for Pacific Arts
and Cultures, the Mid-America Arts Alliance, the Mid-Atlantic Arts
Foundation, the New England Foundation for the Arts, Inc., the
Southern Arts Federation, and the Western States Arts Foundation.

Because information about marketing opportunities can quickly
become outdated, the ideal format would be a computer database—
or, better, an interactive computer database that could provide per-
sonalized information, depending on the user's needs. For a modest
fee, artists could either reserve time for themselves on the computer,
phone or write in their specifications to a staff person who could pro-
gram the computer accordingly and send a printout of the informa-
tion; or log into the computer database through a phone line and
monitor at their local or state arts agency.

The availability of this marketing information is not sufficient.

There should be technical assistance programs through local arts agencies and artists' training programs to teach artists how to use this information and how to identify an agent or representative who could market an artists' work in a satisfactory manner.

Incentives for Investment in Contemporary Art

Arts advocacy groups could propose new legislation that would encourage and promote increased investment in the work of contemporary artists. One such suggestion is offered by attorney Stephen E. Weil, who is Deputy Director of the Hirshhorn Museum. He noted (Weil, 1983, pp. 220–21):

> There might ... be a provision parallel to the present Section 1034 of the Internal Revenue Code, which defers to a later time any capital gains tax otherwise payable on the sale of a taxpayer's residence provided that the proceeds realized are used to purchase a new residence. By giving collectors an incentive to use the entire proceeds from the resale of a work of art—both their initial investment and any profit realized—to purchase additional works of art, substantial additional moneys could be brought into and kept in the market for contemporary art.... Whatever the formula, the object would be to provide an incentive for recycling back into the market—and thus back to artists—100 percent of the funds invested in every kind of art, ancient and modern, domestic and foreign....

Such a proposal could be qualified to stipulate the work of living artists. This type of legislation appears to be more effective in addressing the central issue for artists—that of providing new sources of funds—than the frequently suggested alternative of establishing resale royalties.

Opportunities for Commissioned Work

Arts administrators at the state, city, and local level could be more vocal, supportive, enterprising, and imaginative in suggesting that

special civic occasions be celebrated through commissions to artists. The few examples of this type of opportunity for artists with which I am familiar have been overwhelmingly successful, both for the community involved and the artist.

The city government of San Antonio commissioned choreographer Gerald Arpino, Artistic Director of the Joffrey Ballet, to create a ballet capturing the spirit of the city. In another example, the mayor of Pittsburgh, Pennsylvania, commissioned composer John Harbison to write a piece in celebration of the opening of the Pittsburgh subway. Entitled "Fanfare for Job Well Done," it was performed by members of the Pittsburgh Symphony Orchestra in a downtown park following a parade of hard hat construction workers. These projects resulted in tremendous publicity for both the city and the composer; both also provided new funds for new works of art.

At MIT, the Committee on the Visual Arts planned a May Day celebration to dedicate the arrival of a new sculpture on campus— Michael Heizer's sculpture *Guennette*; the day also coincided with the 350th birthdays of Cambridge and Boston. Landscape architects Martha Schwartz and Peter Walker were commissioned to design an edible outdoor sculpture—a 170-by-100-foot grid of almost forty thousand pastel-colored Necco candies laid end to end and overlapped by a grid of 144 pastel-painted automobile tires. The temporary garden paid homage to the whimsey of spring and mirrored the Beaux Arts formality of MIT's Killian Court, where the sculpture was temporarily installed. The event attracted students, local community residents, art critics, the press, Necco wafer fans, and employees from the nearby New England Confectionary Company.

New and Expanded Percent-for-Art Legislation

Arts advocacy groups need to strengthen their efforts to promote percent-for-art legislation for all publicly funded building projects and to increase the percentage of funds available for such work in existing legislation. Architects and developers of major privately funded construction should also be urged to adopt a similar policy.

The percentage figures should be both fixed and mandatory so that they are not subject to the whim of changing administrations or unrelated budgetary constraints. The base figure on which the percentage is established could be better clarified; in most cases, it is calculated on the actual construction or renovation cost. If possible, existing state buildings and construction projects involving renovation should be considered as part of the percent-for-art legislation. Many statutes could also be interpreted much more broadly to apply to new highways, prisons, power plants, and sidewalks, for example. University fine arts deans could be encouraged to promote a similar percent-for-art policy for the construction and renovation of university buildings.

Imaginative percent-for-art legislation or policy could involve permanent works of visual art for a building or its surroundings, collaborative works involving artists with architects, planners, and community residents, or temporary works in any art form to be commissioned for the building's dedication or to take place in or around the building over an extended period of time.

Public art provides visibility, recognition, and employment for artists; it increases the general public's awareness of contemporary art; and it visually enriches the environment.

New Marketing Opportunities

With the rapid advance in communication and distribution systems, significantly increased opportunities now exist for artists to enjoy broader audiences for their work. Some of these systems include computers, video, cable TV, compact disc, videodisc, and satellite transmission. Because these opportunities are often beyond the reach of the individual artist, artists' service organizations and arts councils might be encouraged to serve as project sponsors and producers and to exploit these systems in marketing the work of individual artists.

Statistics show that televised performances of opera and dance have had a direct and positive impact on the audience for live opera and dance. Bringing the arts to people at home has proven to be one of the best ways to transport people from their homes into the per-

formance halls. The same thing can happen for individual artists. In the not too distant future, more personalized modes of video will be even more effective in expanding the audience for the work of individual artists. Soon, we will have access to "private" viewings of exhibitions, artists' portfolios, screenings, and studio tours as well as readings by poets, writers, and playwrights in our own living rooms. We will also be able to enjoy interactive discussions with an author or artist through the use of "personalized" movies via home computer and videodisc. As videotape and videodisc players and microcomputers are being aggressively marketed to, and purchased by, millions of home owners, arts administrators could be actively assisting artists in an equally aggressive marketing campaign to reach this same audience.

Artists' Rights

Artists as Their Own Advocates

Look at the composition of the board of trustees of any arts organization, institution, or art school nationwide and count the number of artists included among them. Whether you consider a presenting organization, an arts service organization, an arts council, a museum school, or an arts advocacy group, the answer is the same. Very few.

Our arts organizations could better serve the interests of the arts and of artists if individual artists themselves were involved in the policymaking and advocacy efforts. Most boards need to include a high percentage of people who are able to provide the financial support to operate the organization. But it is equally important that the leadership include people who are informed and knowledgeable about the concerns and perspectives of professional artists. If every state and local arts council had artists—both mature professional artists, and younger, emerging artists—involved in their governing bodies, I believe that more of these councils would have funding available for individual artists and that the funding currently available would be more effectively directed to meet real and pressing needs.

Similarly, symphony orchestras, concert managements, cinemas, and museums might find it easier to embrace and encourage the work of contemporary living artists.

The lack of representation of professional artists on the boards of art schools and institutions may be one of the major reasons that the curriculum has not prepared artists for the practical concerns facing them at the time of career entry. The contributions of a professional artist to the policymaking and educational practices of art schools are unique. If there were vigorous student demand, the representation of professional artists might become the rule rather than the exception.

Better Health Insurance

Good and affordable health insurance is a basic and pressing need for independent artists working in every discipline. At present, there are numerous group health insurance plans for an artist to choose from, but they vary tremendously in cost and scope of coverage. In 1986, the Visual Arts Program of the NEA issued a final report from a study investigating the feasibility of health insurance for independent artists. The report, entitled *Insurance Project: Feasibility Study for a Nationwide Health Insurance Plan for Independent Artists*, concluded that a comprehensive nationwide insurance plan would be feasible if made available to artists by the insurance industry. (The report is available from the Public Information Office of the NEA.) Further development of an insurance plan requires a sponsor in the field and test marketing.

The American Council for the Arts is in the process of compiling a directory of health insurance plans currently available to artists. Such a directory would include basic information about how to contact a listed plan, as well as an evaluation system that would provide artists with an easy guide to the benefits and costs of various plans. A directory would also encourage networking among organizations currently providing insurance and those seeking to do so, and could indirectly lead to increased access to insurance coverage for artists.

Ideally, the information would prove helpful to organizations contemplating development of an insurance plan for artists. The ACA is also designing a survey to determine the health insurance-buying motivations of individual artists.

It is important that the NEA continue to address other areas of artists' needs, including unemployment insurance, studio insurance, and pension funds. Let us hope the initiative taken in the area of health insurance will be the first step toward a more comprehensive analysis of other insurance needs of the independent artist.

Authors' Lending Royalties

The notion that authors should be compensated for the lending of their books in public libraries is known as public lending rights or public lending royalties. Although The Authors Guild in New York has supported this idea since 1979, the concept was not introduced in Congress until Senate bill 2192 on November 8, 1983, by Senator Charles Mathias, Jr., Republican of Maryland and Chair of the U.S. Senate Subcommittee of Patents, Copyrights and Trademarks. The bill is still pending Congressional approval. If passed, it will establish a National Commission on the Public Lending of Books. It reads: "to consider whether specific compensation for authors for the lending of their works would promote the economic health of authors and authorship in the United States; and, if so, to make recommendations concerning appropriate procedures for determining the amounts and methods of payment to authors from funds to be appropriated by Congress or from a national trust fund established for that purpose" (Senate bill S.2192). These recommendations would be the first step toward a system under which authors would receive financial benefit from the "use" of their work beyond the original purchase price of a book—for example, compensation somewhat comparable to that now given by federal law to composers for radio play of their music.

The Authors Guild is providing support and information for this Senate bill and is planning to work closely with the National Commission on the Public Lending of Books when it is established.

Although many authors and authors' organizations nationwide have been articulate and vocal about their support of this bill, considerably more support must be demonstrated; it should come not only from writers and other artists, but also from artists' service organizations and arts advocacy agencies.

Various types of author lending royalty plans have been enacted in Australia (1974), Denmark (1946), the Federal Republic of Germany (1972), Finland (1961, but implemented in 1964), Great Britain (1979, implemented in 1982), Iceland (1967), the Netherlands (1971), New Zealand (1973), Norway (1947), and Sweden (1954). In these plans, authors are paid through general tax revenues, not by borrowers or libraries. A variation under consideration would place a cap on the payment to any one author, with excess funds going into a common fund providing travel and scholarship funds for authors as well as administrative costs. The returns from lending rights are small— the estimated average payment to registered British authors in 1984 was US $390, with a maximum payment of $7,500—but so is the average author's earnings (Mitgang, 1984). The average author in the United States earns less than $5,000 annually from his or her writings (Arensberg, 1984). Equally important as the compensation is the encouragement to authors, which would be substantial.

These recommendations are intended to improve the conditions under which artists work. If acted on, they would enhance the contribution that artists can make to our society. They would also help us understand the needs of artists and improve the opportunities available to address those needs. Finally, they would direct more funds and services to individual artists.

More funding alone is not sufficient to improve the condition of artists. Increased funding does not necessarily imply that better art will emerge. On the other hand, the idea that artists have to suffer to be creative is romantic nonsense. If people are interested in art for the positive contribution it makes to our society and culture, then our society should ensure that there is adequate support for our artists.

SUPPORTING YOURSELF AS AN ARTIST:
YOUR EXPECTATIONS

The information in this book will enable you to better support and protect yourself as an artist, and it will open up new funding opportunities. It will not solve all your problems. If this book could help you to get rich, buy a fabulous studio at rock-bottom prices, or become famous, everyone would be an artist. If you expect or feel entitled to make money immediately from your work, then being an artist is probably not the right career choice for you. Most likely, the reason you are an artist is your compulsion or inspiration to create. If you also have talent, then you have the opportunity to build a successful career as an artist. But talent is not enough to ensure that you will be financially successful as an artist. You will probably have to work very hard to support yourself. Those of you who have these qualifications should, after having read this book, be better informed about the opportunities and the problems you will confront during your career. Unlike many artists before you, you will have the benefit of knowing how to deal with some of the decisions that lie ahead—decisions that are critical to your personal and professional well-being. You will also be able to acquire the skills and knowledge you need to help you survive as an artist. In a very real sense, you will know how to help yourself.

Among the greatest losses to the cultural heritage and identity of our society are the many outstanding artists who have turned to far less satisfying, although financially more rewarding jobs because they did not know where to go for support. There are more than a million working artists in America. The majority are not aware of the variety of funds, services, and assistance available to them. Opportunities are not lacking—but you, the individual artist, must take advantage of them.

Appendix A
Résumé
Preparation

CONTENT

A résumé is a written summary of your qualifications and experience. It includes a brief biographical sketch as well as information about your educational training, your accomplishments as an artist, and your related employment experience. It is indispensable as a means of presenting yourself for employment; for exhibition, publication, or distribution opportunities; for potential collectors; for grant applications; for education opportunities; and for use as a reference tool. If you are presenting yourself as an artist, your résumé should include only the professional experiences that relate to your artistic career—not your part-time job as a waiter or waitress, for example.

FORMAT

Your résumé should be divided into sections, each of which highlights an important part of your artistic career. A visual artist, for example, might organize his or her résumé under headings of Edu-

cation, Solo Exhibitions, Selected Group Exhibitions, and Related Work Experience. A filmmaker might use the headings Production Experience, Video Editing Experience, Education, and Teaching. Younger artists with less experience may choose a chronological format and list information year by year.

A four-part format is suitable for most artists.

1. *Personal identification.* Put the most important information first—your name, address, and the phone number(s) where you can be reached during the day. If your résumé is to be sent abroad, remember to include your country.

Résumé

ALISON ROSS BLACK

497 West 107th Street, Apt. 7A
New York, New York 10025
(212) 476-2544 (Home)
(212) 591-5846 (Studio)

EDUCATION

M.F.A. 1984 State University of New York,
 College at Purchase, New York
B.A. 1982 University of Wisconsin, Madison, Wisconsin
 Magna cum laude

HONORS AND AWARDS

1987–88 Residency at the Experimental Television Center
 Owego, New York
1986 New York State Council on the Arts
 Individual Project Grant
1985 Creative Art Award, Ithaca Art Association
 Ithaca, New York

2. *Education.* This section should include the name and location of your college, dates of attendance, degree earned or your specialization, and date of graduation. Only list the courses that directly relate to your career. If you had a high grade point average, were graduated with honors, or received an award or special recognition, note this. Also include special training courses, master classes, or apprenticeships.

3. *Artistic accomplishments.* Your professional qualifications as an artist should include your exhibitions if you are a visual artist (divided into solo and group exhibitions); your publications if you are

SELECTED EXHIBITIONS AND PERFORMANCES

5/87	Alternate Space Gallery at West Broadway New York, New York "Live Space: Performance with Sculpture and Dance"
2/86	Roy R. Neuberger Museum, Purchase, New York "Inside Art: A Performance"
6/85	Festival Ithaca, Ithaca, New York "Art and Technology Installation"
11/84	Arnot Art Museum, Elmira, New York "Performance Sculpture"
6/84	Festival Ithaca, Ithaca, New York "New Stagings: Video and Performance"
7/82	The Showing Room, New York City "Collaborations: Getting to the Art of It"
7/81	The Center Gallery/Art Place, Madison, Wisconsin "Video One"

PROFESSIONAL EXPERIENCE

1988	Children's Museum, New York, New York Consultant for exhibition "Footlight Parade"
1985–86	H. F. Johnson Museum of Art, Ithaca, New York. Exhibition design and installation

a writer; or the names of new works and their date of performance if you are a choreographer or a composer.

4. *Related experience.* If you have worked in a commercial gallery, spent a summer internship as a theatre technician, done odd jobs for a local arts organization, or taught dance courses at a local school or college, include this information here. If you belong to professional associations, note them here unless the list is long enough to warrant a separate heading.

It is generally assumed that you will be able to provide references on request, therefore, there is no need to include a statement to this effect or to list names of people who will write letters of recommendation for you.

For most purposes, a résumé should be no longer than one or two pages. Be selective about the information you include and use only the points that illustrate the development of your artistic career. As you acquire credentials, add them to your résumé and eliminate the less important ones.

Your résumé should be neatly typed and free of grammatical and typographic errors. Always ask a friend or relative to read your résumé for corrections in style and grammar before it is typed in final form. A visually unattractive résumé, with typing mistakes, corrections, and poor layout, is not a good indication of professionalism and artistic competence. If you cannot type well yourself, pay a professional typist to do it for you and have it duplicated. Use good quality 8½ × 11 paper.

THE COVER LETTER

Rather than revise your résumé every time you submit it, attach a brief cover letter that directly addresses the current circumstances. In this way, you can send the same résumé to a grant-making organization, a publisher, a gallery owner, or a potential employer. Address the letter to an individual by name and refer to some of the

points in your résumé that you expect would be most interesting to the person. Always end the letter with a specific statement about your intention to call to arrange an appointment or interview. Don't wait for them to call you.

February 4, 1990

Fulton City Arts Commission
15 Main Street
Fulton, Missouri 75144

Dear Ms. Johnson,

In response to the CITYARTS grant announcement, I have attached my résumé and application form for your review. My residency last year at the Experimental Television Center greatly enhanced my experience in video presentations of dance performances. I would like to pursue this interest further, as described in the attached proposal. I shall be in town at the end of this month and would appreciate the opportunity to discuss the proposal further with you. May I call you next week to arrange a time?

Thank you very much for your consideration.

Sincerely,
Alison Ross Black

Appendix B
Organizations
Cited

Accountants for the Public Interest
1625 I Street, NW
Washington, DC 20006
(215) 659-3797

A nonprofit organization that encourages the spread of public interest accounting in the United States. Provides free accounting services to individuals and organizations nationwide that otherwise would not have access to needed professional assistance. Newsletter and quarterly. For a partial listing of API offices nationwide, refer to Chapter 3.

Affiliate Artists
37 West 65th Street
New York, NY 10023
(212) 580-2000

An organization coordinating residencies for solo performing artists including classical singers, instrumentalists, actors, dancers, choreographers, and mimes. To be eligible, artists must be in the early midstages of their careers and have the potential to become major performing artists. Paid residencies are arranged in communities across the country for periods of one to six weeks.

Alternative Spaces Residency Program
(See: City Beautiful Council, City of Dayton)

American Alliance for Theatre and Education
Division of Performing Arts
Virginia Tech
Blacksburg, VA 24061-0141
(703) 961-7624

A national service organization for professionals in the theatre and theatre education. Activities include conferences, publications and advocacy.

American Composers Alliance
170 West 74th Street
New York, NY 10023
(212) 362-8900

A national membership organization that represents American composers of concert music. Advises members on "workaday problems"; performs services in the areas of copyright, licenses, contracts, and legal protection. Serves as an information center.

American Council for the Arts
1285 Avenue of the Americas
3rd floor
New York, NY 10019
(212) 245-4510

A national membership organization for individuals and organizations interested in the arts. Its purpose is to provide professional development services to strengthen cultural activities in the United States and to develop new possibilities for arts expansion and support. Publishes and distributes numerous materials.

American Craft Council
401 Park Avenue South
New York, NY 10016
(212) 696-0710

A service organization for collectors, professional designers, architects, and crafts people. Stimulates public awareness and appreciation for American crafts people working in ceramics, glass, metal, textiles, wood, etc., through museum exhibitions, visual aids, and publications.

American Craft Enterprises
P.O. Box 10
New Paltz, NY 12561
(914) 255-0039

The marketing subsidiary of the American Crafts Council. Sponsors four craft fairs each year in Baltimore, Dallas, San Francisco, and Springfield, Massachusetts, featuring the work of professional crafts people.

American Dance Guild
33 West 21st Street, 3rd floor
New York, NY 10010
(212) 627-3790

A national membership organization serving the needs of dancers, choreographers, dance teachers, historians, critics, and students in the field of dance, in all phases of their development and career. Sponsors conferences, workshops, master classes, and concerts. Maintains a placement service. Publications and newsletter.

American Film Institute
P.O. Box 27999
2021 North Western Avenue
Los Angeles, CA 90027
(213) 856-7743

American Film Institute
The John F. Kennedy Center for the Performing Arts
Washington, DC 20566
(202) 828-4000

Nonprofit, governmental corporation dedicated to preserving and developing the nation's artistic and cultural resources in film. Among many other

activities, it provides grants and fellowships to film and video artists, awards internships for major motion picture productions, and acts as a bridge between learning a craft and practicing a profession. Publications.

American Music Center
250 West 54th Street, Room 300
New York, NY 10019
(212) 247-3121

A professional organization for composers, librettists and lyricists. Operates the Composers Assistance Program to help composers pay for copying music and extracting performance materials, and the Composer/Librettist Dating Service, which helps composers and librettists find collaborators. Publishes a newsletter.

Artists Community Federal Credit Union
280 Broadway, Suite 412
New York, NY 10007
(212) 227-3770

The first nationwide credit union for artists of all disciplines. Services include personal loans, interest-bearing savings accounts, and a financial referral service.

Artists Foundation
110 Broad Street
Boston, MA 02110
(617) 482-8100

A public, nonprofit organization that works to enhance the professional careers of creative artists, with a major emphasis on those living and working in Massachusetts. Operates fellowship and grant programs, residencies, and training workshops; assists artists with housing and legal problems. Quarterly newsletter and numerous publications.

Artpark
Box 371
Lewiston, NY 14092
(716) 745-3377

A publicly funded state park dedicated to all aspects of the arts, located on 200 acres of New York State park land along the Niagara River Gorge. Provides a broad range of arts programming for a general audience; assists in increasing public understanding and awareness of artists and their art forms; offers artists the opportunity to experiment, collaborate, and develop their artistic skills.

Arts Apprenticeship Program
Department of Cultural Affairs
2 Columbus Circle
New York, NY 10019

A publicly funded program that places college students interested in careers in the arts in one-year apprenticeships with professional artists and arts organizations throughout New York City.

Arts Extension Service
Goodell Building
University of Massachusetts
Amherst, MA 01003
(413) 545-2360

A community development program providing services, programs, and educational offerings to individuals and organizations involved in developing art and arts interests on local, regional, and national levels.

Arts International Program
Institute of International Education
809 United Nations Plaza
New York, NY 10017-3580
(212) 984-5370

A program that services artists and arts groups of all disciplines with information, research, and administration of international arts exchange programs worldwide. Also administers fellowships and grants for cultural exchanges, including MUSICA, which sends young musicians to international music competitions. Provides technical assistance, referrals and newsletter for a minimal fee. Technical assistance covers such areas as funding sources, overseas contacts, festivals and competitions, study programs, artist colonies and networking.

Arts Midwest
Suite 310
528 Hennepin Avenue
Minneapolis, MN 55403
(612) 341-0755

A regional consortium of the state arts agencies of Illinois, Indiana, Iowa, Michigan, Minnesota, North Dakota, Ohio, South Dakota, and Wisconsin. Provides services that increase opportunities for the public to experience the arts, expand professional opportunities for artists who live and work in the Midwest, and strengthen the capabilities of artists and arts organizations to accomplish their purposes.

Arts Resource Consortium and Library
1285 Avenue of the Americas
New York, NY 10019

Offices and 15,000-volume library combining the resources of the American Council for the Arts, the Center for Arts Information, and Volunteer Lawyers for the Arts. See individual listings for phone numbers. Call for an appointment.

Artspace Projects
400 First Avenue North, Suite 203
Minneapolis, MN 55401
(612) 339-4372

A nonprofit corporation assisting in the location, development, and management of artists' living, working, exhibition, performance, and support space. Primary focus is on the Minneapolis area, but services are extended to artists nationwide.

Association of Hispanic Arts
200 East 87th Street
New York, NY 10028
(212) 369-7054

A nonprofit organization serving the Hispanic arts community. Serves as a clearinghouse for information on all the arts; publishes a journal providing information on grants, contests, and workshops; organizes annual Hispanic arts festival; offers workshops and technical assistance; operates a funding resource library.

Association of Independent Video & Filmmakers
625 Broadway, 9th Floor
New York, NY 10012
(212) 473-3400

A nonprofit trade association providing services for independent film and videomakers, producers, directors, writers, and individuals involved in film and TV. Attempts to open pathways for financing and exhibiting independent work. Publications and newsletter.

ATLATL
402 West Roosevelt
Phoenix, AZ 85003
(602) 253-2731

A national, nonprofit organization dedicated to the preservation, promotion, growth, and development of contemporary and traditional native American arts. Services include a newsletter, journal, calendar, information center, and the Native American Resources and Distribution Clearinghouse. (The name ATLATL is an Indian term for a device for throwing a spear or dart.)

Authors Guild
234 West 44th Street
New York, NY 10036
(212) 398-0838

A national society of professional authors, including writers of books, poetry, articles, short stories, and other literary works. Provides authors with numerous business and professional services such as assistance with contract negotiation and information on copyright and taxation. Offers a health and life insurance plan. Bulletin and other publications.

Authors League of America
234 West 44th Street
New York, NY 10036
(212) 391-9198

A professional organization composed of the 12,500 members of the
Authors Guild and the Dramatists Guild, including authors of books, mag-
azine material, and plays. The League takes an active role in advocacy for
all issues concerning authors and playwrights, including copyright, freedom
of expression, and taxation. Through the Authors League Fund, it makes
available interest-free loans for published authors who have sudden finan-
cial emergencies.

Black Filmmaker Foundation
80 Eighth Avenue, Suite 1704
New York, NY 10011
(212) 924-1198

Media arts center established to support the independently produced work
of black film and video artists. Sponsors programs to facilitate this work and
activities that will promote public recognition and support. Operates BFF
Distribution Service.

Boston Visual Artists' Union
c/o The Art Institute of Boston
700 Beacon Street, 3rd Floor
Boston, MA 02215
(617) 266-1101

An artists' cooperative formed to educate the public about art and the
improvement of all aspects of artists' lives. Supports member artists of
every discipline through exhibitions, workshops, and support of personal
and professional rights.

Bush Foundation
E-900 First National Bank Building
322 Minnesota Street
St. Paul, MN 55101
(612) 227-0891

Bush Foundation Fellowships for Artists are awarded to promising writers or visual artists to meet an artistic goal or generally to advance a professional artistic career. Applicants must be residents of Minnesota.

Business Committee for the Arts
1775 Broadway
New York, NY 10019
(212) 664-0600

A national membership organization of United States business leaders committed to supporting the arts and encouraging new and increased support from the business community. The BCA counsels businesses that want to begin a program of support for the arts, and provides the business community and the public with information and statistics about business support to the arts.

Business Roundtable
200 Park Avenue, Suite 2222
New York, NY 10166
(212) 682-6370

An "influential lobbying force" representing the views of American business and composed of the chief executive officers of major United States corporations. Members examine public issues that affect the economy and develop positions that seek to reflect sound economic and social principles.

Cambridge Arts Council
City Hall Annex
57 Inman Street
Cambridge, MA 02139
(617) 498-9033

A nonprofit, community arts council serving artists and arts organizations in the Cambridge community through the distribution of grant funds, coordination of the Cambridge River Festival, an extensive art in public places program, and other special projects.

Center for Arts Information
1285 Avenue of the Americas
New York, NY 10019
(212) 977-2544

A national clearinghouse for and about the arts. Its information and referral
services are available to all members of the arts community and the general
public by appointment. The extensive research library is part of the Arts
Resource Consortium and Library. A quarterly newsletter provides artists
with information on publications, fellowships, grants, residencies, and
other topics of interest.

Center for New Television
912 South Wabash Avenue
Chicago, IL 60605
(312) 427-5446

A media arts center and professional association serving independent tele-
vision producers, video artists, social service and cultural organizations, and
others. Provides access to video production and postproduction equipment
and facilities; offers an educational program and an exhibition program;
publishes a magazine.

Chicago Artists Coalition
5 West Grand Avenue
Chicago, IL 60610
(312) 670-2060

An artist-run coalition of visual artists that serves as an advocate for issues
concerning the rights of visual artists. Provides professional and educa-
tional services for artists and the arts community, and attempts to improve
the environment in which artists work and live.

Chicago Council on Fine Arts
78 East Washington Street
Chicago, IL 60602
(312) 744-6630

A service agency of the city government that works to create an envi-
ronment where arts and cultural activities may flourish. Provides funds,

services, and publications for artists contributing to cultural activity in Chicago.

City Beautiful Council of the City of Dayton
101 West Third Street
Dayton, OH 45402
(513) 443-3694

An office of the city government that, with the Wright State University Department of Art and Art History, operates the Alternative Spaces Residency Program. This program is designed to bring contemporary art to public places within Dayton.

Committee on the Visual Arts
Massachusetts Institute of Technology
Building E15-109
20 Ames Street
Cambridge, MA 02139
(617) 253-5076

A committee of faculty, staff, and student members that oversees policy for noncurricular activities in the visual arts at MIT. A professional staff organizes an active exhibition and publication program, develops and maintains a Permanent Collection and two student loan collections, and sponsors educational events.

Consortium for Pacific Arts & Cultures
2141c Atherton Road
Honolulu, HI 96822
(808) 946-7381

A regional consortium of the state arts agencies of Guam, American Samoa and the Northern Marianas that provides a variety of services including a performing arts touring program, the Festival of Pacific Arts, an apprenticeship program, technical assistance, and special projects.

Council for the Arts at MIT
Room E15-205
20 Ames Street

Massachusetts Institute of Technology
Cambridge, MA 02139
(617) 253-4003

A university arts agency within the Office of the President of MIT that works to support and foster all the arts, both curricular and noncurricular, at the university. Operates a grants program and numerous endowed awards in the arts; publishes an arts calendar and newsletter; raises funds for MIT arts activities.

Council on Foundations
1828 L Street, NW
Washington, DC 20036
(202) 466-6512

A national membership organization representing independent, community, and company-sponsored foundations and corporate contributions programs throughout the United States. Works to increase public understanding of the role of philanthropy in American life.

Creative Time
66 West Broadway
New York, NY 10007
(212) 619-1955

A not-for-profit arts organization that supports the creation of new work by professional artists for public presentation in vacant spaces of historical and architectural interest throughout New York City. Programs include visual and performing arts and architecture and are designed to encourage a dialogue between the artists and the community. The organization responds to a diversity of artists' needs by providing opportunities for experimentation, securing exhibition spaces, requesting funds, seeking in-kind contributions, providing artists' fees, and coordinating and promoting the projects.

Deaf Artists of America, Inc.
P.O. Box 2332
Westfield, NJ 07091

A national arts organization dedicated to recognition and support of hearing impaired visual and performing artists. Publishes a newsletter, and is compiling a registry of deaf artists.

Disabled Artists Network
P.O. Box 20781
New York, N.Y. 10245

An information exchange for disabled artists in the visual and sculptural arts. For information, send a stamped, self-addressed envelope.

Doctors for Artists
123 West 79th Street
New York, NY 10024
(212) 496-5172

A nonprofit referral service that recommends doctors who offer health care at reduced rates for artists.

Dramatists Guild
234 West 44th Street
New York, NY 10036
(212) 398-9366

A professional association of playwrights, lyricists, and composers. Conducts symposia and weekend workshops. Provides use of minimum basic production contract; offers royalty collection, business advice, members' hot line, health insurance, marketing information, and publications, including a quarterly magazine and a newsletter.

The Exploratorium
3601 Lyon Street
San Francisco, CA 94123
(415) 563-7337

A center for adults and children to explore science, art, and technology. The works of artists are an integral part of the museum's exhibition program. Through commissions and an artist-in-residence program, the

Exploratorium provides artists with an unusual context in which to work. Approximately 4–6 artists are chosen each year to produce works that usually become permanent installations. Artists receive a stipend; they have access to the museum's technical staff and workshop; they also have the opportunity to use the museum as their studio.

First Night
739 Boylston Street, Suite 402
Boston, MA 02116
(617) 424-1699

A community-wide celebration of New Year's Eve through the arts. Founded in 1976, the Festival brings the city, suburban, and neighborhood communities of Boston together for a joint celebration, while providing the public with an alternative way of ushering in the new year.

Ford Foundation
320 East 43rd Street
New York, NY 10017
(212) 573-5000

A private philanthropic institution chartered to serve the public welfare by giving funds for educational, developmental, and experimental efforts designed to produce significant advances on selected problems of national and international importance. Most grants are awarded to organizations working in one of the the following three areas: Education and Public Policy; International Affairs; and National Affairs. Details of Foundation activities are given in the *Annual Report* and in the pamphlet, *Current Interests*.

Foundation Center
888 Seventh Avenue
New York, NY 10106
(215) 975-1120

A nonprofit educational and service organization established to collect, organize, and disseminate information on foundations, grants, and philanthropy. Maintains a nationwide network of research libraries for free public use. To check on new library locations, call toll-free 800-424-9836.

Fulbright Program
Institute of International Education
809 United Nations Plaza
New York, NY 10017
(212) 883-8200

An educational exchange program formed to strengthen understanding and communication between the United States and over 120 nations. Fellowships are available for students, faculty, and teacher exchanges.

General Services Administration
Art-In-Architecture Program
Public Buildings Service
Washington, DC 20405
(202) 566-0950

Commissions artists to produce works in all media (painting, sculpture, fiber-works, and architecturally scaled craft works) for federal buildings throughout the country. Approximately 25 commissions are made per year. Artists are nominated through a cooperative procedure between the GSA, the NEA, and the project architect. To be included in the GSA slide registry, artists should send a résumé and slides.

Ingram Merrill Foundation
P.O. Box 202, Village Station
New York, NY 10014

Awards grants to further the advancement of the cultural and fine arts by supporting individuals engaged in creative and scholarly pursuits. Grants have been primarily for independent projects or advanced study by individual artists, musicians, theatre artists, poets, and scholars in literary criticism and art history, with some emphasis on writers rather than visual or performing artists.

International Women's Writing Guild
Box 810, Gracie Station
New York, NY 10028
(212) 737-7536

An alliance of women writers in the United States, Canada, and abroad, including playwrights, TV and film writers, songwriters, and producers. Offers a semiannual, week-long writing conference; publishes a newsletter; offers health and life insurance.

Koussevitzky Music Foundation
415 Madison Avenue
New York, NY 10017
(212) 752-5300

Awards commissions to composers who have demonstrated outstanding merit. No special form of application is required. Decisions are based on the work itself or the recommendations of established composers.

Lawyers for the Creative Arts
623 South Wabash Avenue, Suite 300-N
Chicago, IL 60605
(312) 427-1800

An affiliate organization of Volunteer Lawyers for the Arts providing free legal representation for artists and arts groups that meet certain financial criteria. Informs the arts community about artists' rights and responsibilities and encourages lawyers to provide their services in support of the arts. Publications and newsletter.

Los Angeles Contemporary Exhibitions (LACE)
1804 Industrial Street
Los Angeles, CA 90021
(213) 624-5650

A nonprofit interdisciplinary exhibition and performance space for the presentation of innovative contemporary art, and a forum for the enhancement of dialogue between emerging and established artists and their audiences.

MacArthur Foundation, John D. and Catherine T.
140 South Dearborn Street
Chicago, IL 60603
(312) 726-8000

A foundation most widely known for its MacArthur Fellows Program that provides fellowships to highly gifted individuals of all ages to enable them to pursue their work in diverse fields with no restrictions. Selection is made by a group of 100 nominators who make recommendations to the Foundation board.

Mid-America Arts Alliance
Suite 700
912 Baltimore Avenue
Kansas City, MO 64105
(816) 421-1388

A consortium of the state arts agencies of Arkansas, Kansas, Missouri, Nebraska, Oklahoma, and Texas that administers tours of performing and visual arts programs, and a variety of service programs to help artists, arts institutions, administrators, and community sponsors become more skilled as arts presenters.

Mid-Atlantic Arts Foundation
11 East Chase Street, Suite 1-A
Baltimore, MD 21202
(301) 539-6656

A regional consortium of the state arts agencies of New York, New Jersey, Pennsylvania, Delaware, Maryland, Virginia, West Virginia, and the District of Columbia that provides services including a performing arts touring program, a fellowship program, a computerized information system about artists and arts organizations, and a residency program for visual artists.

Midmarch Associates
Box 3304
Grand Central Station
New York, New York 10163
(212) 666-6990

A women's art service organization that plans and coordinates exhibitions, conferences, and festivals. Maintains an information clearinghouse and resource center for artists; publishes books primarily for women artists and women's arts organizations.

Museum of American Folk Art
444 Park Avenue, South
New York, NY 10016-7321
(212) 481-3080

In an effort to make the arts more accessible to the blind and visually impaired, the Museum of American Folk Art, together with the American Foundation for the Blind, has published the *Art Resource Directory for Blind and Visually Impaired People*.

National Artists Equity Association
P.O. Box 28068
Central Station
Washington, DC 20038
(202) 628-9633

National organization of visual artists working to promote and protect the interests of all professionals in the visual arts. Through almost twenty chapters across the United States, it serves as an advocate for legislation benefiting visual artists, and works to prevent or abolish abuses to visual artists. Discounts on art magazines and books; fine art insurance; debt collection service; legal referral and information; model contracts; newsletter; other publications. Maintains a listing of public art programs nationwide. (See also: New York Artists Equity Association.)

National Assembly of Local Arts Agencies
1420 K Street, NW, Suite 204
Washington, DC 20005
(202) 371-2830

A membership organization encouraging the coordination, promotion, and development of educational, informational, and cultural activities among local arts agencies throughout the United States. Includes over 2,500 arts councils, and city or county arts agencies.

National Assembly of State Arts Agencies
1010 Vermont Avenue, NW, Suite 920
Washington, DC 20005
(202) 347-6352

A nonprofit membership organization of the state arts agencies in the fifty states and six special jurisdictions of the United States. It exists to enhance the growth of the arts, develop an informed membership, represent the collective needs and concerns of the member agencies, and provide forums for development of national arts policy.

National Association of Artists' Organizations
1007 D Street, NE
Washington, DC 20002
(202) 544-0660

A service organization for nonprofit organizations dedicated to the creation and presentation of contemporary visual and performing arts in all media. Promotes the awareness of artists' organizations and their contribution to contemporary American art and artists. Organizes conferences and produces publications including the National Directory of Artists' Organizations.

National Center on Arts and the Aging
600 Maryland Avenue, SW
West Wing 100
Washington, DC 20024
(202) 479-1200

A program of the National Council on the Aging. Maintains a slide registry of artists over 55 years of age; exhibits works of older artists; offers seminars and workshops; produces publications.

National Endowment for the Arts
1100 Pennsylvania Avenue, NW
Washington, DC 20506
(202) 682-5400 (Public Information & Public Affairs)
(202) 682-5410 (Office of Private Partnership)
(202) 682-5748 (Civil Rights Division)
(202) 682-5496 (Telecommunications Device for Deaf People)
(202) 682-5562 (International Office)

An independent agency of the federal government created to encourage and support American art and artists. Awards matching grants to arts orga-

nizations and nonmatching fellowships to individual artists; provides leadership; and promotes advocacy activities.

National Endowment for the Humanities
1100 Pennsylvania Avenue, NW
Washington, DC 20506
(202) 786-0438

An independent federal grantmaking agency created to support projects of research, education, and public activity in the humanities. Projects aid scholarship and research in the humanities, help improve humanities education, and foster a greater curiosity about and understanding of the humanities.

New England Foundation for the Arts
678 Massachusetts Avenue, Suite 80
Cambridge, MA 02139
(617) 492-2914

A regional consortium of the state arts agencies of Connecticut, Maine, Massachusetts, New Hampshire, Rhode Island, and Vermont that administers programs in the performing, visual, and media arts and serves as a regional research and information center.

New York Artists Equity Association
32 Union Square East, Room 1103
New York, NY 10003
(212) 477-8295

A nonprofit and independent service organization that represents the economic, cultural, and legislative interests of professional visual artists nationwide. Provides legal counsel to its members for art-related problems. Publications, including monthly newsletter.

New York Foundation for the Arts
5 Beekman Street, Room 600
New York, NY 10038
(212) 233-3900

A not-for-profit corporation established by the New York State Council on the Arts to provide and administer statewide services for artists, arts organizations, and the general public in New York State. The programs focus on administrative and fiscal management, artist needs and professional options, and community arts development. For individual artists, the Foundation offers residencies, project sponsorship, information and technical assistance, and workshops.

Partners of the Americas
1424 K Street NW, #700
Washington, DC 20005

An organization arranging exchange residencies of one month or more for artists in the United States, Latin America, and the Caribbean. Airfare, room and board, and some expenses are provided.

PEN American Center
568 Broadway, 4th Floor
New York, NY 10012
(212) 334-1660

An international association of writers, translators, literary editors, and agents. The American Center is the largest of the more than eighty centers that constitute International PEN. Offers numerous publications, prizes, and awards; a monthly series of symposia and readings; a translator-publisher clearinghouse; publisher-writer programs; and other services.

Philadelphia Volunteer Lawyers for the Arts
260 South Broad Street, 20th Floor
Philadelphia, PA 19102
(215) 545-3385

One of many affiliate organizations of Volunteer Lawyers for the Arts, serving the Delaware Valley. Offers free legal assistance for qualifying artists and arts groups; educational programs to alert artists and arts groups to business and legal issues before problems arise; and publications.

Poets & Writers
201 West 54th Street
New York, NY 10019
(212) 757-1766

An information clearinghouse for the literary community. Assists writers
and sponsoring organizations in arranging readings and residencies. Pro-
vides a telephone information service and a reading and workshop pro-
gram. Maintains computerized information service for writers. Numerous
publications and a newsletter.

Prescott Park Arts Festival
P.O. Box 4370
Portsmouth, NH 03801
(603) 436-2848

An annual six-week festival of dance, music, mime, and visual arts held
during the summer in Portsmouth. Features local New Hampshire artists.

Publishing Center for Cultural Resources
625 Broadway
New York, NY 10012
(212) 260-2010

A nonprofit organization that helps plan, produce, and distribute publica-
tions for nonprofit groups and institutions. Their catalog includes numer-
ous publications related to the arts.

Renaissance Development Corporation
131 West Main Street
Louisville, KY 40202
(502) 581-9023

Cultural arts organization providing technical assistance to minority artists
in Kentucky. Also serves as a presenter for black dance and theatre perfor-
mances, poetry readings, and visual art exhibitions.

Rockefeller Foundation
1133 Avenue of the Americas
New York, NY 10036
(212) 869-8500

The Arts and Humanities program provides support for creative individuals, and fellowships for writers and scholars in the traditional humanistic disciplines.

San Francisco Foundation
500 Washington Street
San Francisco, CA 94111
(415) 392-0600

A community foundation that gives grants in six areas: the arts; community health; education; environment; humanities; and urban affairs in the Bay Area counties of Alameda, Contra Costa, Marin, San Francisco, and San Mateo, unless otherwise specified by the donors.

Southern Arts Federation
1401 Peachtree Street NE
Suite 122
Atlanta, GA 30309
(404) 874-7244

A regional consortium of the state arts agencies of Alabama, Florida, Georgia, Kentucky, Louisiana, Mississippi, North Carolina, South Carolina, and Tennessee that administers performing and visual arts touring events, special development services to minority and emerging artists and arts organizations, and other services and information.

Spoleto Festival, U.S.A.
P.O. Box 157
Charleston, SC 29402
(803) 722-2764

A two-week international festival of opera, music, dance, visual arts, theatre, and jazz under the artistic direction of Gian Carlo Menotti. The festival is held annually in late spring in Charleston, South Carolina.

Theatre Communications Group
355 Lexington Avenue
New York, NY 10017
(212) 697-5230

A national arts organization for the administrators of nonprofit theatres, theatre artists, and theatre technicians. Combines the activities of a service organization with that of a national professional association. Serves institutions and individuals through casting and job referral services, management and research services, conferences and seminars, publications, and other programs.

United Arts
Resources and Counseling Program
411 Landsmark Center
75 West Fifth Street
St. Paul, MN 55102
(612) 292-4381

A community arts council offering low-cost, business-related information, counseling, and training programs for arts managers, organizations, and artists.

U.S. Copyright Office
Library of Congress
Washington, DC 20559
For registration forms: (202) 287-9100
For information: (202) 287-8700

An office of the federal government that examines copyright claims for literary, artistic, and musical works; registers those claims that meet the legal requirements; catalogs all registrations.

U.S. Information Agency
Washington, DC 20547
(202) 485-2355

An independent organization responsible for the U.S. Government's over-
seas information, educational exchange, and cultural programs. Primarily
an overseas agency with its work carried out by Foreign Service officers.
Promotes and administers educational and cultural exchange programs in
the national interest, such as the Fulbright academic exchange program;
the Arts America program, sending a limited number of performing groups
and fine arts exhibitions abroad; and the Artistic Ambassador Program,
sending gifted American musicians, who are neither currently under man-
agement nor have had a major debut, on solo tours overseas.

U.S. Small Business Administration
Office of Management Assistance
P.O. Box 15434
Fort Worth, TX 76119
(817) 334-3777

A federal agency created to help people start a business and stay in busi-
ness. Through more than one hundred offices nationwide, it provides pro-
spective, new, and established people in the small business community
with financial assistance, management counseling, and training.

Very Special Arts
Education Office
John F. Kennedy Center for the Performing Arts
Washington, DC 20566
(202) 662-8899
(202) 662-8898 (Telecommunications Device for Deaf People)

A nonprofit organization dedicated to enriching the lives of people who are
disabled by encouraging creativity. Operates in over 440 communities
throughout each of the fifty states. Organizes festivals and special pro-
grams, offers grants, and publishes a quarterly newsletter.

Veterans Administration
Committee on the Arts
Washington, DC 20420
(202) 389-3742

Provides commissions to artists to create original artworks for installation
in new VA buildings nationwide. Artists are selected through a cooperative
procedure between the VA, the NEA, and the project architect. To be
included in the VA slide registry, artists should send a résumé and slides.

Volunteer Lawyers for the Arts
1285 Avenue of the Americas, 3rd Floor
New York, NY 10019
(212) 977-9270

A nonprofit, tax exempt corporation providing artists and arts organiza-
tions from all creative fields with free legal assistance, representation, and
comprehensive legal education. For a brief listing of VLA affiliate organi-
zations, refer to Chapter 3, or call the New York office. Produces numerous
publications on arts-related legal issues and a quarterly law journal.

Western States Arts Foundation
141 East Palace Avenue
Santa Fe, NM 87501
(505) 988-1166

A regional consortium of the state arts agencies of Alaska, Arizona, Cali-
fornia, Colorado, Hawaii, Idaho, Montana, Nevada, New Mexico, Oregon,
Utah, Washington, and Wyoming. Provides services that increase oppor-
tunities for the public to experience the arts, expand professional oppor-
tunities for artists who live and work in the west, and strengthen the capa-
bilities of artists and arts organizations to accomplish their purposes.

Women in the Arts
325 Spring Street, Room 200
New York, NY 10013

A nonprofit organization dedicated to overcoming discrimination and pro-
moting wider opportunities for women artists of all ethnic and economic
groups. Offers newsletter and educational programs.

Glossary

In compiling this Glossary I have drawn liberally from a variety of sources, including the Foundation Center, the Council on Foundations, and the NEA.

Abstract A statement summarizing the important points of a proposal or another given text.

Annual Report A published report issued annually by corporations and many foundations that describes their activities and provides their income statement during the past year.

Application A request, usually on a printed form, for a grant or contribution. An application form usually requests detailed information concerning the need for the grant, the plan for meeting the need, the amount of money needed, and background about the applicant/organization.

Art Bank A program, usually operated by a state, to purchase art work by the state's artists and then offer it on rental or loan for public display in public or private nonprofit facilities. Often, these rental fees are used to purchase new art and to cover administrative expenses.

Art in Public Places Works of art located in public places, often paid for through percent-for-art funding; frequently involves dialogue and collaboration between the artist and an architect, planner, or community residents.

Artist Colony A type of support for artists, usually associated with a place to work and the opportunity to create in an environment with no demands and no obligations on the artists' time.

Artist-in-Residence Program A type of support for artists, usually associated with an opportunity to reside in a given community as an artist/ educator.

Commission An authorization, specified by the person or organization that requests and provides funds, to perform a certain task or create a specific work.

Consignment An arrangement in which an artist entrusts his or her art works to another individual or organization, such as a dealer or gallery. The artist is paid a portion of the price the gallery receives on the sale of the art work.

Contract A legal agreement between two or more parties. Also, the written document containing such an agreement.

Copyright The right granted by law to the creator of an original work of art to protection from unauthorized use of his or her creation.

Corporate Foundation A private philanthropic organization established and funded by a corporation whose primary purpose is to make grants.

Corporate Giving Program A philanthropic program operated within a corporation whose primary purpose is to make grants. A corporate giving program is not subject to the same reporting restrictions as private foundations.

Endowment Funds or property intended to be kept permanently as a means of income to provide continued support for an organization.

Estate The value of all property owned by a person at the time of death.

Fellowship A grant or scholarship providing support to an individual for training, study, travel, or for advancing one's career in other ways.

Fiscal Agent See Institutional Sponsor.

Foundation A nonprofit organization that is given the privilege of almost complete tax exemption because it contributes some portion of its funds to charitable causes.

Giving Program See **Corporate Giving Program**.

Grant A contribution, either of money or in-kind.

Guidelines A statement of policy that outlines the principles by which a proposal or application is to be judged.

Incorporation The process of forming a legal corporation, the advantages of which are limited liability and tax benefits.

Independent Foundation A grantmaking organization designated by the IRS as a private foundation. An independent foundation is estab-

lished through the gift of an individual or a family and often carries
the name of the donor. It may also be known as a family foundation, a
general purpose foundation, a special purpose foundation, or a private
nonoperating foundation.

In-kind Support A contribution of equipment, supplies, or other prop-
erty, including space and staff time. The donor may place a monetary
value on in-kind gifts for tax purposes.

Institutional Sponsor A nonprofit, tax-exempt organization that agrees
to apply for funds on your behalf. If funding is awarded, the institu-
tional sponsor will be the recipient of the funds, will administer the
money, and is legally responsible for insuring that the funds are used
for the purposes stated in the project proposal.

Insurance A contract binding a company to protect an insured party
against specified loss in return for premiums paid. There are many
types of insurance, including life, health, liability, workmen's compen-
sation, vehicle, rain, shipping, dwelling, and property.

Letter of Recommendation A written, favorable statement concerning
the character or qualifications of someone.

Local Arts Agency A community organization or an agency of a city or
county government that primarily provides financial support, services,
or other programs for a variety of arts organizations or individual art-
ists and the community as a whole.

Matching Gift A financial or in-kind contribution that matches another
contribution toward the total cost of a project or program. The match
may come from the grantee, a corporation, foundation, or other orga-
nization. It may be an exact match of funds, a ratio match, or a per-
centage of the cost.

Nonprofit Organization An organization that does not seek to make a
profit but, instead, uses its income to support its operations.

Percent-for-Art The allocation of a certain percentage, often 1 percent,
of the annual construction budget of state, federal, university, or other
buildings to commission or purchase art.

Program Officer A staff member at a government agency, foundation,
or corporation who is responsible for screening grant applications,
reviewing written proposals and budgets, answering questions posed
by applicants, and, in many cases, making recommendations about
proposals.

Project Grant An award providing funds for a specific project or for a
work-in-progress.

Proposal A written request (in a format determined by the grantmaker)
for a grant or contribution. It provides detailed information concerning

the need for the grant, the plan for meeting the need, the amount of
money requested, and background about the applicant/organization.

Résumé A written summary of experience submitted by a grant appli-
cant. Also referred to as a curriculum vitae.

Scholarship A grant awarded to a student to pay for education-related
expenses.

Site Visit A visit by one or more people representing a funding agency
to an applicant, whether individual or organization, in order to obtain
additional firsthand information by which to evalute a proposal.

Slide Library See **Slide Registry.**

Slide Registry A public repository for written and visual information
submitted by contemporary artists about their work—contains slides,
résumés, addresses, and, often, photographs, catalogs, and critical
reviews.

State Arts Agency An organization or agency of state government that
receives an annual appropriation from the state, is designated by fed-
eral legislation to receive funding from the NEA, and provides finan-
cial support, advocacy, services, and other programs for arts institu-
tions and artists within that state.

Tax Deduction An item that you are legally allowed to subtract from
your gross income.

Tax-Exempt Status A classification granted by the IRS to qualified non-
profit organizations that frees them from the requirement to pay taxes
on their income. Private foundations, however, must pay a small excise
tax on net investment income.

Technical Assistance Services, including training, consulting, peer asso-
ciations, and publications, for the transfer of skills, information, and
insights related to professional problems. Artists often seek technical
assistance for fund-raising, budgeting, legal matters, recordkeeping,
marketing, and promotion.

Trustee A member of a governing board, which is often referred to as a
Board of Directors.

Bibliography

American Art Directory. 51st ed. Ed. and comp. Jaques Cattell Press. New York: R. R. Bowker Co., 1986. (Biennial)

Gives descriptive information about American museums, libraries, arts organizations, arts schools, arts magazines, scholarships, and fellowships in the visual arts.

American Council for the Arts. *A Guide to Corporate Giving in the Arts-4.* New York: American Council for the Arts, 1987.

Includes information on the giving policies of over 700 major corporations. Well indexed.

Arensberg, Suzi. "Guild Pursues Royalties for Library Book Loans." *Authors Guild Bulletin* (Fall 1984):1–4.

Artists Equity Association. *Artists Live/Work Spaces: Changing Public Policy.* San Francisco: Artists Equity Association, 1981.

Excellent handbook for artists who have or anticipate housing problems.

Artists Foundation. *Artists Guide to New England Galleries: An Insider's Resource Book.* Boston: Artists Foundation, 1984.

A comprehensive directory of more than two hundred commercial, nonprofit, and university galleries, craft shops, and exhibiting artists' associations that involve contemporary artists working in all media.

———. *Artists-in-Residence: A Sponsor's Planning Guide.* Boston: Artists Foundation, 1983.

Detailed information about the scheduling and arrangements involved in a residency. Includes descriptions of artists' residencies.

Arts Extension Service. *Fairs and Festivals in the Northeast*. Amherst: Arts Extension Service, University of Massachusetts, 1987.
A comprehensive listing of arts fairs and festivals in the New England area, with useful information about direct marketing.

————. *Going Public: A field guide to development in art in public places*. Amherst: Arts Extension Service, University of Massachusetts, 1988.
A detailed reference for planning public art work, both for administrators and for artists.

Bay Area Lawyers for the Arts. *The Art of Deduction: Income Taxation for Performing, Visual, and Literary Artists*. San Francisco: Bay Area Lawyers for the Arts, 1983. (Revised annually)
Short and clear, with lots of examples. Easy to use.

Beardsley, John. *Art in Public Places*, ed. Andy Leon Harney. Washington, DC: Partners for Livable Places, 1981.
Documents fifteen years of art in public places projects funded by the NEA. Includes photographs and essays about the process and future directions of public art.

Biberman, Nancy, and Evans, Roger K. *Artists' Housing Manual: A Guide to Living in New York City*. New York: Volunteer Lawyers for the Arts, 1987.
Detailed, excellent reference on the history and rules governing lofts and special artists' housing in New York City. Contains useful information for artists in search of housing nationwide.

Briskin, Larry, comp. *Arts and the States*. Denver: National Conference of State Legislatures, 1981. (1984 Update)
Analyzes numerous arts-related issues of interest to state arts councils, including arts lotteries, consignment laws, the arts in education, artists' rights, tax legislation, and percent-for-art.

Brooks, Valerie F. "Confessions of the Corporate Art Hunters," *Art News* 81 (1982):108–112.

Caplin, Lee Evan, ed. *The Business of Art*. Englewood Cliffs, NJ. Prentice-Hall, 1982.
Relates specifically to visual artists. Useful chapters on promotion and marketing.

Center for Arts Information. *Artist Colonies*. New York: Center for Arts Information, 1986.
Lists names, addresses, and phone numbers of thirty-seven artists' retreats located in the United States, and 9 located abroad; classified by discipline.

———. *Copyright*. New York: Center for Arts Information, 1985.
One-page listing of thirteen publications containing information about copyright law and how it applies to various artistic media.

———. *Group Health Insurance*. New York: Center for Arts Information, 1987.
Lists professional associations offering group medical insurance programs to their members. Includes definitions of some of the benefits offered by these associations.

———. *International Cultural Exchange*. New York: Center for Arts Information, 1985.
Lists eighty-five organizations that facilitate or fund international cultural exchange programs. Includes a brief bibliography.

———. *Percent for Art Programs*. New York: Center for Arts Information, 1987.
An explanation and guide to local arts councils and agencies that monitor percent-for-art programs nationwide.

———. *A Quick Guide to Loans and Emergency Funds*. New York: Center for Arts Information, 1986.
A nine-page brochure; includes a description of twelve loan or emergency funds for artists.

———. *Sponsors: A Guide for Video and Filmmakers*. New York: Center for Arts Information, 1987.
Describes how to find and interview a potential sponsor; discusses tax implications; and provides a sample letter of agreement.

———. *Visual Artists' Grants: A Report to the Field*. New York: Center for Arts Information, 1988.
Lists 85 sources of funding for direct, non-project support. Includes application information, adjudication policies, award amounts, etc.

Chamberlain, Betty. *The Artist's Guide to the Art Market*. New York: Watson-Guptill Publications, 1983.
Focuses on exhibition, promotion, and sales information for fine artists.

Cochrane, Diane. *This Business of Art*. New York: Watson-Guptill Publications, 1978.
Focuses on writers and visual artists. Good for information about contracts, cooperatives, insurance, bookkeeping, and taxes.

Coe, Linda C.; Denney, Rebecca; and Rogers, Anne. *Cultural Directory II: Federal Funds and Services for the Arts and Humanities*. Washington, DC: Smithsonian Institution Press, 1980. (Out of print).
Includes descriptions of more than three hundred federal programs, activities, and resources that offer various types of assistance to individuals, institutions, and organizations in the Arts and Humanities.

Council on Foundations. *Corporate Philanthropy*. Washington, DC: Council on Foundations, 1982.

A collection of essays by directors of corporate foundations and giving programs about the philosophy, management, trends, future, and background of corporate philanthropy.

Crawford, Tad. *Legal Guide for the Visual Artist*. New York: Madison Square Press, 1987.

Good reference for the sale of art works, contracts, sales by galleries and agents, video art works, lofts and leases, and copyright.

————, ed. *Protecting Your Heirs and Creative Works: An Estate Planning Guide for Artists, Authors, Composers, and Other Creators of Artistic Works*. New York: Graphic Artists Guild, 1980.

A good, clear presentation.

————. *The Writer's Legal Guide*. New York: Hawthorn Books, 1977.

A handbook covering copyright laws, income taxation, libel, contracts, censorship, rights of the writer, estate planning, and self publication.

Crawford, Tad, and Mellon, Susan. *The Artist-Gallery Partnership: A Practical Guide to Consignment*. New York: American Council for the Arts, 1981.

Deals clearly with the legal and technical complexities of a consignment relationship and explains the provisions of a standard consignment agreement.

Davidson, Marion, and Blue, Martha. *Making It Legal: A Law Primer for the Craftmaker, Visual Artist, and Writer*. New York: McGraw-Hill, 1979.

Especially good information on incorporation. Many sample contracts and agreements.

Foundation Center. *Corporate Foundation Profiles*, 5th ed. New York: Foundation Center, 1987.

Lists 240 corporate foundations. Indexed alphabetically by state, subject (including the Arts), and by type of support (including fellowships).

————. *Foundation Directory*, 11th ed. New York: Foundation Center, 1987. (1988 Supplement).

Lists over five thousand corporate, private, and community foundations, including their giving interests; addresses; telephone numbers; grant amounts; names of donors, trustees and officers; and full application information. Well indexed.

————. *Foundation Grants to Individuals*, 5th rev. ed. New York: Foundation Center, 1986. (Annual)

Indispensable reference for information on fellowships and scholarships. Well indexed.

Gadney, Alan. *How to Enter and Win Contests.* New York: Facts on File, 1984.
> A series of twelve guides listing contests, awards, and prizes in each of the following areas: Fine Arts and Sculpture; Fabric and Fiber Crafts; Video/Audio; Design and Commercial Art; Non-Fiction and Journalism; Jewelry and Metal Crafts; Film; Photography; Wood and Leather Crafts; Clay and Glass Crafts; Fiction Writing; and Black-and-White Photography. Information is adequate and well organized. Good for special interest projects.

Georgia Volunteer Lawyers for the Arts. *An Artist's Handbook on Copyright.* Atlanta: Georgia Volunteer Lawyers for the Arts, 1981.
> Basic introduction to copyright for artists of all disciplines.

Green, Laura R., ed. *Money for Artists: A Guide to Grants and Awards for Individual Artists.* New York: American Council for the Arts, 1987.
> Profiles organizations, government agencies and foundations providing support to artists in the literary arts, media arts, multidisciplinary arts, performing arts and visual arts. Poorly indexed.

Hoover, Deborah A. "A University Grants Program: The Arts at MIT," *Connections,* vol. 2 (June 1984): 3, 26–27.
> Describes MIT's self-supporting grants program of financial and technical assistance to members of the university community.

Horwitz, Tem, ed. *Law and the Arts—Art and the Law.* Chicago: Lawyers for the Creative Arts, 1979.
> Excellent chapters relating to legal problems of performing artists, film and video makers, and visual artists, financial planning, and budgeting.

Howarth, Shirley Reiff, ed. *ARTnews Directory of Corporate Art Collections.* Florida: International Art Alliance, and New York: ARTnews Associates, 1986.
> Almost six hundred listings, in alphabetical order, of U.S. companies with art collections. Includes the names of personnel who oversee the collection, the governing authority, the year the collection began, size of collection, location, description, and more. Indexed by state.

Jensen, Timothy S., Esq. *VLA Guide to Copyright for the Performing Arts.* New York: Volunteer Lawyers for the Arts, 1987.
———. *VLA Guide to Copyright for Musicians and Composers.* New York: Volunteer Lawyers for the Arts, 1987.
———. *VLA Guide to Copyright for Visual Arts.* New York: Volunteer Lawyers for the Arts, 1987.
> Clear and instructive information about copyright. Not too technical.

Jobst, Katherine, ed. *1987 Internships.* Cincinnati: Writer's Digest Books, 1986. (Updated regularly)

Lists thousands of training opportunities nationwide for college students and adults. Headings include Arts, Communications, and International. Detailed information provided.

Koek, Karin, and Martin, Susan Boyles., ed. *Encyclopedia of Associations*, 22nd ed., 3 vols. Detroit: Gale Research Company, 1988. (Biennial)
Lists hundreds of arts service organizations with description, address, and phone number under "Cultural Organizations."

Landsmark, Theodore C. *Artists' Space: A Study of the Development of Artists' Living and Working Space in Boston*. Boston: Artists Foundation, 1981.
Provides easily understandable information about artists' assessments of space requirements and recent efforts to make artists' housing more readily available. Includes case studies.

Leland, Caryn R. *The Art Law Primer*. New York: Foundation for the Community of Artists, 1981.
Short good articles on print commission contracts, negotiation of commission agreements, artist-museum loan agreements, sales agreements, leases, and hiring a representative.

Levine, Mark L. *Negotiating a Book Contract*. Moyer-Bell, Ltd. 1988.
Concise guide to negotiating a fair publishing contract for authors, illustrators, their agents and lawyers.

Lipsky, Mike. *Artists' Housing: Creating Live/Work Space that Lasts*. New York: Publishing Center for Cultural Resources, 1988.
A basic primer on artists' housing problems, including six case studies of successful live/work spaces nationwide.

Margolin, Judith B. *The Individual's Guide to Grants*. New York: Plenum Press, 1983.
Although not written specifically for artists, this book is especially helpful for developing a positive attitude about seeking support as an individual and understanding what makes a good idea for a proposal.

Mellow, Craig. "Sacred Support," *American Arts* 15 (May 1984): 9–11.

Messman, Carla. *The Art of Filing: A Tax Workbook for Visual, Performing, Literary Artists and Other Self-Employed Professionals*. Minneapolis, Minnesota: United Arts, 1987. (Annual supplements available)
Step-by-step guide to preparing and filing individual tax returns for artists. Simple, readable format. Provides detailed instruction regarding what constitutes income, deductions, and tax credits for professional artists. An addendum or new edition is prepared each year.

Mitgang, Herbert. "England Now Has a Most-Borrowed List, Too," *New York Times*, January 15, 1984, p.E6.

Museum of American Folk Art and American Foundation for the Blind. *The Art Resource Directory for Blind and Visually Impaired People.* New York: Museum of American Folk Art, 1988.

Provides information concerning organizations, newsletters, classes, workshops, and competitions for visually impaired artists. Available in large-print, braille, and cassette formats.

Namuth, Hans. "Keepers of Corporate Art," *Fortune,* 107 (21 March 1983): 114–21.

National Association of Artists' Organizations. *National Directory of Artists' Organizations.* Washington, DC: National Association of Artists' Organizations, 1987.

Describes, with addresses and phone numbers, over twelve hundred artists' organizations, including those associated with contemporary visual, performing, and literary arts.

National Endowment for the Arts. *A Compilation of Excerpts from Remarks by Frank Hodsoll, Chairman. Arts Review Supplement,* Summer 1984.

———. *Directory of Minority Arts Organizations.* Washington, DC: NEA, Civil Rights Division, 1987.

Lists over 350 nonprofit performing groups, presenters, museums, galleries, arts centers, and community centers with significant arts programming, leadership, and constituency that is predominantly Asian-American/Pacific Islander, black, Hispanic, native American, or multiracial.

———. *Five-Year Planning Document: 1989–1993.* Washington, DC: NEA, 1987.

———. *Guide to the National Endowment for the Arts.* Washington, DC: NEA, Office of Public Affairs, 1987. (Annual)

Describes each of the NEA's programs and its purpose; outlines the types of projects supported in each of the NEA's funding categories.

National Endowment for the Humanities. *Overview of Endowment Programs for 1984–85.* Washington, DC: NEH, Office of Public Affairs, 1984. (Annual)

Provides information on the activities supported by grantmaking divisions and offices of the NEH with a schedule of their application deadlines.

Navaretta, Cynthia, ed. *Guide to Women's Art Organizations.* New York: Midmarch Associates, 1979. (Includes 1985 update)

Gives a brief description, address, and phone number of women's arts organizations, activities, networks, and publications in all artistic disciplines. Also extensive references.

Nesson, Jero. *Artists in Space: A Handbook for Developing Artists' Space.* Boston: Fort Point Arts Community, Inc., 1987.
An excellent guide for groups of artists interested in developing affordable studio space on a rental or ownership basis.

Oryx Press. *Directory of Grants in the Humanities.* Phoenix, Arizona: Oryx Press, 1987.
Lists over 2,500 funding programs that support research, performance, travel, etc., in all arts disciplines. Well indexed.

Paleologos-Harris, Stacey, ed. *Insights/On Sites.* Washington, DC: Partners for Livable Places, 1984.
Five essays exploring the traditions and current issues of art in public places. Insightful discussion of the process of selecting art and artists for public places. Peppered with color photographs of innovative projects in public art.

Philadelphia Volunteer Lawyers for the Arts. *Guide to Artist-Gallery Agreements.* Philadelphia: Philadelphia VLA, 1981.
A well-written brochure describing sales agreements, loans, rentals, insurance, reproduction rights, termination of agreement, and statements of account.

————. *Legal Guide for Emerging Artists.* Philadelphia: Philadelphia VLA, 1981.
A brochure with good, well-presented information about leases, copyright, and taxes.

Pies, Stacy. "On Cloud Nine: 24 Heavens for Writers," *CODA,* 10(April/May 1983). (Reprint)
Reprint available by sending $1 and a self-addressed stamped envelope to Poets & Writers.

Rand-Herron, Caroline. *A Writer's Guide to Copyright.* New York: Poets & Writers, 1979.
A clear and well-written handbook, with useful appendixes.

Schlachter, Gail Ann. *Directory of Financial Aids for Minorities.* Los Angeles: Reference Service Press, 1986–87.
Lists over 1,000 references to scholarships, loans, fellowships, grants, awards, and internships designed primarily or exclusively for minorities. Well indexed.

————. *Directory of Financial Aids to Women,* 2nd rev.ed. Los Angeles: Reference Service Press, 1987–88.
Lists programs, including scholarships, loans, fellowships, grants, awards, and internships, designed primarily or exclusively for women. Well indexed.

Sinclair, Stephen. "Behind Closed Doors," *Cultural Post* 6(May/June, 1980): 6–9.

Sternberg, Stam. *National Directory of Corporate Charity*. San Francisco: Regional Young Adult Project, 1984.
> Lists alphabetically 1,600 companies with giving programs. Provides addresses, phone numbers, types of programs funded, nonmonetary assistance, examples of organizations funded, how to apply, and contact person. Detailed information; indexed by state and subject matter.

Standard and Poor's Register of Corporations, Directors and Executives, United States and Canada. New York: Standard & Poor's Corporation. (Annual)
> A detailed reference guide to the business community and the people who run it. Indexed by location, personnel, and industrial classification.

Strong, William S. *The Copyright Book: A Practical Guide*, 2nd rev. ed. Cambridge, MA: MIT Press, 1986.
> Lengthy but well written. One of the few books about copyright that discusses the problems of media artists.

The Taft Group. *Taft Corporate Giving Directory*. Washington, DC: The Taft Group, 1988. (Annual)
> Lists 441 corporate contribution programs nationwide. Detailed information and excellent indexes.

Tomkins, Calvin. "Perception at All Levels," *New Yorker* 60(December 3, 1984): 176–181.

U.S Copyright Office. *Copyright Basics*. (Circular R1). Washington, DC: U.S. Government Printing Office. (Annual)
> A free, twelve-page brochure explaining basic information about copyright, registration, and application.

————. *Publications of the Copyright Office*. (Circular R2). Washington, DC: U.S. Government Printing Office. (Annual)
> A list of all the material published by the Copyright Office. Free of charge.

Useem, Michael. *The Inner Circle: Large Corporations and the Rise of Business Political Activity in the U.S. and U.K.* New York: Oxford University Press, 1984.

Volunteer Lawyers for the Arts. *The Art of Filing*. (See Messman, Carla)

————. *Artists' Housing Manual: A Guide to Living in New York City*. (See Biberman, Nancy, and Evans, Roger K.)

————. *Legal Guide for the Visual Artist*. (See Crawford, Tad)

————. *Negotiating a Book Contract*. (See Levine, Mark L.)

————. *To Be or Not to Be: An Artist's Guide to Not-for-Profit Incorporation*. New York: VLA, 1986.
> A twelve-page booklet designed to help you investigate the possibility of forming a legal entity through which to conduct your artistic activ-

ity. It is written primarily for small groups although it can be applied to individuals.

———. *VLA Guide to Copyright Series.* (See Jensen, Timothy S., Esq.)

Wassall, Gregory; Alper, Neil; and Davison, Rebecca. *Art Work: Artists in the New England Labor Market.* Cambridge, MA: New England Foundation for the Arts, 1983.

Presents findings from the first comprehensive regional study of labor market experiences of individual artists. Documents how New England artists survive economically—what they earned in 1981, how they found jobs, the disparity between men and women artists' incomes, and the influence education has on artists' ability to earn a living.

Weil, Stephen E. *Beauty and the Beasts: On Museums, Art, the Law, and the Market.* Washington, DC: Smithsonian Institution Press, 1983.

Wiese, Michael. *The Independent Film and Videomaker's Guide.* Sausalito, CA: M. Wiese Film Production Press, 1984.

Well-presented information on distribution, marketing, presentations, and market research for video- and filmmakers.

White, Virginia P. *Grants for the Arts.* New York: Plenum Press, 1980.

An excellent book written primarily for arts administrators. Useful as a general reference book for artists.

Index